T0251967

Distributed Game Development

Harnessing Global Talent to Create Winning Games

Tim Fields

Routledge
Taylor & Francis Group

LONDON AND NEW YORK

First published 2010
by Focal Press

2 Park Square, Milton Park, Abingdon, Oxon OX14 4RN
711 Third Avenue, New ork, N 10017, USA

Routledge is an imprint of the Taylor & Francis Group, an informa business

First issued in hardback 2017

Library of Congress Cataloging-in-Publication Data
Fields, Tim.
 Distributed game development: harnessing global talent to create winning games/Tim Fields.
 p. cm.
 Includes bibliographical references and index.
 ISBN 978-0-240-81271-7 (hardcover: alk. paper) 1. Computer games–Programming. 2. Computer software–Development. 3. Electronic data processing–Distributed processing. I. Title.
 QA76.76.C672F55 2010
 794.8'1526–dc22 2009049368

ISBN-13: 978-0-240-81271-7 (pbk)
ISBN-13: 978-1-138-42748-8 (hbk)

I dedicate this work to all of the wise mentors who have taught me so much over the years: V. Fields, V. Jewett, B. Fregger, E. Boling, D. Stafford, L. Acton, J. Ybarra, DB23, E. Roberts, Alanha, P. Watt, S. Barcia, L. Lapierre, R. Wallace. And always, RS.

Contents

About the Author

Tim Fields is a 16-year game industry veteran producer, project manager, design lead, and business developer. Tim has helped small studios and top publishers such as EA and Microsoft run teams that create great games. He has worked on shooters, sports games, racing titles, and RPGs using talent and teams from North America, Asia, Europe, and the United Kingdom. Tim has been involved in one way or another with franchises like Need for Speed, Halo, SSX, Brute Force, and Call of Duty. He loves visiting about game development and design and can be reached at tfields@distributedgamedevelopment.com.

One
Preface and Overview

1.1 Introduction

Some time over the last 15 years, the geeks won. Bill Gates became the richest man in the world, at least for a while. The personal computer moved to the center of private life for hundreds of millions worldwide. The planet got wired, got flat, and got an e-mail address. Most fun of all, games moved from being a marginalized form of entertainment at the fringe of social acceptance to being mainstream. And beyond mainstream, video games became cool, no longer just the province of the stereotypical outcast adolescent male. Consequently, video games became delightfully profitable.

Hand in hand with this rise to popularity, our entertainment software has become more complicated. Gaming hardware, from PCs to high-end consoles, has become more powerful, and the types of content have become much more involved. Gone are the days of single textured polygons or even basic hardware shaders. Simple LAN-style multiplay is long gone too, and an escalating war of feature brinksmanship is leading to ever more sophisticated ways to play. Input mechanisms have become more varied and sophisticated, with motion-sensing devices like the Wiimote and those fantastic little plastic guitars opening up new types of gameplay to all new audiences. The proliferation of mobile phones capable of running complex software has created new markets for casual gamers who don't even own dedicated high-end hardware. At the same time, our users expect ever more accessible interface models, better matchmaking that is more transparent as well as more accurate, and so on. Finally, the profusion of different platforms, from PC to handhelds, means that it is no longer enough to build a great game on one gaming system. To reach massive commercial success, it often needs to be built for six or seven. As if all of that weren't enough, the marketplace has become so crowded (because of the delightful profits I mentioned previously) that you need to have brilliantly marketed products. Moreover, all versions of those products need to simultaneously hit store shelves on the same day so you can get the most out of

doi: 10.1016/B978-0-240-81271-7.00001-1

1

those brilliant marketing dollars. Beyond that, you'll need to have downloadable content, expansion packs, and sequel or franchise plans in place so you can ensure that your hit game isn't a flash in the pan but instead starts a franchise dynasty that will have your investors rolling in the Benjamins until the next ice age.

1.2 How Is a Team Leader to Juggle All of This?

Luckily, a few things have evolved to make this daunting task a little easier. First, the software tools we use to create games have gotten better – a lot better, in fact. From modern versions of 3D packages such as Maya to middleware such as Havok or Gamebryo and the software development kits that we use to interact with console platforms, our tools are just plain better. Our defect tracking software has improved, as has the server hardware and the version and source control software. Moreover, there are many more professional game developers now, and our methods of communication have become much more varied and powerful. Gone are the days of firing up a dial-up modem and logging into a BBS to ask technical questions. There are thousands of websites devoted to helping engineers ask questions and wiki-type collaborative projects that serve up vastly better documentation than was common a decade ago.

Finally, our organizational processes have become more advanced. First, we've embraced a level of specialization in many roles (physics engineer, rigger, CG Sup, lighter, etc.) that would have been unheard of when all game developers were expected to be generalists. Second, we've refined some of our management roles and added a layer of facilitators such as development directors and associate producers. Teams can grumble about the introduction of these kinds of middle management roles, but it seems clear that when used properly, they help reduce friction, increase communication, and make possible the feats of coordination required to deliver top-selling titles in such a complex marketplace.

Perhaps the most sweeping change to the way we organize ourselves to facilitate the creation of entertainment software is a process that has only recently come online. It is widely remarked that the world has become "flat." Advances in communication, the opening of global markets, and the widespread adoption of English as the lingua franca assist an educated class that can collaborate across borders regardless of distance or time zones.

To be fair, "collaborate" is my word. And It's chosen to frame our subject in the appropriate light from the outset. Unfortunately, too much of the discussion about our new flat world has centered on fear mongering about lost jobs and discussions of the perils of outsourcing. Although much of this seems to be little more than political pandering in the developed world, it does speak to a greater truth: The ways in which we can turn the world to our advantage are often ill understood. An educated, global workforce with the tools of communication that allow them to collaborate can be used to benefit most industries. The creation of goods and services, like gaming software, is not a zero sum game. It is possible to make better

products, more efficiently, which reach broader markets, and delight a wider range of consumers, if the power of distributed collaboration can be effectively harnessed. We can increase the number of jobs, make better games, and all make more money than we have in years past if we can embrace the options we have available.

In particular, we're going to spend the next few hundred pages visiting about how to harness the global talent pool to create winning games – games that exceed sales expectations, games that thrill our customers, and games that help build sustainable franchises and make a lot of money for our investors and, it is hoped, for you.

This is a book about the organization of teams – about how to make use of a wide, flat world of resources and eager developers in order to accomplish the daunting tasks described previously.

Approximately 15 years ago, I was handed a book on software project management by one of my bosses, software guru David Stafford. The book, the venerable *Debugging the Development Process* by Steve Maguire, is one of the bibles of software development, published at a time when Microsoft Press was working hard to create a world in which a lot more people would understood how to develop professional software for Windows. In the book, Maguire used the metaphor of the software project as a large truck. This big rig is moving, ideally moving fast, and has to be somewhere that (hopefully) everyone has agreed upon in advance. As a leader of this project, it is your job to ensure that the truck does not encounter any roadblocks, does not run out of gas, is not broadsided by another giant truck that wants to monopolize the same section of road, and so on. To extend the metaphor, Maguire likens the software project leader as a member of an advance crew who goes ahead of the truck, looking for likely obstacles that will slow or stop its progress and radioing back course corrections to the folks with their foot on the pedal. I have always liked this metaphor and thought it nicely described the way one should approach software project management.

Only now, things are different. With projects of the complexity we've discussed previously, and a world in which you can and should be distributing the workload among several different teams, your job is more akin to that of central dispatch, or an air traffic controller. To deliver complex entertainment software on time, across a variety of platforms, in a host of different languages, to a bunch of varied markets, all on time and on budget, you need a fleet of different trucks, each manned by capable drivers.

This book will teach you how to direct them all effectively.

1.3 Who Is This Book For?

There are still some games that do not require any sort of distributed development. Let's say that you're a member of a small team building a free web game. Let's imagine that you're all in the same physical space, a small office maybe, and you aren't planning any particular marketing or QA process for your title, outside of

what can be provided by friends or a few local testers. You don't have a publisher – you're self-publishing. You're on the smaller side of indie, and you're comfortable staying that way. If this describes your team, then you likely don't need this book (though I'd hope that you still might find it illuminating, if only to see how big and complex the machine can get). Otherwise, if you are involved professionally in making games that you hope will reach a large audience, you'll be interested in what we'll be talking about here.

Specifically, however, this is a book for project leads or those who hope some-day to become project leads. It's for the harried executive producer at one of the top publishers – Activision, Microsoft, Electronic Arts, Tencent, Ubisoft, THQ, or similar – who has just finished another game and can't help but think that there must be a way to bring a little sanity to the process. It's for the development director helping keep a team alive at a small development studio doing work-for-hire for its publisher. It's for the art director of an art outsourcing house. It's for the motion graphics expert at a video production company's gaming division. It's for the lead designer trying to ensure that her vision, her baby for all intents and purposes, gets properly translated across to even the handheld version. It's for the marketing product manager who is trying to get a grip on how to help the development team create a more predictable process and a better Metacritic-rated game.

This is also a book for teachers and students. If you are a student of the games business or in an RTF program who wants to understand more about how modern games are built – and how to find your niche in this fascinating, profitable, dizzying industry – I believe you'll find a lot here. It's also a book for teachers: My goal is for this book to serve as a backbone textbook for courses on production.

Finally, this is a book for investors. If you are one of the millions of people who owns stock in a company that derives profits (or seeks to) from creating games, then this book will teach you a lot about how games are made and how to evaluate what's really happening behind the glossy press releases.

Although this book deals with team organization and the best practices for running software projects at a fairly advanced level, I endeavor to explain industry jargon as clearly as possible for those who are not already familiar with it. If you've never worked on software before, just hang in there – there's a lot to pick up, and you'll likely be amazed at how complex it all gets. But then, the inside of a sausage factory never has been a pretty place. By the time you've finished the tour, however, it won't seem so foreign. Now here's your hardhat. Let's proceed.

1.4 Preamble on Distributed Development

1.4.1 *Why Would I Use Distributed Development?*

There are dozens of reasons why different teams find themselves using a distributed model. It can be a load-balancing technique for larger companies that need to find work for their teams temporarily between production phases. Or maybe there

are possible synergies to exploit between different teams using similar technology. Alternately, distributed development can be a great way to allow smaller companies to avoid the burden of carrying too many full-time staffers.

Any time you've got a project that is meant to hit store shelves simultaneously across several different platforms (Xbox 360, iPhone, PS3, PC, PSP, Nintendo DS, and so on), you're likely to need some level of distributed development. If your project is tied into a movie license such that you're coordinating with a Hollywood studio, then you're likely distributed. Also, if you're working with a publisher of almost any size, then you're probably distributed to some degree (even if it's just your localization, QA, marketing, or sales departments that are located elsewhere).

Ultimately, however, there seem to be two main reasons to use distributed development:

- To get the best people and teams on the job
- To save money

Since the latter can be a nice side effect of clever resource organization, I strongly suggest focusing always on the former. Racing toward the bottom almost never gets you a great product, and poor products seldom create the kinds of long-term sustainable franchises that generate real revenues. Focus on using the techniques in this book to get the best minds on the planet thinking about how to make your game great. If you do this, the money will follow.

1.4.2 *So You Don't Like Outsourcing and Think It's a Bad Idea*

While having lunch with a young designer recently, I mentioned the ways in which a current project of mine was working and discussed my plan to write this document. His response surprised me: "I don't like outsourcing, or working with remote teams. I'm not sure teams should do it."

What surprised me wasn't the attitude; many people are afraid of job loss, of losing control of a project, or just afflicted with plain old xenophobia at the thought of having to collaborate with people in a distant land. What surprised me more was the idea that anyone believed that using some type of distributed team was optional.

Make no mistake. We are now firmly in the era of distributed, collaborate development and production. Personal preferences do not much enter into the question anymore. For projects of even a modest size, the question for you isn't "Will I have to collaborate with some external teams in order to succeed?" The question for you is "How do I ensure that this collaboration results in a better end product and more effectively meets my parameters for success?" There's no "if," only "how."

According to a 2009 article from *Gamasutra*, the online arm of *Game Developer* magazine, 86% of teams polled reported using some form of externalized development, and 20% of those projects polled spent more than $2 million on an externalized

component.[1] In some cases, these may have been traditional outsource deals. In many other cases, these are likely already distributed development deals of the type with which this book is concerned.

The world got very flat within the past decade, whether you were paying attention or not. The winners in the next century are not spending today debating about whether or not they should be collaborating with the best people for the job, regardless of geography. They are investigating how to best overcome the obstacles that have historically made this kind of collaboration challenging.

This document is not an attempt to convince you to collaborate with external or remote teams. I sincerely doubt you'll have a choice if you want to build the best games possible. Rather, this book will share with you some best practices for how to collaborate effectively, through a frank discussion of the process and its pitfalls, and through sharing the thoughts of a number of individuals who have integrated such collaborations successfully into their game development process.

1.4.3 *The Difference between Traditional Outsourcing and Distributed Development*

It's critical that we draw a distinction between two fundamentally different development practices. "Outsourcing" is when your team takes a known group of tasks and hires a subcontracting company to perform those tasks, either once (e.g., model and texture 60 background items based on these technical specifications) or in a recurring capacity (e.g., answer the phone and run callers through a branching script in order to collect and fill their orders). Outsourcing is a fine technique for well-known types of problems and tasks, in which substantial documentation or scripts and defined procedures already exist. This type of development is also best suited for cases in which quality is either not particularly important or a final polishing phase can be completed by someone from home, later in the development phase. It's not that a traditional outsourcer cannot hit a high-quality bar; many are superb at what they do. However, traditional outsourcing does not work very well in cases in which iteration is required to achieve the necessary quality.

"Distributed development" is when a collection of individuals or teams not geographically co-located collaborate on a project composed of a collection of tasks, some of which may not be fully understood. This might be for a video game project in which there are a few dozen engineers in one place and an art team in another. It might be a short film in which the dailies shot in Los Angeles are sent off to a post-production house in Dallas for color treatment. It might be a Facebook gadget where the programmer working on the features is collaborating with a content team at a major publisher. In all of these cases, there are numerous research

[1]Game Developer Research (April 2, 2009). Survey: Outsourcing in game industry still on increase. Available at http://www.gamasutra.com/php-bin/news_index.php?story = 23008.

and development components of the task, as well as a relationship between collaborators that stretches beyond a traditional contractor and client relationship. Distributed development management methods are designed for these types of tasks that require autonomy, creative decision making, and lots of iterative cycling toward quality.

1.4.4 Who We Will Meet in Our Case Studies, and Why We Care about What They Have to Say

No games are built by a single individual anymore, no matter what a few egoists like to believe. And as entertaining as I am, our topic here is too important to trust to just one voice. So we've recruited a few industry veterans to help lead us.

This book contains a number of interviews conducted and presented in Q&A format, designed to offer advice from experienced development directors, producers, lead programmers, art directors, motion graphics experts, and the like. They share their hard-earned wisdom and war stories with us, each dealing with some element of distributed games development. These are some of the top names in the field, whose products collectively have grossed hundreds of millions of dollars during the past decade. Their experiences are generously shared with us so that we might learn from them and continue to produce our own great products.

Although any fool can learn from his own mistakes, a wise man just might get ahead of the curve and learn from the experience of others.

Now let's talk about how to make great games.

Two

Overview of the Development Process

2.1 The Basic Games Development Cycle

It's likely that if you're reading this book, you may have already been through one or two game development cycles. Now that our industry has become a bit more mature, it's likely that many of you have been through five complete cycles or more. And a rare number of you may have game credits in the double digits. So you might know the basic framework of a development cycle these days. On the other hand, our industry is still fairly immature, and terminology and procedure differ even between established publishers. So we're going to discuss a simplified version of a production cycle as a way of setting some terminology and making sure we're all thinking about roughly the same core phases of planning, development, and product launch.

For those of you who haven't yet had the pleasure of going through a full development cycle, or who have been so heads down in the day-to-day functions of your job, this chapter serves as an introduction to the formal phases of game development. The steps described here are applicable to development no matter how many different teams or individual contributors are on a project. It's a framework that works equally well for distributed development and more traditional team organizations. Interspersed throughout this chapter are observations on ways you can ensure success at each phase and how and when to incorporate distributed teams. So let's dive in and look at the game development process!

Let's start at the beginning and briefly discuss each phase of a typical development cycle (Fig. 2.1). We'll also address some of the challenges and situations that tend to be unique to distributed development projects.

doi: 10.1016/B978-0-240-81271-7.00002-3

FIGURE
2.1

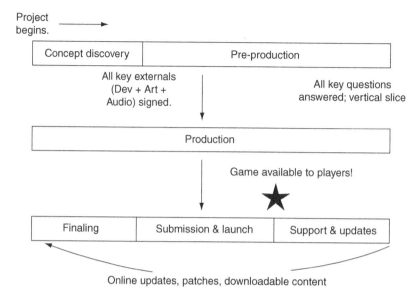

The Basic Development Cycle

2.2 Concept Discovery

In the beginning, you're likely to already have an idea for the kind of game you want to make. Or maybe your host organism, publisher, or team has come to you with something they are pretty sure they want to be made. If this is a movie-licensed title, or a sequel in a well-understood franchise, then the concept discovery phase may be slightly less complex for you, and you may be able to spend less time in this phase. If this is a new intellectual property that you hope to get off the ground, then you're likely to want to spend extra time here. Either way, what you're doing at this point is positing different product propositions and determining how they work for your target audience. It's possible that you'll also need to spend some time on understanding who your target audience is in the first place. There are many ways to approach this phase, but here are a few general suggestions:

- Don't get too attached to any one concept or idea at this point.
- Use inexpensive methods to mock up many different concepts.
- Short descriptions of features should be put in front of average users.
- Get concepts in front of consumers often, and work to understand what they mean, not just what they say.
- Mock game boxes are a good way to judge purchase intent between different possible products.
- Survey Monkey-style surveys are a great way to let users prioritize features so you know what they care about most.

- Find out whether the intent to purchase changes considerably based on setting, a different main character, or different art styles.

- If you cannot afford proper focus groups, get local game store managers and their friends to offer input and compensate them with pizza.

- People will tell you what they think you want to hear, so study carefully their intent, and try not to let the way you ask questions "lead the witness" too much.

Frankly, this phase is critically important even if you are creating a product that lives inside a known product family. Even if the core mechanics, setting, audience, or characters are carried forward from a previous title, this is still the cheapest way you'll ever have to test consumer reaction to various possible features. Heading down the wrong path here can doom you to an expensive debacle that no amount of hard work can make up for on the back end. From a concept standpoint, few people are likely to buy *Barbie's Chainsaw Golf*, no matter how good the artwork or how stellar the multiplayer component. Better to learn that now and throw the idea out before you spend precious time and money on development. From a feature perspective, few people are likely to care about an advanced create-a-character system inside your casual puzzle game; use this phase to recognize these kinds of pitfalls, and don't waste time on this feature just to cut it later. (Obviously, these examples are over the top in order to make a point, but it is easy for a development team to fall in love with an idea that the consumer just won't care about. This initial phase is the time to put a bullet in those expensive forms of hubris.)

Beyond just imagining, mocking up, and validating potential concepts and features, you should also be using this time to form some alignment between your key stakeholders. Make sure that marketing thinks it can sell the game you're narrowing in on. Make sure it fits into the SKU planning that your publishing team is doing for the release window you're considering. Make sure the key members of your team have the appropriate amount of enthusiasm for the software you're going to build. Get alignment from everyone who matters, and if they don't seem too interested, find out why not. Don't let a land mine in some division of your team or publisher catch you unaware once you've already committed a fortune and your reputation to this project.

Another way to spend time during this phase of the project is on identifying the likely "big buckets" or general categories of work that will need to be done to build the type of game you wish to make. What kinds of content will you have, and how much of it will you need? What software systems do you currently own that you can leverage to make this kind of game? What new systems will you need to invest in? Will you "roll your own," or are there off-the-shelf solutions you can use? And so on.

Note that there is a risk of falling into the "design by focus group" trap here. We've all played games that seem watered down, like they've been designed to be an amalgam of the best ideas from the previous year's hits. The best antidote to this potential poison is a core design team (which isn't necessarily a part of the "designer" job family) that is passionate and empowered. Build such a group and encourage its members to stand by – and test – their convictions, and you won't end up with a generic, knock-off product.

Although the line between the concept discovery phase and pre-production can be slightly blurry, especially since at least some of the assets you are creating and some of the design work that is being done will move forward into the true pre-production phase, you'll need to resist the temptation to hurry to pre-production. Whatever inexpensive early prototyping and validation techniques you use at this point, there are a few key things you should know before you consider this phase complete:

- Who is your target market?
- Why will they buy this game?
- Who is your chief competition?
- What are the core features that matter most?
- What are the key technologies required?
- Who are the key human resources required for you to succeed?
- Does everyone who matters in your food chain believe this product can be a hit?
- What platforms are you making this game for?
- What is your target launch window? (In what quarter will you release?)
- What is the general scope of this game (8-hour single-player campaign, casual web, pervasive massively multiplayer online [MMO], etc.)?

If you don't have at least a coarse grain answer to most of these questions, you're likely not yet ready to move out of the concept discovery phase.

These days, because you're likely to be using distributed development methods, you're likely to have an extra step here, beyond what you might have done historically. You'll need to determine what partnerships you have to make to get this product out the door. You need to reach out to likely partners, evaluate their work, and verify that they have the capacity and interest to collaborate with your team. Also, of course, you'll need to determine if mutually agreeable financial and contractual terms can be reached. All these details are discussed in-depth in the next chapter, but as you'll notice from Fig. 2.1, at this phase you should really have all of your primary collaborators identified and have at least gone through enough early phase negotiations that you are reasonably certain you've got the support you need to build the product you and your audience wants.

2.3 Pre-Production

Although the border between the concept discovery phase and pre-production can be somewhat shadowy territory, your goals before exiting the pre-production phase are clear. You need to know answers to the following questions with a fairly high degree of certainty:

- What are you building?
- Who will build it?

- How will it be built?
- When should each piece be complete?
- Why will all of these pieces combined be a great product?

To break some of these questions down into more discrete chunks, you should ask yourself (and be able to answer) the following:

- What are all the features this software needs?
- What is the plan for building and testing each feature?
- What content is required?
- Who will build each piece of content?
- How long will it take to build and integrate everything?
- Are the right teams and people in place in order to get the product built fast enough, to quality, and within your budget?
- What are your major risk items, and how do you mitigate them?
- What does your high-level schedule look like?
- Are all of your distributed teams in place, under contract, and staffed appropriately?
- Is the publishing and marketing arm of your publisher prepared for this product?
- Do you have sufficient resources to build and test the game you're about to build?

Simply put, this is the last time you can back out of or change plans relatively cheaply. Once you start full production, your monthly staff costs will tend to increase a great deal, and getting out of contracts (even using some of the techniques discussed in later chapters) will become much more expensive. So use this phase to make sure that everyone who needs to sign off on and believe in your plan can do so comfortably. Course corrections in subsequent phases of development are more expensive and, therefore, much more painful.

You'll face many critical and unique challenges during this phase, especially when using distributed development. First, determining the correct workload for each developer and partner takes a lot of time. Coming to terms on costs and other contract details can also be a lengthy process. Plan accordingly because everything, ultimately, will have to go through legal approval on both sides. Beware: The wheels of justice are notoriously slow to turn.

During this phase, you'll also need to make sure that your workflow and pipelines are in place. Under a distributed development model, this means you'll need the ability to transfer build data, to get your source control systems in place and on site at each location, and to understand who is in charge of troubleshooting the data transfer or other technical issues that arise with your communications pipelines. Establishing tight pipelines can be considerably more complicated when there is significant distance or several groups involved. These issues are discussed in-depth in later chapters.

Finally, before you can truly exit the pre-production phase, whether you're using traditional or distributed development models, you'll need a playable example of what the shipping product should look and feel like. This example has come to be called the "vertical slice." This slice should showcase every major game feature, your art style, some relatively polished gameplay, and refined audio. In short, this should be nearly a consumer demo-level quality of a piece. Every major publisher will want something like this before greenlighting a costly move into full production. But even in the publisher's absence, you'll need to get to this level in order to prove to yourself or your investors that what you're about to invest a lot of time and resources in to build actually works as a game. If your vertical slice provides compelling gameplay and distinct visuals and is memorable in a way that will help distinguish it from the competition, offering a unique consumer proposition, then you're probably looking at a success.

What makes a good greenlight presentation:

- A great build of your game that shows it's visual promise and unique gameplay, in approximately 30 seconds

- A clear understanding of your audience and how your product compares to other products they've bought

- Concise explanation for the costs of the project, with enough supporting detail to address any questions

- A realistic timeline and schedule

- A clear diagram listing all the teams and subcontractors you're using and what each is responsible for

- Major risks and their mitigation

For distributed developers, there's another critical component involved in making this vertical slice. Because part of the proposition here is to prove that you are able to build a full game to this level of quality, ideally you'll also need to have tested and stressed your workflow and pipelines. This means that you'll need to ensure that each external resource you plan on using can contribute to the creation of the vertical slice. Think of it as a trial run of a complex manufacturing assembly line. The very first item that rolls off the line is not necessarily meant to be sold or used; it's meant to let you slowly test each and every component of your workflow. Leave plenty of extra time here for troubleshooting and repairing all of the inevitable workflow problems that arise. The content and features that you build here should take longer than everything you build hereafter. You're using this time to work the kinks out of the system. If you don't do this now, then you'll have to do it piecemeal during production, when you've got many other complicated issues in play. It helps to have dedicated operations or IT people on every team communicating directly with one another to sort out many of the initial technical problems you'll encounter.

The following are common problems here, which usually need attention:

- Data transfer rates between various teams turn out to be woefully inadequate.

- Version mismatches between different content creation packages (Maya, etc.) complicate the handoff of assets.

- Communication personnel holes are revealed as details fall through the cracks.

- Minor differences in the development environment have unexpected consequences. (Questions arise, such as "Which visual studio processor pack is the team in Shanghai using?")

- It takes far longer to build some kind of asset than expected. (e.g., "Unwrapping UVs on every face takes days! We need a new Maya script to help with this!")

- The work quality or professionalism of one or more of the partners proves lacking. ("Every time we get a build with new code from the Singapore team, multiplayer becomes really unstable. They need to be testing more thoroughly before submitting.")

It's safe to say that this is the most difficult part of the development cycle to get right, for both traditional teams and distributed teams. There's a natural tendency to rush into production because everyone is excited; because your team is finally getting to build things, which is why most of them get up in the morning; and because you know you're set to reach the finish line and you're concerned about how little time you have to get everything built. However, these are the emotions you most need to control. Jumping into production too early is the best way I've seen (short of building the wrong game in the first place) of ending up having to redo or throw away lots and lots of work, endangering the game that you're so eager to build. Also, there's little that's more demoralizing to a team, or more expensive to a studio, than cutting features or content that are *almost there* but not quite. In fact, the only thing worse is shipping something crummy that should have been cut.

If you're part of a mature publishing organization, you're likely to have some kind of formalized greenlight process. If you're not, you'll want to institute your own. Simply stated, you need all key decision makers from development, marketing, and publishing to get together and have a frank discussion about the opportunity, the promise, and the costs of publishing the game you're about to spend a lot of money building. There's a tendency on the part of the development team to want to convince the rest of the organization that the product is one that should be built. However, if the team can't get wholehearted agreement from the rest of these groups, you should have serious trepidation about embarking on full production. You're just about to commit many resources – minds, hearts, and cash – to building something. Make sure your stakeholders have officially bought in and are ready and excited to hold up their part of the bargain.

Don't short-change yourself in pre-production. You need this time to understand your game and to work out the kinks in your process before you move on to full production.

2.4 Full Production

Can you hear that? It's the satisfied humming sound of a well-oiled machine, running smoothly and efficiently. Those excited voices? Those are the sounds of your team when they are happily creating great content, enjoying a new feature that just came online, and expressing their confidence in the idea that what they're building is going to be great. If your concept and pre-production phases were properly executed, and no nasty surprises arose that changed the world on you, then your production process should sound like this.

Of course, the soundtrack to real life is seldom as melodious as the one we imagine. For most teams, the production phase is a stumbling, shambling lurch from one milestone to the next, usually punctuated by subteam Scrum-style sprints every few weeks. Although at first this process might seem a fairly straightforward matter of determining what the milestone needs to entail, executing on it, and then moving on to the next one, there is typically a bit more complexity.

Let's take a look at the way one milestone flows into the next and some of the key beats that will need to be hit along the way. Figure 2.2 is a simplified diagram showing two milestones.

Since the first milestone or two in the production phase tends to be special cases of working out a few kinks or getting a few core tools up and working so that all of

FIGURE
2.2

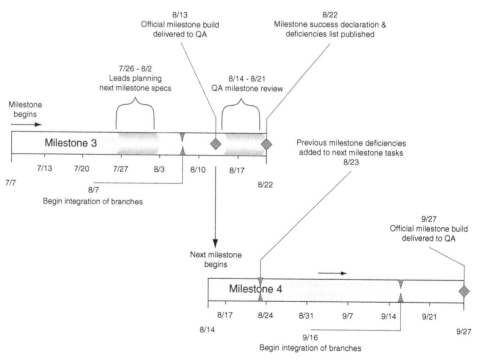

Simplified Milestone Flow

your teams can be effective, we'll assume that the project has already been through these kickoff milestones. So let's say that you're a few milestones into production. Things are moving smoothly.

In this hypothetical, we're looking at two typical mid-production milestones. They could really be from almost any type of project. The first milestone is on July 7. The team should know what they're working on, and that they have 6 weeks before they are expected to deliver a milestone build to the QA department, which will then review the build and make sure that the project leads are aware of anything deficient that needs to be addressed. Our discussion will start on the third and fourth milestones.

Let's take a closer look at Milestone 3 (Fig. 2.3). Assuming that all of your teams and subgroups know what they should be working on, and that they understand the team's dependencies and deadlines, the first few weeks should focus on development. Your primary job during this period is to help facilitate communication between teams, to check out new features and content as it is created, and generally to help facilitate the development process any way you can.

Midway through this milestone, a new task should begin to dominate your thinking. You'll need to work with the leads and subleads across all teams to plan the details of the next milestone. This is obviously tricky because you're only halfway through the last one. Thus, first, your leads will need to gather a sufficient amount of information from everyone on their teams about the game's current rate of progress. You'll want them to try to project forward a few weeks to determine where all of your key features will be. You've already achieved a high-level understanding regarding what this next milestone needs to accomplish from your work in the pre-production phase, so now your job is to determine the details of exactly who will be doing what, starting in approximately 3 weeks, to get the game to its overall goal. This step of the process is really an exercise in educated

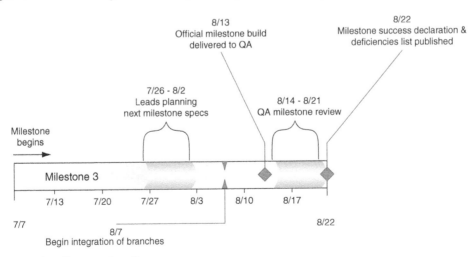

FIGURE
2.3

Sample Milestone Detail

best-guessing. (Remember, however, that you're only projecting ahead by a few weeks, and hopefully your leads are experienced in this process so that the guesses they make are likely to be pretty informed.)

Once your leads have come up with the next milestone goals and the team has worked out task lists, you'll need to have them vetted by the general team for accuracy, clarity, and achievability. You'll also want your QA leads to become involved, once the team has approved the next milestone task list, because during the next week or so, QA will need to come up with their test plans for milestone four (M4). This planning exercise should take no more than 4 days, but its important to remember that this step touches each team you work with and involves a fair amount of communication both up and down the ladder. Because your workers all still have a milestone that they're in the middle of, you'll want to make sure that as little of this burden as possible is passed down to them. (This is where your mid-management layer of associate producers, development directors, and group leads will have their mettle tested.)

After your mid-milestone planning session, you should have a few days left to really push toward wrapping up any outstanding milestone tasks. Then it's time to start the process of integrating everyone's work into a single coherent build.

Stated simply, the integration phase begins the moment that the teams working on disparate branches (the rendering branch, the art branch, etc.) start to collaborate on pulling together the different code blocks and content bases, incorporating the various pieces into the main trunk. Most teams, distributed or not, go through this process periodically, and your technical director should be very experienced at this. For more highly distributed teams, there will probably be more branches to the tree, and integration is likely to be a little trickier. That's the reason why in this example, we've set aside a full week for this step.

Notes on integrating the different branches:

- You don't have to fold all of the branches back into the main trunk at every milestone.

- You don't want to wait too long between integration stages, however, because the longer you wait, the more complicated the task will be.

- It is possible to deliver multiple builds to QA from the different branches. Just don't get into this habit because eventually you'll need to integrate it all into a cohesive whole.

- The task of branch integration is one of the most commonly mis-estimated. I've seen branch integrations that were supposed to take 2 days end up taking a month. Make sure you leave yourself enough time to complete this process, even if it means delaying some work until the next milestone.

- Locking out the branches and the main for a few days, sharply limiting the number of engineers who are responsible for branch integration, usually helps restore stability quickly and efficiently.

- Because you may have to lock down certain branches, establishing a set off-hour time for branch integration can help limit downtime.

Once your branches are tidied up and you've got a working build for each platform, a build that demonstrates all (or most) of the various features and content you'd hoped to accomplish for the milestone, it's time to hand it off to someone else to validate that what you'd hoped to achieve was, in fact, accomplished. Usually (and ideally), this will be your QA group. Occasionally, this duty is assumed by the production or management group responsible for going through the milestone plans, line by line, to ensure that everything you set out to achieve works as expected. Provided that everything is there and working, no more need be done – you're ready to move on to your next milestone.

Of course, sadly, real life is seldom so harmonious. Usually, some of what you'd hoped your teams would accomplish won't get done; what you've ended up implementing works differently from what you expected; or design changes brought about by necessity, mid-milestone, ended up changing the software in some fundamental way. In all of these cases, you'll need to identify what didn't get done and address it on the next milestone work list (unless, of course, it's been decided that the feature is no longer needed or the specification for the software has changed in some other way).

Since your mid-milestone planning already produced a detailed work item, don't force your teams to wait around while their milestone build is reviewed for deficiencies. Instead, have them start working on the next milestone right away. Once you have a full understanding of any hangover work from the previous milestone, work with your team leads and other individuals to slide the hangover items onto the list for the next 5 weeks.

Often, when too many of these sorts of unexpected extra work items combine with integrations that take longer than expected, and other surprise delays occur (which is common), you'll find yourself needing to take a serious look at the project schedule as a whole, and what you'd hoped to accomplish in the upcoming milestones, to determine where you'll find the time for all of the unexpected but highly predictable extra work. Get ahead of this game whenever you can by expecting some amount of hangover and integration delay and planning accordingly. I suggest that a conservative estimate of 15% additional time allotted for unaccounted for tasks such as these is appropriate. Plan for it now, and you won't have to crunch for it later.

2.5 A Word on Demos

If the name "E3" strikes a little fear in your heart and you remember the sick feeling of having been up too many nights in a row while your DICE deadline loomed, then you're likely to find this section familiar. You might even shudder at the memory of trade show and magazine demos and of both press and public playing your unfinished game. You might remember moving pizza boxes off the floor under your desk so that some weary team member could catch a few hours of sleep before continuing the hunt to find and kill each devastating bug. If you've been around

game development for a while, you've likely experienced your share of demos. They're a necessary evil in this business, allowing your marketing team to generate hype for the game in advance of your launch. Sometimes they can even be of benefit to the development team, focusing their energy and firepower on getting one portion of the game polished and playable and helping the team get early feedback from potential customers on what works well and what doesn't. The following sections present some ways to plan for demos to reduce their impact on your team and a few thoughts on how distributed development can help.

2.5.1 How to Prepare Properly

A demo doesn't have to kill your team or blow your schedule out of the water, provided you've properly planned for it in advance. Part of this process, obviously, is knowing in advance that you're going to need to show something to someone, before the game is ready to go into a box. But you can likely predict these types of demands within at least a 60-day window; you know when the trade shows are coming, you know when your game is scheduled to be ready, and you (should) know how aggressive you want your marketing team to be. So:

- Plan a milestone around the likelihood of a particular demo.
- Make sure your first playable demo can function as a consumer demo, when possible.
- Get your QA team engaged early.
- Use branches to get a demo stable and polished, without slowing development on the main line.

2.5.2 How to Use Distributed Development Teams to Alleviate Demo Problems

If you have the resources, and you're likely to have multiple demos to deliver in a short period of time (more likely if your title is hotly anticipated), consider cultivating a side group and branch focused only on demos. This will allow the rest of your team to keep working on shipping the product. Try also to get marketing to work directly with this group in order to ensure that what's being built is something that marketing can use and that they can themselves demo effectively.

2.5.3 When They're out of Control

I've seen teams get stuck in a cycle of creating a new demo every 2 or 3 weeks. Usually, the first demo isn't great, and publishing's top brass ends up wanting more regular reassurance. It is your job to prevent this from happening, to have the courage

to stand up and put a stop to it, or at least pick and choose your battles carefully. If the team is doing a lot of throw-away work for demos, you're likely to have problems with the overall game. See if there are other ways you can communicate your status to upper management. If the audience is different, can you reuse your demo builds effectively? Will a few screenshots do the trick? Will another demo really result in a higher number of sales? What's the real motivating factor behind this supposed need?

Don't let your team end up becoming demo monkeys, duct-taping together one dog and pony build after another. It'll kill your project and your team.

2.6 Alpha, Beta, Final

2.6.1 *Finaling*

Happy day! You're almost there!

After months or years of planning, design, prototyping, and pre-production, you made it into the production phase of the game (Fig. 2.4). Your hard working

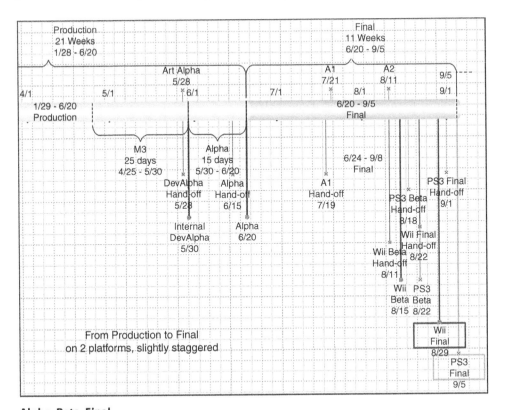

FIGURE
2.4

Alpha, Beta, Final

21

engineers crammed in as many great features as possible, your artists have madly modeled and polished polygon counts, and your scripters and designers have created some unique and mind-blowing sequences of gameplay. Even the audio is starting to sound pretty good. Now you've got to finish the thing. Ship it. Put it in a box. Congratulations. You've arrived at the most difficult part of your job!

Putting any product through a final production phase, getting it ready for public consumption, is difficult. It's frequently compared to giving birth, and the metaphor seems apt. It's usually a painful, bloody mess that involves lots of specialists, with whom you'll need to become far more intimate than you'd probably like, for the duration of the production process.

Your finaling process usually begins soon after you've reached a level with the game where it is fully working, can be played through all the way in all of its various modes, and has all of its representative content in place (from models to characters and music). Most publishers and development houses would call this an "alpha candidate" or something similar. The point is that the game is all there and is more or less working. From this point on, you should be able to clearly identify all of your product's shortcomings and all the work remaining to get the product into a box.

Your goal during this time period should be to remove as many defects as possible from the project (usually called bugs), to get the product as polished as possible in the time allowed without adding too much additional risk to your dates, and to finish any lingering small tasks that remain incomplete. This will also be when all translated (or localized) content should be put in place and typically when all last-minute performance or game balance optimizations are made. Once these tasks are complete, you'll submit various versions of the game to the different quality assurance groups that represent your external partners. (Note that these are not your internal QA testers and managers; they've been partnering with you for months.) These quality assurance teams are usually distinct political groups inside the publisher. In the case of console products, they are the "first party" quality control and certification groups that work for Microsoft, Sony, Nintendo, and the like.

So what is different for you, the manager of this distributed development process? In a typical traditional development model, the producers, project managers, or development directors act as a focal point for feedback on the game. This feedback will come in very quickly and often at odd hours. For those used to the distributed development model, this phase may not be as much of a shock to the system as it could be for more traditionally structured teams. Why? Because you should already be used to getting information and managing communications with remote teams, in different countries, from people you may have seldom met. You should already be a veteran at dealing with the 24-hour development cycle that distributed development tends to favor. For you, all that has happened now is that the extended family that comprises your team has expanded to include localization, CQC, ECG, first party, and other far-flung stakeholders who tend to go by acronyms rather than names.

First, because your team is more spread out than a traditional team, extra strain will be put on your communications systems. Your defect tracking process needs to be tighter, and managing turnaround on fixes to critical issues will be more complex than what you've faced in traditional models of development.

Communications systems are the first place you'll feel the strain. Simply put, everyone involved in managing the process will suddenly have to become a highly efficient traffic director, able to route new issues to the appropriate subgroup and, ideally, the appropriate individual within that subgroup. For example, let's say a critical bug arises, identified by some underappreciated tester. First, the bug must be brought to your attention. You need to recognize that this is no ordinary problem – it's a major problem that needs immediate scrutiny. You'll need to triage the matter, either quickly by yourself or with an assembled group (perhaps over the phone), to determine whether or not you're going to fix the bug and who needs to evaluate that fix. Then you'll need to quickly route the problem to the person who can best reproduce and evaluate the issue in order to determine what solution is most likely to fix the problem without causing other unforeseen consequences. To do this, you'll need a thorough understanding of every major part of the software and of which of your teams was involved in writing it. If it's a straightforward problem, such as a bug in rendering, and all of your rendering engineers work in the same office, great! But what if it isn't so straightforward? You'll find that the more complicated boundary issues that might be either in code or in content, or issues that exist where systems overlap, tend to really strain your organization and communication systems. These particularly difficult bugs will sometimes require direct real-time debugging between people located in different areas, sometimes without a common spoken language. So plan for these kinds of coordination issues, and give yourself extra time during this final phase to work out these defects. Even if only 2 % of your total issues are these kinds of difficult to resolve boundaries cases, they can still represent hundreds of difficult to solve bugs. Make sure that each of your teams is armed with a phone system (or Skype or other VOIP solution) that can be used at anyone's workstation, and make sure that everyone understands that diplomacy is a most prized virtue. You don't want a stressed out rendering engineer in San Diego getting into a shouting match with a character animator in Hue, Vietnam.

Your defect tracking system needs to be given special consideration. You'll have to track and assign your bugs across all team boundaries. It's likely that your core team and developers each already have a system they prefer to use. It's equally likely that there are multiple systems in place, each with strong proponents within the individual teams. If possible, in the beginning phases of the project, you'll want to consolidate your tracking systems so that all teams and stakeholders can log into the same system. Ideally, you should have a web client available for remote locations, where it might not be possible to have a proxy server or a sufficiently fast VPN connection to the primary host of the system to get the job done. But be sure to test the speed of the system at each location, using a previous project's fully populated bug database, to make sure that the tools in place are sufficient to the task ahead. Frequently, things scale well with

a few hundred bugs but not nearly as well with a few thousand. The following suggestions, it is hoped, will make your life easier when the time comes to deal with the onslaught of bugs:

- Make sure each client has fast enough access that editing and sorting bugs isn't painful.

- Make sure that subleads have the right to assign bugs to their reports.

- Work with your QA group to identify the correct flow for bugs.

- Make sure each sublead understands the software and the bug flow.

- Ensure that the different platforms or development environments required can be identified and sorted by the software.

- Consider identifying individuals by group in the software so that it's easier for team members at remote locations to know who to bounce a bug to when the need arises.

- Identify likely human bottlenecks. Anyone responsible for the distribution of more than 10% of the total bug count is a bottleneck. Anyone responsible for more than 30% of distribution has the power to kill your project. Bottleneckers are discussed in a later chapter.

- Fight against the tendency to want to have all defects go through a single person. One person just can't scale his or her time up enough to avoid introducing delays once the volume increases.

Turnaround time for fixing critical issues must be ruthlessly shortened. Pagers, on-call agreements, off-hour triage times, and other clever solutions need to be employed in order to move quickly. Why? Because the alternative is that you miss tight third-party acceptance deadlines, and these end up impacting either your manufacturing time or your ship date; because issues won't necessarily be discovered during the last month of the project; because surprises will arise; and so on. No matter how good your planning is in the earlier phases of the project, there will always be some number of last-minute "gotchas" that arise when a group of fresh testers, all using a new process, start looking at your software.

You'll need to fix these issues quickly. So, for example, when you're alerted via e-mail late on a Friday night that you have failed a memory card text message guideline, or some similar problem has presented itself, you may need a new build to be turned around by Monday. If this is a submission candidate, then you'll need to give your internal QA team enough time to sanity check the build that you plan to hand off. Thus, you'll really need your fix to be understood and implemented by Saturday night.

Finally, keep your team members well rested during this process so that they can respond crisply. Wells Fargo stops used to keep some portion of their horses rested at all times so they could be prepared to deliver a critical message as fast as possible. At the risk of comparing brilliant developers to horses, do the same with your team. Make sure that even the hardest workers on your team are getting the breaks they need. Rested people make fewer mistakes. Insane work hours are never the right answer.

Interview with David Wiens, Project Manager at Disney Online

"How Development Teams Can Work Well with QA"

David Wiens has been making games better since 2001. He has worked in localization and as a QA lead for Electronic Arts on numerous AAA franchises, including *NHL, FIFA, James Bond, SSX,* and *Need for Speed.* He is currently a project manager for Club Penguin at Disney Online Studios in Kelowna, BC. David holds an MBA in Finance from the University of Manitoba. He can be reached at *david_wiens@yahoo.ca.*

Q: Tell us a little bit about yourself, your history, and your experience working with distributed game development. What's your most recent title?

A: I started with Electronic Arts in the Localization QA department in 2001. Over the years I held various titles in both the Localization QA group and later on in the Localization Production group. Working in Localization required you to be able to work with remote groups, be it either on the testing side or on the production side. On *Need for Speed Undercover* I had the job title of QA Development Manager and responsibility for all aspects of functional software testing. Both the development and testing side were distributed in various locations.

Q: In your role as a QA development manager for a highly distributed development project with fierce deadlines, what were some of the techniques you used to help keep all the different teams on the same page?

A: Early on during the production or milestone phase it was weekly meetings and reports sent to all different teams informing them of what QA was working on, had accomplished and planned to focus on the following week. As we moved into the finaling

phase, e-mails, reports, and the amount of meetings increased. I personally use *Outlook* a lot to set up recurring reminders to ensure that critical reports are sent in a timely manner. I also use the Task List a lot to write down tasks I need to complete or items I need to follow up on at a later date. As a project manager you need to figure out what works best for you to keep track of all the different aspects of the project you are responsible for. On top of that you need to try and build relationships with all the key people on the various teams you interact with. A lot of information comes your way informally through these relationships and will help give you a clearer picture of what is happening on your project.

Q: What do you see as the biggest problems associated with achieving a high quality bar on games that are built using distributed teams?

A: Ensuring each group has the internal capabilities and capacity to complete the work it is given. When working with tight deadlines, any slippage can throw off the schedule and you either have to find ways of making up time by redistributing work or some features/functionality may need to be cut to bring the project back in line.

Q: When you think about the full production phase of game development, when all the teams are pushing for the next milestone, what advice do you have for team leads on how to best work with your department to ensure that milestone builds are able to be evaluated thoroughly and quickly?

A: Bring QA in early and show them what you want accomplish. Break your deliverables down into items that can be verified by your QA group (features, game functionality, etc.) and items that are production/development checks (i.e., implement new SDK). Then work with your QA group to write test cases that ensure that all aspects of the feature/functionality will be tested properly at the time of the milestone.

You should work on trying to get your list of deliverables locked down for the next milestone before the QA group does their full milestone check, and report on the current milestone (i.e., lock down deliverables for Milestone 2 before QA completes their full milestone check of Milestone 1). This way, while QA is doing their milestone checks, development is already working on the next milestone and fixing major crashes or anything that is hindering the QA group from completing their work.

One last thing. If a feature is scheduled to be completed by the middle of the milestone, do not wait until the end of the milestone to get it verified. Work with your QA group to have it pre-verified. This helps find software defects early and helps reduce the amount of time QA will need during their full milestone check. If they have seen a feature fully functional earlier in the milestone, they can spot check it to ensure it is still working and focus on the rest of the outstanding deliverables.

Q: What kinds of tools or techniques would you encourage small developers to make use of to help make the milestone review process go more smoothly?

A: I would encourage small developers to start early on ensuring software stability. At various points before the milestone build needs to be delivered, compile it and check to see what major problems exist or have been introduced, and work to fix them. All too often QA receives a build that doesn't boot or fails early on in the testing. This delays QA's ability to verify deliverables and send Development their results.

Q: Talk to us about the role of embedded testers in the final phases of a project. When do you think QA staff or managers should be onsite with developers (if at all)? What value do you think this adds to the process?

A: Embedded testing during the finaling phase of a project should be used in areas where a quick turnaround is needed between QA and Development. For example, in cases where QA is seeing problems with the game that the development group is not seeing or is having trouble reproducing, or high-risk areas that require testers to use specialized tools or hardware (i.e., optimization testing). By embedding these testers, you are giving the group of developers dedicated resources which they can work closely with on resolving issues as they arise.

Q: What other advice do you have for readers who are about to embark on building a game using several teams that are geographically separated?

A: In my opinion, communication is one of the most important aspects of any project. With having teams in different locations/different time zones, any weaknesses in your lines of communication will become clear fairly quickly. Working to make sure the right people are involved in the right meetings or receiving the right reports will go a long way toward keeping everyone on the same page.

Q: We've visited in this book about the importance of concept discovery and the pre-production phase in defining project specifications. What role do you believe Quality Assurance should play during these early phases of a project?

A: I think Quality Assurance can play a role in giving input into features they think would be of value to the game, generating new ideas, and giving feedback on possible ideas or themes that Production/Development is considering. This may be a stretch for some QA groups where most of their work is on the quantitative side of things, but I think this is where Quality Assurance can provide added value, if asked. Within each QA team there are the hard-core gamers and probably long-time fans of the game they are working on. They will have strong opinions of what they like or dislike and have ideas as to which direction they would like the game to go.

2.7 Manufacturing and Distribution

Once your project has finally been approved by the publisher's agents, and the first party platform, you're done, right? Well, not quite. You've still got to manufacture all those discs and boxes, if it's a retail product. This means another opportunity for things to go wrong.

Since product recalls from the shelves are incredibly expensive, and tend to generate ill will with retailers, at the very least you'll want to test a copy of the game that's been burned to final media through the manufacturing process. The manufacturing plant can likely express mail you a copy. Get your brightest testers, who are both experienced enough with the game to detect problems quickly and understanding enough of the importance of this process that they won't cry wolf on small issues, to test the game as vigorously as time allows. Only in this way can you avoid the kind of strange mistakes that only crop up on final manufactured discs but occasionally ruin product launches and relationships with retailers.

Once you've tested this version, and it's known to be good, you probably won't have anything else to do until the game hits store shelves. (But stay by your phone, and don't dismantle your development organization just yet.)

2.8 Launch Day

I strongly encourage you to withhold a final payment to each extended team until some time after the intended launch date for your project. No matter how well you've planned, or how thorough your QA department is, things can sometimes slip through the cracks.

Once your product becomes commercially available, more eyeballs will be on it than ever before. If your team is making a major release game, you'll potentially have millions of hours of play logged within the first few days. The public is bound to find problems that you missed.

So be aware and ready on launch day – and for the week that follows. Have your people trolling the forums looking for early reports. Don't send your team on extended vacations until after you're pretty certain you're not going to need to issue a rush job patch or take some other kind of emergency evasive action.

And, of course, if your game is an MMO, your fun is really just beginning.

2.9 Post Launch Support and Updates

For the last ten years (1999–2009), there were two common and fairly separate ways things could go, once your project had been accepted and put on store shelves. If you were building a console product, you were done. Your team could

take a break (and usually some number of them would disperse onto other projects or other walks of life). Then you'd start planning for the next project. If you were building a PC project, you'd start thinking about a patch. If you were launching an MMO, your heartache was just beginning since support and regular updates are key.

The two models have grown much closer together since the advent of the wired, always online console. First, users now expect that titles not be "fire and forget" – and no longer are console patches demanded just for crashes and major security issues. Even console titles are expected to deliver title updates in response to community feedback, perceived balance issues, and so on.

Moreover, in recent years publishers of console products have found that one of the more insidious threats to their profits is the growing popularity of used game sales. One of the ways to counter this problem is to create longer lasting value by offering downloadable content or other types of product updates that keep users engaged. Hence, for months or even years after a title is released, you'll often be expected to issue regular updates, extensible multiplayer modes, and other ways of maintaining user engagement.

Details regarding the management of a permanent development team of the type required to support year-on-year updates and expansion packs is beyond the scope of this discussion. However, clearly it poses particular challenges for a highly distributed team, spread across several discrete companies. If you find it likely that you're going to be asked to support the product for an extended period of time, you're going to have to find a way to do the following:

- Ensure that you have long-term ownership of any key talent centers.
- Eliminate proprietary knowledge that resides only with one or two people. Eventually, you'll lose them.
- Document both processes and tools.
- Invest in operations and certification experts on your team. You'll be doing lots of it.
- Start working to build a data mining process to get direct information on how your users interact with your product.

2.10 Summary

That's enough overview of the process. In the next chapter, we'll talk about the major groups you'll want to bring in and what kind of people you'll want to surround yourself with to ensure success for your distributed development project.

Interview with Rhett Bennatt, Art Director, Aspyr Games

FIGURE
2.6

Rhett Bennatt has been making games and movies for more than 10 years. Rhett holds an MFA in Digital Media from Texas A&M University. He currently works as an art director for Aspyr Media in Austin, Texas. Rhett has been involved in creating art and managing teams on *Starlancer, Freelancer, Brute Force, Perfect Dark, The Sims*, and *Guitar Hero*. He can be reached at *rhett.bennatt@gmail.com*.

Q: Tell me a little about your background in managing international distributed teams in the U.S. and abroad?

A: My first experience doing any kind of distributed development work was with Digital Anvil in Austin, Texas. We used a team in Kiev called Boston Animation to generate characters and animations for a third-person action shooter. That was 10 years ago.

Since then, I've managed external content development for Microsoft, and on two additional projects for a company called Aspyr Media. We built three titles under *The Sims* brand for Electronic Arts, generating all new content. Some of these were just reskinning existing assets, and some were all new.

Q: When you're trying to determine how to coordinate between an internal art team and external partners, what criteria do you use for deciding who should do what? How do you ensure consistency between the two?

A: Luckily in this case I had an art lead who had a lot of familiarity with the franchise, because he'd worked on a *Sims* game before. So he was instrumental in helping us understand the specifics of what we needed to build. So the way we decided was that any type of object that was going to be something new that required new functionality – that we'd have to animate and build hardpoints for and so on – those I wasn't comfortable farming out.

Q: So the complexity of the assets was the deciding factor?

A: Absolutely. So for many objects, we could just determine what special boundaries needed to be maintained, then we'd provide reference art and guidelines and rely heavily on the creativity of our partner team. We knew they had creative staff and we'd let them run with it, then have our art lead who was so familiar with the content review it.

Q: Did you find that there was any cultural nuance that affected their creativity, or gave you content that you weren't expecting?

A: Not really, they were pretty familiar with it, and we had lots of reference. Sometimes they would come up with something that would end up being a very pleasant surprise – something we didn't expect! It's part of my philosophy to hire really good artists, and then art direct just by explaining boundaries and not telling people what to do. In this case, the team we'd hired to collaborate with was excited because they got to really put a lot of themselves into the project. And I think that may be the nature of that particular culture, in Mexico, or that particular company.

I've heard though that other companies in other parts of the world, like China, are often more comfortable with exact specifics. So sometimes you may not want this kind of creative latitude. For some types of projects, creating licensed cars or something, you might not want that kind of creative interpretation. So it really depends on the project.

The beauty of distributed work is that every project you have the opportunity to pick your best team for a particular job, and you don't have to employ them all the time. You can work with people, find out who is good at doing a particular thing. And a lot of firms have found out that they can specialize – become great at a particular thing. And as long as that something is significant enough, then that's a good business model for them.

Q: When you're working with different teams who have never met each other perhaps, and especially with creative people, how do you instill a sense of ownership in a creative team without making them feel like they are part of an "art assembly line"?

A: The best way I know to do that is to allow some room for creative license. There may be some projects where that's not appropriate, but I've never had to work on one. You want to have your teams invested in some way, have them be excited in some way. One great way is to have them see their content in game as frequently as possible, I've seen that pay dividends frequently. Even if it's just sending them screenshots, it helps them get excited. There may be some reason they aren't allowed to have a build of the game, if they're not too integrated into the process. But having them see their work, and see how it impacts the product gives them a lot of reward. No matter what, you need to do this. But beyond that, you need to find some way for people to have that creative license. No one wants to feel like they are just a cog in a giant machine – even when they are.

Q: Working for a publisher, when you're looking to hire a development house for content, what are you looking for first? Let's say they are a first-time studio opening up somewhere. What would you want to know to hire them?

A: I probably wouldn't. I wouldn't want to try to start up something like that right now. I've been solicited by so many studios and art houses over the last few years. There are a lot of talented groups out there. So you find groups you can rely on and trust, and you're likely to keep using them until they fail you.

So for me, it's all about recommendations. I probably won't respond well to anyone who is soliciting me – I've got a long list of studios that I trust that I've gotten from other directors and producers that I trust. I also look a lot at credits from other big games, high-quality games. When I have the opportunity to meet with studios personally, at game conventions and so on, I try to do that to establish that relationship. I want to have that comfort level that I've met them a number of times. Then maybe I'd be willing to do some sort of test.

You've got to trust whomever you're dealing with. You're about to sign a contract that is legally binding on both sides, and with development costs what they are, none of us can afford to make a mistake. If things don't go right, it's my fault. Even if it's their fault.

Q: So what's a warning sign when you're in the middle of a contract? What clues you in that something may be going sideways.

A: The biggest issue I see is that consistency can begin to drop off. How do you ensure that your team remains your team? If you don't sign key individuals for a contract that lasts 4 or 5 months, then maybe suddenly things start to change halfway through. Or maybe it's as simple as your needs and demands changing.

So you've got to truly understand the capacity of your studio. What type of content are they used to doing? You need to do benchmark processes to establish a quality bar, fine. But then say you're building a hundred assets that first month, and you get the quality to be fine. But then you ramp up to three hundred assets. Means they're putting more people on. How effectively do they scale? This is when the content starts becoming inconsistent. Too many people, and the art direction on their side can get overwhelmed, because they just can't scale up well.

And then on our side, as we scale up, we've got to have adequate resources to be able to provide feedback as well! Because there is art direction on both sides – it's the only way to get quality and consistency.

But when you've picked someone that you trust and feel good about, you can work together to work out the problems and deal with the difficulties in scaling, and any inconsistencies.

And of course, you've got to have reasonable expectations. You get out of the relationship what you put into it.

When you're off-site, you're not looking at the same things. Your perspectives are different. Your partners don't always know exactly what game they're making. Not intimately in any case. But that's where we are in game development. You can't have sustainable development with huge teams in the same place.

So I think there is a lot of benefit in taking game development global. I think we're learning things from our partners all the time, which I think is great. And they're learning from us as well.

Q: In the last 10 years we've seen an explosion in team size, in complexity, in the assets we're building, and in the associated rise in global distributed development. How do you see the way we build games changing over the next 10 years?

A: I think the biggest improvements will be in the IT technology side of things. When we're working together, how do we communicate better, and remain more in step? Other than time zone differences, I think that the barriers to fluid communications are going away. And even the time zone issues are going away. Regular, constant communication between, say, a studio in Shanghai and the large parts of the U.S. game development community on the West Coast of the U.S. You're going to see people working from home more, and when they're working becomes more variable. So an artist in Texas might be working at the same time as my artists in Bangalore.

Having really fluid communication letting you have more face-to-face time, even across distance. E-mail is so impersonal, especially on the art side. There's just too much nuance you miss. Artists especially can be sensitive, so as much of a true human-to-human communication you can achieve the better. So hopefully people will begin to enjoy collaborating in this global development environment. Because they'll get more out of it than just the job they're doing. They'll start learning about the culture they're working with. It's the path we're on. And we're not going to turn back.

Nationalism is a dangerous thing, but in another few decades, there is going to be even less of it. The world is getting more connected, and the more connected we get the better.

Three

Your World and Your Internal Team

3.1 Types of Distributed Collaboration: How to Organize Your World

We've discussed at a high level the key phases your development process is likely to go through. Let's turn our attention now to the major players in this drama, their key roles, and ways to organize them. After a quick overview, we focus in particular on envisioning an internal dream team that you can rely on to help manage difficult distributed development projects.

3.1.1 Organization of Key Players: Developers, Publishers, Customers, and Retailers

Perhaps Fig. 3.1 doesn't make the organization of teams and key groups in the process look all that simple. To rectify that, let's discuss the details of what is going on here. Segments of this chart might look familiar to those of you who already work for a major publisher or for those who lead development houses. But other parts may be fresh, and there's a lot of value in stepping back to look at the world from a broader perspective now and again. For those of you who have been a bit more heads down in the specifics of your craft or discipline, this quick overview of the presiding theology will help serve as a clarification of and a backdrop for many of the details we will discuss in subsequent chapters. It will also help us to put common terminology to the moving parts in this business.

Let's start with the most important of these parts: the consumer. It's all too easy to forget, in the midst of honing a new feature, debating what components of a scripting language to implement or dealing with pipeline headaches, that development is a necessary evil, as is publishing, the trucks required to speed copies

FIGURE
3.1

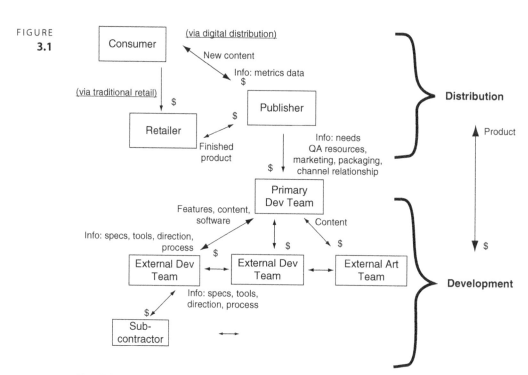

Simplified Flow of Resources

around the world, and the stores that sell our games to our fans. To the gamer, the game is the thing! So it's important to spare a few moments to think about how they see the world and your role in it.

3.1.2 *Traditional Distribution Model*

For several decades now, a consumer who wanted to buy a game had (with few exceptions) only one real choice: Get in the car, go to the store, and buy a game in a box. This worked well enough from a consumer standpoint; indeed, it was the time-honored way consumers bought everything else. However, those digerati out there (you may well have been one of them) knew of other ways to get a copy of a desired game – either by downloading it through illegitimate channels or using a shareware model like the kind that popularized *Doom* and other games of that era. But for the vast majority of customers, and certainly those on consoles, buying a game meant going to Target, Walmart, or the boutique games store of their choice. By and large, this is still the model for most consumers. They give money at the altar of retail, and the retailer gives them, in return, a boxed product. Once the transaction is concluded, its time to open the shrinkwrap, to eagerly read the paltry document that usually passes for a manual, and to hurry home to play!

Behind the scenes, this transaction has some problems. For starters, the retailer has to gamble on the number of units of the product it will initially order from the publisher. The retailer can shoot low and reorder, but then it risks losing sales if a game is a hit. The publisher has to part with a chunk of its revenue and often has to make a number of other concessions to the big retail chains. Then there's the inefficiency of boxing up and physically shipping media out to every store in the land. Add to this the waste of packaging materials, the cost of manufacturing cartridges, discs, etc., and you can see immediately that there's a lot of inefficiency in the retail distribution system (Fig. 3.2).

Worse, though, in many ways is the layer of indirection between the customer and the creator of the game. The more difficult it is for the customer to give feedback to the creator, the less likely it is that the developer will be able to fulfill all the customer's needs in the future. When a message has to travel from retailer to publisher and then on to the developer, you can easily end up with a real mismatch in expectations and a cave full of games you can't sell. Just ask Atari.

3.1.3 *Digital Distribution Model*

Fortunately, now that broadband penetration has reached adequate levels, there's a second option for consumers and publishers: digital distribution. PlayStation 3 (PS3), Xbox 360, PC platforms such as Valve's Steam, and even some handheld games can now be directly downloaded to the client device, bypassing the retailer altogether. Although the specific economics of cutting the retailer out of the picture are still being hotly debated in back rooms and trade shows throughout the world, it's clear that there are financial incentives for the publisher to move toward a more fully realized distribution model. From the publisher's and developer's collective perspective, digital distribution has the additional benefit of cutting out used game sales, which generate great profit for the reseller but none for the creators or publishers.

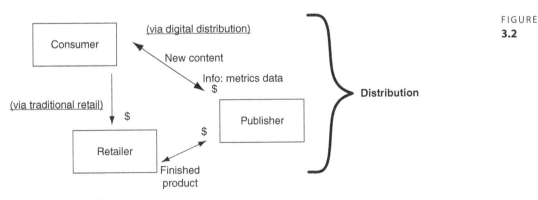

FIGURE
3.2

Traditional Distribution Model

Fortunately, the consumer also benefits from the digital download model. First, it's convenient. No driving to the store is required. Second, and more important, digital distribution lets consumers directly offer feedback to the publishers in the form of data derived from play sessions. This is where the developer and distributed development comes into the picture.

In a digital distribution model (Fig. 3.3), the development team can have a much more direct relationship with the consumer than it can using traditional distribution models. Game creators can get information from their customers about how they play, what they like, and how to tailor future products more directly to their needs, all through the auspices of the publisher.

With distributed development, you can perhaps go a bit farther. Since your development team is made up of several disparate entities, it is quite possible for you to take small chunks of the team as a whole – for example, a small software development house and an art subcontractor – and apply them to the task of analyzing metric data you receive from your customer, creating new content, new play modes, or other types of features that will extend the life of your product while allowing the bulk of your team to shift their focus to a sequel or another profitable product. Essentially, a distributed development team can subdivide more easily than can a monolithic single team; this allows for a certain amount of flexibility in the way you attack ongoing support problems, which in the end benefits your customers and reduces your costs. You could operate in this manner even within a traditional retail model, but the lower profit margins make add-on content, map packs, and other features impractical for all but the biggest hit titles. This is not so with digital distribution.

There's much more to say about digital distribution – the ins and outs and the problems with widespread adoption. But ultimately, this book focuses on the matter of setting up and maintaining distributed development teams. We'll have to leave this fascinating topic for now, and move on to the organization of distributed development teams.

FIGURE
3.3

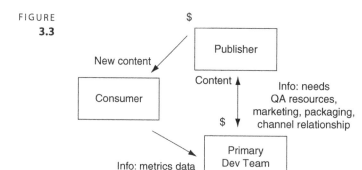

Digital Distribution Model

3.2 Organization of Distributed Development Teams

There's no one-size-fits-all chart that can show you how to organize your team around every possible project. The games we're all making are too wonderfully diverse, and the demands of schedule, the talents we have locally, and a thousand other factors all mean that, ultimately, you'll need to determine what fits best for your game, in your particular situation. However, there are some commonalities we can talk through that will help arm you for the customizing process.

3.2.1 *The Core Team*

Let's imagine that for the diagrammed case shown in Fig. 3.4, we have a development with some expertise on both the PC and the Xbox 360. There is a product that needs to ship in 11 months on PC, Xbox 360, PS3, and the Wii. The team is building a sequel to a popular shooter but one that hasn't shipped since the PS2 era; thus, there is no meaningful code to reuse from the title. Fortunately, the team has the core engine and pipelines in place from a previous action title it shipped last summer. (Without any tech at all, the team would be unwise to sign up to deliver all of the preceding items in 11 months.) The team needs a highly polished, 12-hour, single-player campaign, and a reasonably high-quality online multiplayer offering. How would you handle this situation?

Let's assume further that the primary development team has the core design, gameplay knowledge, and artistic chops to properly define the look and feel of the game. Assume that all of this has already happened, and the primary development team has taken the project through the concept discovery phase. You're now into the pre-production phase, and you're confident that the project has sufficient buy-in from your funding group. Now it's time to start signing up partners to help out.

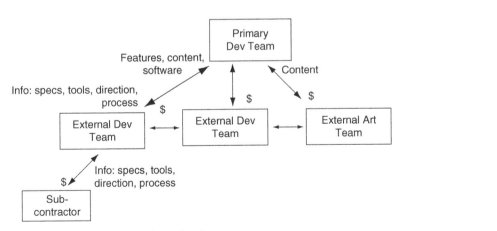

FIGURE
3.4

Distributed Development Organization

39

One way to organize your project would be to assign the Xbox 360 product to be your lead development platform. The 360 is relatively easy to develop for, and our hypothetical primary development team already has the necessary expertise. Tie the PC and PS3 versions to the Xbox 360, because the hardware performance characteristics are fairly similar, and you'll be able to reuse almost all of the art and audio assets among the three. (A few unique front-end components and your online support are likely to be the only substantial differences regarding content.)

3.2.2 *What to Do with the Wii?*

In this hypothetical, your Wii product is your most unique problem, and I'd encourage you to hire an external development team to tackle it. Although you'll be able to get some reuse out of the assets created for the 360 and PS3 versions, all of those assets are going to take some reworking to get ready. This might be a matter of simply "de-rezing" the assets, but more likely there will be some stylistic changes as well. Then, too, there's the matter of gameplay, which simply isn't going to port well across to a platform with a very different controller input model and a very different player demographic. Make sure that the development group you find to deal with this side of things has at least some design chops. In Fig. 3.4, I put this group on the far left. This project will probably need an art subcontract house or a small group of freelance subcontractors to handle the rapid translation of the art assets this product will require.

3.2.3 *Separate Multiplayer*

The next major portion of the title that makes sense to give to a separate team is the multiplayer component of the high-definition platforms (360, PS3, and PC). Although there are other ways to divide up a product, the single-play/multiplay chasm tends to be a reasonable place to start. First, creating high-quality online multiplayer modes tends to require a very different skill set than creating a single-player campaign with all the unique scripting that such an endeavor tends to entail. Second, beyond core game mechanics, much of the gameplay code need not necessarily overlap too greatly. Finally, the bugs you get will tend to divide well into one of these two camps, with fairly few existing on the border between single and multiplay. Let's pencil multiplayer in as the middle "external dev team" in Fig. 3.4.

Finally, let's assume that unless your primary development team happens to be part of a large multiproject studio, you're likely going to need additional support with asset creation during the heat of production. This is where your external art team can come in. Since they can really specialize on creating assets (if the specs they are given are good enough), it's possible that they can hand off versions of the content to the Wii team directly.

3.2.4 How Many People per Group?

You'll notice that we've not assigned any particular numbers to the sizes of the teams discussed previously. There are a couple of reasons for this. First, without a fairly detailed understanding of our hypothetical game's design and parameters, we'd be shooting in the dark. Some kinds of shooters can be done with 20–30 people total, spread out across the five teams mentioned previously. Some can take 200 or more. For more casual products, flash games, or similar, I suppose it's possible that each of the boxes in Fig. 3.4 could represent just one person. Fundamentally, the way you think about subdividing the problem doesn't change much.

Assuming that the way you organize can differ based on project needs (but also that it's more likely that you define groups along logical divisions in the software than according to the size of your team), what else can we learn from the diagram shown in Fig. 3.4?

One thing you should note is the arrows indicating resource flow. Figure 3.4 assumes that the primary development team is the ultimate owner of the product vision. Indeed, it's possible that if you're operating as an "external producer" for a publisher, your primary development team is really not responsible for *any* of the actual coding or content creation. In that case, the use of the word "Dev" might be a bit of a misnomer, but it doesn't change the way the resources flow.

The publisher's external production team works with the external development teams to define features, content needs, software specifications, and schedule parameters, and it also doles out milestone payments. It may also help provide some tools and help establish the overall process (particularly regarding the specifics of the finaling phase). In exchange, it gets back software and content.

3.2.5 Subcontractors

An additional item worthy of comment is the use of the subcontractor. Although one could easily structure a product such that the subcontractor is yet another external art team reporting in to the primary development team, there are some good reasons to have a slightly more regimented hierarchy:

- Too flat a reporting structure can create bottlenecks at key decision points. Beyond the inefficiencies, this can generate a tremendous amount of ill will. Remember, development houses are predisposed to dislike publisher teams in the first place. Empower them to manage their own subcontractors.

- The developers are likely to know more precisely what they need. As always, let the people closest to the problem define the work.

- Developers will likely have relationships that you don't; by including them in the recruiting and management of things, you can instill a greater sense of ownership and find better people than you might be able to on your own.

- A smaller, independent developer can likely get cheaper rates from contractors than can a higher profile team or publisher.

- More groups reporting to a single point of contact can quickly result in an increasing amount of paperwork. Besides, the larger the legal department, the more likely it is to slow down the process.

- Your risk is reduced in the case of project cancellation or similar; subcontractors need to be dealt with by the individual development teams in the unfortunate case in which the project is canceled.

3.3 How to Pick Your Internal Reps

No matter what size your primary development team is, those members who are responsible for managing the relationship (or even just working with the remote teams or team members) should have some particular characteristics, if possible. The simple fact is that any team you manage needs to have the best people you can find. But distributed teams add a few layers of communication complexity, political complication, and (often) cultural sensitivity that increase the requirements on your team members to be more superhuman than even regularly required to make great games. Some key characteristics of internal support that makes distributed development work are discussed next.

3.3.1 *Flexibility*

Physical location isn't very important, but being available to answer questions from externals almost 24 hours a day is mission critical. This doesn't mean that your key coordinators need to be working insane hours all the time but, rather, that they need to be comfortable with flexible schedules that can adapt to the peculiar demands of working with disparate groups across widespread locations. You should consider providing cell phones and Blackberries (or some similar remote e-mail device) for each member of your key team. The reduced friction on your cross-team communications will be worth the cost alone.

3.3.2 *Diplomacy*

Working with distributed teams is a matter of leadership and organization first and technical knowledge second. Everyone in your inner circle should be a diplomat, capable of representing the project or publisher's interests effectively, and of casting the leading group in a positive light in all communications. Above all, everyone in charge needs to be tirelessly dedicated to identifying possible causes of friction or strife between the teams and to smoothly resolving it. This is not the place for you to station an abrasive or pugnacious leader on your team. Particularly in the

heat of finaling, tempers will tend to fray and patience will run short. You need people who are naturals at disarming these sorts of problems, who will help you lead the charge.

3.3.3 *Travel*

Everyone on your core team needs to be willing and able to travel, sometimes for as much as 3 weeks at a stretch. Passports and a home life conducive to travel are required for this type of development. (For example, try not to put folks who are expecting a baby during the course of the project in this position.)

3.3.4 *Technical Skills*

Complex software projects are technical enough in the first place. Add language barriers and distribution, and you'll need people who have at least enough technical savvy to communicate effectively with engineers on various teams. Too many technical problems will arise, both in software creation and in the infrastructure that supports your process, for you to be able to use folks who don't have a good technical understanding of platforms, software development practices, etc. If source version control, file transfers, the difference between RAM and hard disc space, 3D technology, networking, etc., are mysterious to any of your people, this isn't the right job for them. You'd think that this would generally be the case in the field of game development, but because of the highly creative, highly visual nature of the medium, one often finds teams staffed with very skilled artists who just don't have the technical chops to deal with the "programmer" side of things. These folks may have a role in your organization, but it isn't on your core team managing a distributed development process.

3.3.5 *Dedication*

You need people who have a sincere motivation to deliver a quality product, on time, using external resources. One would hope that this would be the case for anyone lucky enough to get to make games for a living, but sad experience informs us that this simply isn't the case. Folks get jaded. I'll not rant against them here; life gets to people, even in so gilded an industry as this. However, you need to ferret out these people and ensure that they are not on your distributed teams. You don't want to have to rely on anyone who doesn't want to be doing this job or who is going to constantly threaten to resign if they are given a difficult problem to solve. They will *all* be difficult problems. Don't put problem players or the erratic genius in this role; they may be able to survive in more traditional team structures in which their attitudes can be offset by the quality of their work, but they'll be too much of a burden here and will act as a toxin on your diplomatic efforts.

3.4 Key Roles and How to Identify Good Candidates

If you're a team lead on the primary development team or are internal to a publisher and creating a AAA multiplatform title, the following are some of the cast of characters that can make your world, and your game, work much more smoothly. We discuss key characteristics of each, along with a few suggestions for how to hire into these positions.

3.4.1 *Producer*

This role is called by many different names, including production manager, program manager, and the like. To my mind, the two PM descriptors shortchange this position by focusing too much on the scheduling side of things and not enough on product focus and the ability to develop and communicate a vision for the game. Producer hires are typically considered one of the most difficult to get right, likely because of the somewhat nebulous nature of the role. One human resources manager told me that fewer than one-third of the new producers hired into the manager's organization lasted more than 2 years. To help you beat these bad odds, the following is what I look for in producer candidates at any level:

- Do they have demonstrated leadership ability? Like the U.S. Supreme Court definition of pornography, you usually know leadership potential when you see it. Often, a candidate's resume will show a history of having been in leadership positions, but is this the same as having leadership ability? Based on the number of producers I've seen who were destructive to a team's spirit, I suggest that the two are not always synonymous. If you can't trust a CV to give you insight here, then what can you rely on? First, look to bearing. A natural leader can often command the attention of a room without trying to, even without speaking. Learn to read body language and posture. Second, ask questions about experience mediating difficult diplomatic problems. How does the candidate relate these kinds of experiences? In my experience, you want to look for people who are natural consensus builders rather than autocrats. You want to recruit people who are populist without being too demurring. This is a difficult quality to evaluate during the course of an interview, so it often helps to reach out to contacts who may have worked with a candidate in the past.

- Can they show written and verbal acuity? Proficiency with the written word and comfort speaking persuasively to groups of people are mainstays of the producer's toolkit. An e-mail discussion is a good way to get a sense of a person's level of literacy without being crude enough to ask for a writing sample. Small group discussions during the interview are a good way to evaluate verbal acuity.

- Are they experienced at shipping products? To be an appropriate candidate for a producer position at any level, from assistant to executive, a candidate needs to have shipped at least one game. Obviously, the number of titles expected should increase with the seniority of the position. A good rule of thumb is that an associate producer should have shipped at least three games, and a senior producer

should have shipped more than five. I see little value in the notion of hiring new assistant producers who are fresh to the industry. This erodes the value of the position, and there are many other entry-level positions in other disciplines that will help convey valuable experience to the candidate.

- Do they have game design experience, sensibilities, and vocabulary? This is best measured by trying to discuss a broad array of games that have emerged throughout the years with candidates. Can they clearly discuss many different games in-depth? Can they detail what would improve flawed game mechanics? Can they weigh two different pieces of software in terms of their relative strengths and weaknesses? Playing many games and reading many game reviews over a matter of years tends to be the best way to build these muscles. Ideal candidates will also have plenty of examples of how they have solved game mechanic or content problems in titles they've created. These don't always have to be video games; pen and paper, card games, or homemade board games are fine, too. The point here is that unless you play a lot of games, think a lot about what makes great games great, and build your own games as a hobby, then you likely don't have the design chops to be a great producer. And design chops tie directly into product focus. No matter how good the designers you have working on your product are, if your producers don't intimately understand game design, you've got a problem.

- Do they have technical ability and experience? This is best measured by asking questions about hardware and software. Can they explain in broad strokes why optical media data transfer rates differ from HD data transfer rates? Have they ever written any software (even Flash stuff or a Pascal class in college)? Can they describe how to resolve a driver problem, or even what a driver is? I find that technical experience and familiarity with engineering practices is one of the most prominent qualities that most producers at the top publishers lack. Although often creative, this job is fundamentally about technical problem solving. Without at least a minimum background in this area, it will be difficult for a candidate to ever become a great producer.

- Do they posses artistic ability and interest? This is best measured by looking at examples of what they have created, the vocabulary of how they describe the things they like visually, and the types of content creation software in which they have some demonstrable ability. If you don't understand 3D, can't explain what UV coordinates are, can't talk about poly density and why it matters, then you can't evaluate 3D artwork. If you can't describe how and why the palette choices in a particular scene from a film support the emotional target of that scene, then you can't clearly direct the creation of artwork. If you don't have at least basic Photoshop proficiency, it'll be very difficult for you to create documents that communicate visually to others. Producers are often called in to art direct in a pinch; this means that being able to think and speak clearly about 2D and 3D graphics is a must. Given the amount of the job that deals with video as well, it's ideal that the candidate at least have dabbled in video editing. Three programs that an ideal candidate has at least a hobbyist's experience with are Max/Maya, Photoshop, and Adobe Premiere.

- Are they business savvy? An ideal candidate has some demonstrable understanding of the value of a dollar. At its lowest level, this is a resume that shows me you've had to work for a living. At the highest level, it is an ability to discuss the differences between different markets and micro- and macro-economic trends, and some experience dealing with contracts is a great help. Negotiation with peers, externals, or other business units within the participating companies is a daily facet of being a producer, even at a fairly junior level. Although formal business training (MBA or an economics degree) isn't essential, some proven understanding of business models, employee contracts, etc., is very helpful.

An outstanding candidate usually can impress on at least five or six of these areas. A minimum hire for me would be able to speak convincingly about at least four. Without at least three of these areas well covered, the candidate is likely to be miscast.

3.4.2 *Associate Producer*

For assistant and associate producers whose job it is to help out the primary producer, the skills and abilities required are identical to those of a top-line producer. The only difference is the level of accomplishment they've demonstrated in the past. An associate producer candidate should be able to demonstrate at least three of the preceding proficiencies, and you'd want to feel confident that he or she could learn the others.

3.4.3 *Development Director*

How does a development director differ from a producer? Sort of the way a raven differs from a writing desk. But a simpler answer is that a development director is expected to be focused primarily on the people making the product, on their time and well-being, whereas a producer is expected to champion the product quality and the consumer experience. In reality, these job roles tend to overlap extensively and require many of the same skills. Ideally, a great producer and development director pairing can lead to a product that is on time, on budget, a good experience for those who work on it, and a great experience for the end user. When looking to hire a development director, I suggest focusing on the following characteristics:

- What type of leader is this person? He or she should be there to serve the team, the project, and to instill a sense of process.

- How does this person deal with the soft side of people under stress? A great development director is one part priest.

- Is this person able to deal comfortably with positions of ambiguity and decipher shades of gray? Often, there are no perfect answers, and a development director's job will be to choose between poor options.

- He or she should have experience on many projects.

- He or she should have some formal project management experience, ideally experience with both Scrum/agile development and more traditional waterfall scheduling models.

3.4.4 *Art Director*

A number of people I trust have told me that they believe hiring a great art director to be the most difficult HR job a team leader is likely to encounter. My experience suggests they are right; this is a difficult role to fill with a great contributor. You'll need artistic ability in spades, of course. A fair amount of technical savvy is critical as well, since deriving a unique and consistent look for a product, which is likely the art director's most important task, is inherently wrapped up in technology. As with all of your leads, mentoring younger artists is critical as well, and given the seemingly subjective nature of many of the calls required and the sensitivity of many artists, diplomacy is also critical. There's usually some scheduling component to the job as well, although you'd be wiser to lean on your development director or PM to handle this part of things. The following are a few highlights for what else to look for:

- Ensure that your art director candidate is someone who demonstrates passion and experience in driving an overall product vision.
- The candidate should have a track record of hands-on experience or knowledge in creating 2D and 3D art, lighting, modeling, and texturing. Ideally, he or she also has at least some experience with creating motion graphics and video work.
- The candidate should have a background in studio art, fine arts, graphic design, or advertising.
- An incredibly developed eye for detail is a must.
- He or she should have the ability to work well with a variety of personality types and disciplines from engineers to schedulers.
- Ensure that the candidate is able to show samples of his or her ability to communicate ideas visually in a quick manner. You don't want people who are only able to show you a finished project that takes days; sometimes quick sketches to test out ideas are the best.

3.4.5 *Technical Director*

Your technical director doesn't need to be your most skilled programmer, but as the point person, you are going to rely on him or her to understand technical trade-offs, make the final call on key technical decisions, evaluate your engineering staff,

and mentor younger programmers. As such, your technical director needs to be awfully close to your best. In addition to a wealth of experience writing code and shipping products, your technical director needs to be process minded and have the diplomacy required to mediate heated technical discussions and nurture a disparate group of engineers. What are some key things to look for when evaluating candidates for a role as a technical director on a distributed development team? First, from a technical standpoint:

- Your technical director should have as much practical game experience as possible. How many games have candidates shipped? There's just no substitute for experience in this role.

- How many platforms have they worked on? Have they built code for the platforms you're currently tackling? Have they ever shipped a launch title?

- How do they handle localization? Are they familiar with the unique problems associated with products that ship across several languages?

- Have they dealt with first party certification requirements before? These are a unique and often frustrating bunch of minutiae to deal with.

- Especially if your product has multiplayer components, find out if your technical director is also online savvy. (Although these days it's difficult to imagine that another who has been around long enough to be considered for this kind of role wouldn't be.)

Next, take a look at their communication, management, and planning skills:

- How large a team have they managed?

- What are the issues that surface with engineers, and how did they handle them?

- How do they motivate?

- Can they talk you through what makes a good alpha and beta plan?

- Do they understand cost/risk analysis and planning? (What features are expensive? What features add risk?)

- Do they understand source control? Are they comfortable managing branch mergers between different project groups?

- Can they sit with engineers when times are tough?

- Can they stand up to mean producers?

- Are they prepared to final a game?

- What was the most difficult project they have worked on? Why?

- How do they handle build breaks?

- How do they handle code reviews?

- What are the coding standards they believe in?

- Have they ever managed teams of engineers who were not on-site before?
- Finally, you want a technical director who is hands on – not someone who is interested only in pontificating about high-level architectural decisions or, worse, a "futurist" who wants to chase only bleeding edge bells and whistles.

If you can find someone who can thrill you and your technical gurus with their answers to 90% of the preceding questions, then you've likely got a winner on your hands.

3.4.6 Senior Designer

It's likely that various versions of your product, or different subsets built by different distributed teams, will need to have contributing designers on staff. (Indeed, you'll likely need many such designers to build a large, AAA product.) But it will likely be helpful to you to have someone on your core team who is a veteran systems-level builder and tool designer. This person's job should be to ensure that the key features that comprise the consumer promise of the project work well across different versions of the game. He or she will help determine how different variations of similar content work to achieve similar goals on wildly different platforms. This person should also be able to give feedback on tuning and help you deal with other design problems that arise within various teams throughout the course of development. It's likely that this individual will also be one of the key vision holders for the project.

What are you looking for in this person?

- Several years of experience and several shipped titles
- Systems, tools, and level design experience
- Familiarity with multiple platforms (PC, Xbox, PSP, etc.) since this leads to a well-rounded sense of how to solve design problems
- Excellent written and verbal communication skills
- Great understanding of user experience/UI design (This tends to be a real stress point for multiplatform teams.)

3.4.7 Integration Engineer and Build Master

Your needs for a dedicated person to own builds and integration will vary depending on your project. However, it can frequently be helpful to appoint one of the senior developers within your main team and on one of the remote teams to spearhead integration. Simply put, they play such major roles in getting things done on time in a distributed development environment that you want to ensure that you've got the top people on the job.

3.4.8 Technical Art God

There's little more frustrating than seeing your teams create really good-looking art in the 3D software package of their choice and then having to fight tooth and nail to get any of it into the game engine (where it may end up looking nothing like what they created). This problem arises distressingly often when you're dealing with distributed teams trying to create and share assets. The software pipelines that turn source art into runtime assets are invariably arcane, unless you're using one of a very few off-the-shelf engines. (Even the great commercial engines such as Unreal are highly complex and can easily land your art team in the reeds.) If you've got a technical art God, you can often counter these types of problems, keep your artists happy, and get your game back on schedule quickly.

What are the characteristics of such a person? Candidates are usually veteran artists with more than their fair share of technical expertise. They're equally at home with pixels, polys, and naming conventions. They usually have some mastery of the scripting language your 3D package uses (typically either MEL for Maya or MaxScript for 3DS Max). Often, candidates have a title such as CG Supervisor, but they may also be highly technically capable members of one of your art staffs.

The best way to find such a person is to observe your artists to see who it is they first go to when things aren't working out. Pay close attention, and cultivate this sort of behavior through recognition and reward. When it comes time to schedule tasks, consider formalizing this person's role by giving him or her 20% less production art tasks so that he or she is free to spend time helping others with troubleshooting. This person may also be well positioned to analyze and improve your intrateam workflow, which can have huge multipliers for productivity.

How do you hire someone like this from outside your team? You need to look for people at the intersection of engineering, data management, and production art. In every few hundred art applicants, you'll find someone who has moved between the two disciplines, engineering and modeling, or similar. Ask many questions about pipeline problems, and get candidates to describe and diagram on a whiteboard how they would architect a workflow for getting some type of visual asset into an engine. Talk to them about their philosophies on how to improve iteration time for asset creators, and so on.

When you find someone who speaks with passion and experience on workflow and asset creation pipeline improvement, you've likely got a winner.

3.4.9 Audio Guru

One of the consistent sad facts of the gaming industry is that we tend to give a disproportionately small percentage of our headcount (and our wages) to the audio directors, audio engineers, and sound designers who make our games sound great. For every title with *Bioshock* quality audio, there are 10 with substandard music and sound effects. Given the enormous role audio can play in making a game great,

it's a shame that we don't invest more in the professionals who make that happen. There is some hope for the future, though. As music games such as *Guitar Hero* and *Rock Band* capture increasingly more of the public's attention, and their sales continue to climb, it's possible that the ranks of well-paid, full-time audio professionals will swell and become the rule, rather than the exception.

With regard to hiring audio directors, you need to look for the overall number of shipped titles. You can likely expect to find people who have five or more games under their belt. Many will also have experience doing audio work for film. The best bet for interviewing them is to listen closely to their previous work. Visit with them about how to make games sound great, even on non-optimal systems. (You don't want folks who are obsessed only with 7.1 mixes and the like. Most of your audience won't ever hear that level of fidelity, at least not for a few more years.) Beyond this, look for the following:

- Technical aptitude is key. This person will need to work closely with your engineers on various versions of the product to ensure that the right game events trigger the right kinds of sounds. Mixing all of these different events without overloading your memory budgets or audio hardware can be extremely technical. Audio hardware is varied and complex, and most of the available high-end audio software is highly technical as well.

- Organizational ability is as important as technical aptitude. You're likely to have thousands and thousands of sound and voice files for large projects. Naming conventions, file structure organization, and record keeping are critical to prevent all of this information from turning into a giant mess. Arguably, this is more important than any other skill for most people who manage a project's audio. (Audio guru purists will pitch a fit at this idea. "Ear" is the most important, if not the only, aspect from their perspective.) But the best sounding mix in the world is no good if the wrong sounds are triggering at the wrong time, or if your source libraries of thousands of speech files are a muddled mess that no one is able to use to create good cutscenes.

- Some experienced voice-coaching talent is helpful.

- Interest in and experience with a variety of musical styles and a track record of having worked with composers and bands to deliver a certain sound will help because this person will be involved in determining the score for your game.

- This person should be contractual savvy. Audio teams tend to follow a movie business model, which employs many short-term, independent contractors. Each of these jobs will end up needing to be negotiated for and dealt with. You want someone who has a mature view of the negotiation and contracting processes to ensure that you are getting the most for your money and to limit your exposure to possible lawsuits. You can handle this type of thing yourself, or assign it to a PM or development director, but it's helpful if the person who will be assigning out the work also knows how to avoid legal pitfalls.

3.4.10 *News Flash: A Team Is More Than the Sum of Its Parts*

It is easy when thinking about team structure and the key hires you need to make to end up focusing on individual contributors. Indeed, the preceding discussion would seem to suggest that if you simply hire six or seven key players who can dazzle you with some good experience and interview answers, your job will be done. Clearly, nothing could be further from the truth. Experience, intellectual horsepower, and the right attitude for the task at hand can create a powerful individual, but a truly great team can be aptly described as being that oldest of clichés, "greater than the sum of its parts." Hiring great individuals is never enough; you must also hire people with complementary skill sets, pair up people who work well together, seek out and remove political jockeying and, perhaps most important, keep small groups that work well together *together* for as long as possible. This last point is especially challenging in the type of dynamic, distributed development environment we're discussing. But as a Bungie's wise PM, Curtis Creamer, once told me, "almost no team makes a great game their first time together." To create truly great teams that make truly great products, you need long-term associations, the kind that let people gain comfort, trust, and an intimate knowledge of one another's strengths and weaknesses.

Find great people who fulfill the preceding criteria and foster relationships that exist beyond a single project, and you'll be on the right road to having a winning team.

3.5 Insourcing: It's Like Hiring Family Because Dad Told You to

Another common type of team distribution is using internal technology groups, centralized art groups, or other teams under separate management but still inside your publishing company. This can be a common front end skinning and engineering team, a motion captured animation processing group, or, quite commonly, a shared technologies foundation team. These sorts of resources are excellent because they often are well funded and have excellent tools and equipment, as well as much expertise in a particular area. However, they tend to have some common pitfalls as well.

These groups are usually located either at the main headquarters of the publisher or at a low-cost center with a strong student feeder located nearby. They're typically managed by and composed of folks for whom there was no role on any product team and a few key experts who lead.

The benefits of these groups are as follows:

- Often experts in their field
- Have good equipment and tools
- Can be engaged for very short terms

- Can generate internal political goodwill and project exposure
- Already "in the family," so it's much easier to get work started

 Disadvantages include the following:

- Typically fairly expensive since they are under strong pressure to be a profit center
- Scheduling conflicts with other projects are common
- Quality of work can be uneven because there is little accountability
- Easy to get mired in intraproject political issues
- Difficult to "keep a lid on" project assets
- Often easily demoralized
- Can face strong pressure to incorporate tools and packages you don't need
- Often not particularly motivated by deadlines

3.5.1 *How to Use Insourcing Effectively*

Schedule the resources you may need early, before they get consumed by other projects. Ensure that you negotiate costs up front so you're not shocked by a "gray money" bill that is staggering. Try not to rely on internal central groups in late phases of a project when making scheduled dates is of critical importance; you don't have nearly the same leverage with internal groups that you tend to have with external partners. Make sure you have senior technical leadership vet any centrally provided technology you feel pressure to incorporate into your project.

A related trend you'll need to be aware of and potentially on guard against is the drive to mandate the use of shared engines and technical solutions. This is becoming more common at large publishers, and it is a response to the observation that game teams spend a disproportionate amount of energy "reinventing the wheel," or coming up with custom-fit, "one-off" solutions to common problems. This is both expensive and wasteful. If a large development organization comes up with one common solution for these kinds of common tasks (low level I/O, rendering, scene/object hierarchies, packet transfer, etc.) and each team integrates that solution (so the thinking goes), the organization as a whole could achieve some efficiencies of scale, and the game teams would be able to focus more firepower on the distinguishing features of their respective products. The rationale is beautiful and makes perfect sense. It even works in some cases – there is no need to reinvent the wheel for each project. However, on the other hand, as any veteran engineer can tell you, the actual sharing of technology doesn't always work. There's a regrettable tendency for centralized libraries to become bloated with every feature any misguided manager ever requested, and "one-size-fits-all" solutions are seldom as elegant, fast, or low-profile as a solution that keeps in mind the custom needs of a particular game. Tread carefully here.

The bottom line is that being a good company player is likely of secondary importance to shipping the best game you can and shipping it on time. However, with insourcing relationships, the burden will be on you to always keep this corporate politics at the forefront of your mind. Your internal partners won't have the same mandate.

3.6 Summary

We've discussed how development fits into the larger world of publishing and distribution, be it traditional retail or more modern digital distribution models. We've considered a sample development team organization and discussed in detail the characteristics that make for good representatives for the primary developer. We've also taken a look at the criteria for good hires in many key positions. Finally, we briefly discussed some of the benefits and perils of using insourced groups. Next, we discuss how to identify good external partners and how to structure your relationship with them.

Interview with Robyn Wallace, General Manager, Blue Castle Games

"How Leaders Motivate Teams to Do Great Things"

FIGURE
3.5

Robyn Wallace is General Manager of Blue Castle Games in Vancouver, BC. She currently leads the team creating *Dead Rising 2* for Capcom. Robyn has led teams for more than 15 years on several *SSX* titles, *NBA Street*, and *Need for Speed*, among other franchises. Robyn worked as a senior project manager and director of project development before taking over the reins at Blue Castle. She can be reached at *rwallace@bluecastlegames.com*.

Q: *Let's talk about how we can motivate games teams to do great work. Where should we start?*

A: One of the questions I always ask any manager I am interviewing is to describe their philosophy of leadership. There are many people who can manage – schedules, tasks, and even people; there is a much smaller number of people who really understand the notion of leadership and how to get the best out of their staff. *Those* are the people I want to hire. *Those* are the people I want to work with.

So, if it's ok with you, I would like to start by describing my philosophy of leadership. This matters because it is the underpinning of most of the mechanisms or strategies I rely on when motivating a team.

First, empower the team to make decisions. Ownership is motivating – with few exceptions, a team that feels empowered will push themselves and exceed your expectations.

Have the team work to big objectives – not tasks (keeping in mind that objectives need to be appropriate for the experience level of the staff).

Communicate the information the team needs to work effectively. Honesty and trust are appreciated. The actual content of a message may need to be adjusted or tuned to the audience. In the absence of real information, people will make things up; this is almost always detrimental to the well-being of the team and the project.

Expect the best of each member of the team, then hold them accountable for their choices and commitments. It's far more rewarding for people to be appreciated for achievement within this context.

Q: *What are some of the techniques you use to help keep a local team excited about a project after the initial enthusiasm of the honeymoon has worn off?*

A: There are a number of strategies that can help keep a team engaged through production.

Arrange milestones so they are centered on themes versus a random collection of tasks. Successful delivery can demonstrate cohesive sections of the game coming together and this can be very rewarding.

Challenge the team to solve one or two hard and/or risky problems starting from the early production milestones. This keeps the team inspired while benefiting the game, as risk is reduced making the unknowns known as early as possible.

Have individual team members share their work by presenting it at team milestone meetings. This is something anyone on the team can do – not just the leads or producers.

Publicly reward the behaviors you want to see with a variety of forms of reward and recognition. This is even more meaningful when the recognition is delivered by a peer on the team rather than always by a manager.

Q: How do you keep people motivated during the hardest parts of project development?

A: I am not really sure what the hardest part of a project is, and likely it varies for different members of the team.

Pre-pro is actually the most difficult for the majority of a game team because implementers can really struggle with blue sky thinking. During pre-pro the team is as busy defining the work as they are delivering it. Pre-pro works best for team members who are self-motivated and work confidently to identify and deliver very loosely defined tasks. A leader's role in this part of a project is facilitating conversations about any questions or problems there might be, and helping to determine what steps are required to better understand them.

Finaling is difficult as well, though this is largely a function of the volume of work to get through leading to longer hours. Typically the work itself is straightforward for individuals with reasonable problem-solving skills. Setting goals for bug fix rates or target levels can be motivating, especially if the team is driven to hit the numbers rather than just put in a lot of hours. It is surprising how much focus a team can find in order to get out of work on time each day.

At any time during the project, a sincere thank-you can go a long way. I remember reading an article once about how we can fall into the habit of over-rewarding our staff with salary increases, bonuses, rewards and recognition, etc., until all of it just becomes part of the landscape. I guess anyone would be happy to get more money one way or another; however, genuine and specific appreciation offered for work done is compelling and something we do not do enough of.

Q: What are some warning signs that alert you to serious problems on a project before it gets too late to fix them?

A: There are a few kinds of warning signs that lead me to be concerned about the state of a project or the team itself. First, I'd worry about a lack of engagement on the team. Late starts in the morning, long lunches, early departures at night, too much time on the Internet or playing games other than the one we are actually building, that kind of thing. Second, consistent lack of progress overall against scheduled deliverables during production or bug targets during finaling is a sign of trouble. Third, the deliverables are met in spirit; however, overall quality is low so the team is just scraping by. Games are great when teams are passionate about their work.

A failure to get closure on project risks as the game progresses is troubling. Weak or missing design is a cause for concern. And finally, churn or frequent revisiting of completed or partially completed work is a worry, not just because of the lack of progress but also the resulting lack of motivation in the team. Any one of these behaviors may not be a cause for concern (except the first one), but a collection of them means some work needs to be done to get the team back on track.

Q: How do you approach removing as many unknowns as possible from the production process once you are already into a full production phase?

A: The project will advance most effectively if risks are addressed as early as possible. Typically, the majority of risk in a project is related to addressing unknowns. Work on understanding the unknowns and solving the risky problems as early in the project as possible, even though it can be tempting to save this work to the end and deal with the deliverables the team is most confident with first. It is very empowering for the team to do this and helps them address issues more effectively when new ones come to light later in the production cycle.

Make decisions as quickly as possible. We almost never have the time or ability to fully understand all open issues. Strong leaders are able to confidently make decisions as soon as "enough" information is available. This gives the team a direction to work towards. Decisions may require a backup plan if they are made with a high degree of uncertainty. Should more information become available indicating the original decision was incorrect, inform the team members who need to know and make the change as quickly as possible. In my experience, this does not happen frequently.

Q: How do you encourage project leaders to be more effective at staying connected to the concerns, hopes, and attitudes of the "people in the trenches"?

A: The most important part of having leaders stay connected with the team is to hire the right people from the start. This means looking for leaders, not managers.

Reward the folks who have the 1:1s. Grow their staff, and deal directly with performance issues.

I try to always model the behaviors I want to see by working with the project managers and lead the way I want them to work with the rest of the team.

Ensure that all the team leaders pay attention to the work and the results – along with the expressed concerns of the staff. Take the time to understand the challenges in each of the areas of the project. The team will have more faith in their leaders if they see that their issues are understood.

Listen. Listen to the team when they talk about themselves, listen to the team when they talk about each other, listen to the team when they talk about the work and use that information as clues for what you need to investigate further.

Q: How do you help local teams learn to deal with and embrace creative feedback from external stakeholders, even when they don't always agree with the direction?

A: Now that I am working for an external developer I have a much better understanding for the importance of this than I think I ever did when I was working on the publisher's side. Like any other feedback or decision made by another party, the most helpful thing we can do is to give the team as much visibility on the process used as possible.

Allow team members to participate directly in the decision-making process whenever possible. For example, let them hear the feedback directly from the publisher. This is also an opportunity for team members to observe their leaders representing them in the process.

Communicate the feedback with as much background information as possible. Be willing to ask for and provide more information if that makes sense.

If all else fails, it may be necessary to remind them who pays the bill and that this is business. The publisher gets to make the final call just like the team producer does on an in-house product.

Q: How do you motivate a team to give the extra effort required to push a particularly difficult milestone across the finish line?

A: First, set objectives for each person – when they are all done, we are done.

Second, measure only the things you care about because what you pay attention to, the team will pay attention to. Don't measure bug fixes if you are focused on dev tasks. Make sure you are focused, so they stay focused. This means a few key priorities and making the rest stretch goals.

Don't change the goal posts part way through a milestone. Not only will it mess up that milestone, it will mess up the team's confidence in your leadership and future milestone plans. We can't afford to make significant changes to the plan more than once or twice in a project without losing credibility. The reality is that change does happen in a creative, dynamic environment like game development. So, any time something may need to change I try to assess it on that basis. Ask yourself, "Is this the thing I am willing to risk my credibility for?"

Q: How do you pick and mentor team leaders who can serve in external facing roles, interfacing with publishers, partners, etc.?

A: Certain skill sets are helpful for team members to have if they are going to deal directly with the publisher. They need to be good listeners, which includes being engaged and asking for clarifying information. They should demonstrate an openness to other ideas and ways of doing things. They need the ability to facilitate discussion, and draw out others. It helps to have a natural curiosity and willingness to ask questions instead of just offering opinions.

And it helps if they have an understanding of the external development business model and a strong customer service orientation. This can be evident even during in-house development where the producer acts as the internal customer.

Q: How do you approach the difficult task of having to cut features or content that people have poured work into without it being a major morale hit?

A: First, I work with the rest of the leadership group, particularly the producers and designers, to reduce the risk of having this happen. This means ensuring that all members of the team understand the primary underpinnings of the game. Ranking game features with

an investment model: gold–silver–bronze, major/minor, or 1 to 5 are all ranking systems that work. This makes it clear to the team where they should invest effort and focus our energy starting early in development. It is easier to cut a bronze feature than a gold one when the team runs out of time. Making the rankings visible to the team even before rolling from pre-pro into production ensures that production and the team are on the same page. This process makes it much easier to understand what aspects of the design are "filler" and potential cuts down the road. Plan to do those things late in the schedule and don't overinvest.

I also believe in working with the team to deliver the core aspects of the game as early as possible – especially those features with risks – so we can better understand if more capacity is required in those key areas.

Schedule the team to 80% capacity. This gives them head room for surprises and space to make features better, or to add some cool stuff we didn't think of at the start of the project.

Every game needs to have a cut list from day 1 of production. Revisit it every milestone or two. And, okay, so the answer to the original question – if all else fails (and eventually it will) make the cut. Tell them why. If the team has seen all of this effort made, if they are reminded of and live the design priorities that were set at the start of the project, and the decision is clearly communicated and understood, they will cope well. Speaking personally with those most invested is a preferred way to deliver the message, then following up with a broader message to the team.

Q: What do you feel is the right cadence for having visitors from publishing or other external partners come to work on-site with the development team? Does this change by project phase?

A: Try to have your first visit as early as possible to align on high concept. This may even be required during the proposal phase to make sure the developer and publisher align on what project is being quoted. This goes a long way to preventing confusion, an unhappy publisher, and an overworked dev team later.

Once a month is fine during pre-pro (contributing to the creative process) supplemented with weekly calls and e-mail exchanges of documents. Ideally there should be one visit around the time the design is done and the team is ready to go into full production.

Frequency of visits during production are ideally a function of product duration. At this point they can be either direction: having the developer bring a milestone build to the publisher or having the publisher visit the team at a milestone. On longer cycles (greater than a year) every second milestone is likely to be enough. As during pre-pro, weekly calls will continue to be helpful, as well as ongoing e-mail communication.

Other than a visit tied to an event or demo, I do not encourage visits from the publisher during final. Publishers represent design and the team is focused on closing the game out, so these visits can feel confusing. Having said that, the publisher needs to be kept well informed of the progress of the game towards final. Daily QA reports and weekly updates

on progress against the tuning plan and the bug fix rate is generally enough information for the publisher (and the team) to have confidence in how the game is tracking. Call frequency may increase, especially as the project winds closer to final and issues need to be addressed more rapidly to get to closure. Our leads and QA folks are increasingly directly involved at this point of the project.

Q: What are some techniques you use to help make the process of finaling the game more sane, a better experience for everyone involved?

A: One of my goals since coming to the video game industry has been to deliver a game with an empowered team and managed overtime. The second can't happen without the first. In fact, I would argue that the more the team is managed to tasks versus objectives, the more likely they are to require extra hours to get the job done.

The most success I have had is based on setting daily or weekly workgroup/individual goals and letting folks know that they should go home when they are done. This significantly reduces the need for after hours OT or coming in on the weekend. It never ceases to surprise me how much folks can get done in this situation – often with just improved focus and shorter lunches. [Grins.]

Beyond that, when OT is required, having a workgroup plan a night or weekend day to all be in and working together reinforces their camaraderie and support of each other, and they are often hugely productive at those times.

My goal is always to have as many people away from the office as possible while still getting the work done. If QA is testing late, and as we near the end of the project with a faster build cycle, coverage may be required in each workgroup to address late or weekend bugs. Typically we handle this with a schedule and folks volunteering to be available in the office or on call if a problem arises. Leads, PMs, and producers are required to monitor the bug database and call in the staff if appropriate. Often someone already in the office can address another person's bug with some over-the-phone support, as well. At this point, I work with the leads to try and ensure that on call and OT is satisfactorily balanced across a workgroup.

Q: How do you help resolve differences of opinion between departments? How about between different teams on the same project (e.g., remote developers vs. the home team)?

A: In my experience, resolving differences (usually in approach) or solving problems is best done as soon as they arise with an impromptu meeting involving the interested parties. This ad hoc approach is quite effective and keeps folks from getting stalled for any length of time.

My role is to get the right folks together, facilitate the discussions, record the results and get them out of the room and back to work as quickly as possible. I then follow up to keep the process moving towards resolution. Typically we start by making sure that everyone

agrees on the goal or the problem they are trying to solve. Everyone shares their ideas, concerns, risks, and collectively proposes a direction to either better understand the problem or to solve it.

This is intended to be a collaborative process. However, reality does have some impact. Whoever understands the problem best likely gets to make the call. The team with the most capacity is often the right one to solve a problem. In cases where there may be disagreement with the publisher, the one paying the bill gets final say. Our job is to give them the right info to enable decision making.

Q: Any final thoughts on what the future holds for you?

A: I came to video game development in a strategic decision to get out of twilight industries (mining, forestry, etc.) and into an industry that had a tech component and was still growing (I used to be an SE, so tech is my first love). Being a project manager in this industry has not been a disappointment to me. I particularly appreciate the complexity of solving creative problems that often involve technology. The people who work in video games are smart, hardworking, and endlessly creative. That's what gets me in to work each day, and even though I have considered making a change from time to time, it is difficult for me to imagine working in any other industry.

FOUR
External Partnerships

It's go time. Your game has received at least tacit approval from the top brass, or one of your publishers has just come to you with more work than your current team can handle. You need a new team. In fact, you probably need more than one, and you need them fast. They need to be able to start yesterday and be up to speed on the project, the tools, and the other players within a few weeks. They need to be ready to hit hard deadlines, create beautiful art assets, have technical savvy, and work cheaply. So where do you find them, and how do you evaluate them?

4.1 Where to Find Candidates and Teams

If you are part of a mature publishing organization, then the challenges this section is designed to help you overcome will be slightly easier to face. You likely already have a long list of partners with whom your publisher has worked before. If your predecessors haven't burned too many bridges, then you can likely call on some of them again. But if you're part of a newer organization, if your list is outdated and you need some ideas on where to find new talent, or if you are a developer yourself looking to find a partner to collaborate with or subcontract to, then this section will be of help. The following are a few places to start your search:

- *Game Developer* magazine
- Trade shows
- Shipped titles credits
- *Moby Games*
- Co-workers or colleagues
- *Gamasutra*
- *GamesIndustry.biz*

doi: 10.1016/B978-0-240-81271-7.00004-7

- First-party recommendations
- Web search cold calls
- *Kotaku*

4.2 How to Know What You Need

How do you decide who you need to fill out your team? For most projects, the teams are chosen according to two primary factors: with whom the team has a personal relationship and the team's cost. It's easy to understand why this is. It's the same reason why so many people end up married to someone they sat next to in class or who lived in a nearby parish. It's just easy and natural to form relationships with people nearby, and it's natural to think first of those folks on your personal "friends list." There's nothing inherently wrong with this, particularly if you happen to be adept at networking inside the games and film industry. But you should try to think about what you need first rather than first looking to the acquaintances you have who might also be free.

Start by analyzing the task at hand and other tasks that can be similarly grouped. How technically complex is the mission? Are there particular programming languages, third-party tools, platform details, memory constraints, or legacy architecture involved that will add to the skills required?

Obviously, the specific parameters of your project will play a huge role in determining which specific team you want to work with. It's also likely that your company already has some "preferred vendors" or something similar.

The following are a few specific questions to ask when evaluating a team:

- Has this team successfully completed an assignment like this before?

- Who are the key players on the remote team that you need to lock in?

- Could the company fall apart if it lost one or two of these key players?

- What kind of support will be required to ensure success?

- Do they have the equipment and infrastructure required to do the job, or will you have to augment their assets?

- Are the financials of the company sufficiently stable that the company won't go bankrupt during your project?

- Who else does the company do business with?

- Are there adverse regional conditions that could explode during your project (civil wars, economic collapse, etc.)?

- Why does this company want this project?

- What is the best path for extending the working relationship beyond this one project? (That is, are there strategic reasons for using this particular company, team, or vendor over another?)

Questions for Fay Griffin, Development Director, Electronic Arts

On Identifying Partners

FIGURE
4.1

Fay David Griffin is a development director in charge of vendor outsourcing at Electronic Arts. She previously worked in the Art Department at Lucasfilm, JAK Films, and at Skywalker Ranch. She appeared in *Star Wars: The Phantom Menace* and *Revenge of the Sith*, and she worked on visual effects for Episodes I and II. She can be reached at *faygriffin@me.com*

Q: Tell us a little bit about your background in the games industry.

A: I've worked in the games industry for the past 3.5 years. I first started as a game team development director, and then moved into managing outsourcing for two game teams within a studio, and then managed outsourcing on a worldwide level across multiple studios. With the worldwide role came the addition of also managing external vendor partners.

Q: What are some of the criteria that you recommend game teams use to evaluate potential partners?

A: The most obvious thing to look at first is past experience. What's their track record?

Then, especially for outsourcing, you should look at the quality of their work. Give them a test to evaluate their skill set. Next, look into the maturity of process. How well do they understand the production process? You need to consider their size. Are they big enough to do the job? What if the size of the job expands? Are they financially stable? How much do they cost? If all of these look good, then you can start thinking about their location, and how they would be able to integrate with the rest of the team.

Q: How do you suggest unproven development studios go about building a name for themselves?

A: Attend gaming conferences. Get involved in gaming forums where people discuss game development. Tie themselves to reputable art schools in their area as a way to gain talent. Build a solid portfolio highlighting their skills. Find a studio partner willing to invest in the partnership. Sometimes bigger studios or publishers will help. Offer to do tests for different studios to get your reputation out there.

Q: What are some of the best sources for finding new development or art production teams?

A: The best is to start with recommendations from trusted sources. Then, look at game art forums. Go to GDC and talk to people there. Follow the talent – which areas have good art schools and programs focusing on the games industry? Look there.

Q: What are some warning signs that indicate that a particular developer might not be a great fit for a particular project?

A: If they fail an initial test. If the work on their website is not indicative of the work they actually produce. If they don't have the proper skills in house. Say, maybe you need character work but most of the work they have done is on environments, for example. If they seem unwilling to tailor their production processes to work with a studio team. And it's never good if they are disorganized or unresponsive in meetings.

Q: What types of characteristics do you think team leads who are going to collaborate with studios and content providers internationally need to cultivate?

A: Leadership. They need to exude a strong sense of being able to lead a team to instill the confidence of the studios.

Communication. They need to be able to demonstrate they can efficiently communicate between two groups, particularly when it comes to translating the design vision.

Problem solving. They must demonstrate they can see the bigger picture, envision problems down the line, and provide practical solutions when they arise.

They need to be collaborative. They must demonstrate that they have a collaborative nature and can work well with both the internal team and the studio team.

Q: Are there particular types of content that you think are particularly well or poorly suited to distributed development?

A: This question really depends upon the maturity of the studio distributing the work. For some studios who are not as well organized in working in a distributed model, asset-only, simple, one-off, easy-to-define work is ideal.

For studios who are more mature in their approach, they have a good handle on what game it is they are making, they understand the importance of pre-production and have a solid pre-pro process, they stick to deadlines and budgets, and can be disciplined in deciding if changes are needed; the sky is the limit! I've seen complete levels outsourced successfully and full SKUs outsourced successfully with studios who understand the process and are quite disciplined in their approach.

Q: We've seen India, Vietnam, and China explode with game development and art production teams. What do you think will be some of the next frontiers for game teams to start exploring?

A: South America and some new parts of North America. I say North America because several states and provinces offer significant tax credits to bring business to their cities. These will likely never be as cost-effective as lower-cost regions like Asia. However, depending upon the type of work they do, the cost could be offset by other benefits.

Q: What strategic reasons might a team have for choosing one particular vendor over another?

A: If they see a vendor as more of a long-term solution or partner who can grow with them. If they have a strategic initiative to invest their efforts in one vendor, as opposed to spreading efforts across multiple vendors.

Or perhaps if one vendor is much easier to work with than another. Although some vendors may have superior quality, they may be more difficult to work with to get to that quality.

A studio may see more potential in one vendor over another; this could be due to advantages like location, good management, company health and stability, company philosophy, and so on.

Q: Are you starting to see any new trends in the way that development teams or content creation houses are structured?

A: For development teams, I would say that they are getting leaner. They have smaller production execution teams and have focused their efforts on development and design.

For content creation houses, they are getting more savvy in understanding the importance of key roles on a team to be successful. Technical artists, art directors, art leads, QA, specialists in various areas like modeling, texturing, and animation. They are diversifying their service offerings and gaining more knowledge in working on complex tasks such as in the game engine, engineering, and scripting.

Q: If a project is in trouble and the leadership has determined that they need to bring on external collaborators to provide emergency assistance, what are some steps they can take to make success more likely?

A: I never recommend outsourcing as a 9-1-1 measure. Outsourcing engagements I have seen work well are the ones that are well planned out in advance; they are tried and tested.

If a team has no choice, I would recommend the following:

First find contractors they can bring in house to work with the on-site team. If that isn't possible, then lower your expectations or adjust expectations for the situation. Likely if a team is bringing in an external partner at the last minute, they have planned poorly and are running out of time, and won't have time to iterate.

Pick the easier assets that can be more stand-alone to send out of house. LODs, assets that already have a solid technical and design specification that will not change, and such. Pick a vendor they have worked with before and with which they have had proven success. Be prepared to pay for overtime to get a vendor up to speed. Be prepared to send someone on-site to a vendor to work with the team.

Q: Is there any other wisdom you'd like to share with game developers out there who are planning on partnering up with external houses on their next project?

A: Don't look at external partners as simply external. The project needs to be viewed as a whole; whether the work is being done on-site in their studio or external in another studio, it is all part of the same and should be managed as such.

Q: Any personal anecdotes or entertaining stories dealing with cross-cultural communication, overseas travel, or distributed development that you think would amuse our readers?

A: I am a firm believer in understanding the traditions and cultures of the countries I am working in. It helps tremendously knowing how to communicate effectively with your vendor partners.

With this in mind, I was working with a partner in China. Typically in Chinese culture, there is a lot of pride and the attitude of saving face and not embarrassing another party publicly. So any delicate conversations are best handled outside of a group and directly with the individual.

I was invited to dinner and taken to a lovely restaurant with the CEO, COO, and other key members of the partner studio. Being a bit jet-lagged and not really thinking about the restaurant they proposed, I was quite surprised when the restaurant server rolled an enormous, roasted Peking Duck – head still intact – into our private dining room, and then proceeded to elegantly carve it up in front of me. The CEO went on about how special this dish was and the history of it and how you should eat it. Being vegetarian at the time, I had all but lost my appetite. However, I did not want to embarrass my hosts and took one for the team. I enjoyed crispy Peking Duck chased with lots of Tsing Tao, for the first and last time!

4.2.1 *Partner Evaluation Matrix*

Some producers find that if they have a number of different teams to evaluate, it can be helpful to create a spreadsheet to quasi-objectively assess a number of specific areas. These sheets usually have a collection of categories, from "project management experience" to "engineering staff quality." The sheets are then used to weight the various factors according to how important they are for your project in particular. This supposedly gives a more "unbiased" and numerical way of analyzing which team would be the best fit. Figure 4.2 shows an example of a partner evaluation matrix.

As you can see in this example, we've come up with a list of 33 different criteria against which we can measure our hypothetical partner for the multiplayer component of our game, *Wetworld*. Some of these categories are of critical importance to us, such as "Multiplayer Experience" and "Experience in AAA Development." Others just don't matter at all for this project, such as "Experience with PSP Development."

We weight the relative importance of each criterion (done here using the "Importance" column). Then we assign a quality rating to this particular developer for that particular area. Here, we think that Fat Frog Games has a very good design staff, but apparently we don't think too highly of their artists. Luckily, since they're building multiplayer game modes using art from the single-player campaign, we should be okay. Apparently, Fat Frog has no experience building PS3 games – that's bad – but they have extensive experience building both multiplayer games and shooters.

Next, you multiply the rating by the weighting value for the criteria and then divide it out by the maximum possible number of points (the number of points they'd have if they were experts in absolutely everything) to determine some kind of a suitability index. (Fat Frog would apparently be 65% suitable for our purposes but perhaps could improve considerably if it hired someone who had, for example, shipped a PS3 game or two.) Then you can compare this value with those of other potential partners you've run through this matrix and choose the best possible candidate for your project.

This exercise can be beneficial. It helps you articulate and rank those criteria most important to you, and it forces you to spend time thinking about the relative strengths and weaknesses of each team or company. It can also identify key places where a small change (like the PS3 hire here) could give you significantly more confidence in a team or reduce your risk considerably. Any exercise of this stripe can add value by getting you and other members of your decision-making team to really think and talk through things with a little objectivity.

Beyond these types of added value, however, I don't personally place too much stock in the idea of a matrix such as this as an "objective" rating of a particular developer. First, it's still entirely subjective since someone has to subjectively evaluate how a team ranks for the particular criteria. Second, it's very easy to get caught up in the picayune using this method. Fat Frog Games has clearly shipped a number of AAA multiplayer shooters. Is its 65% suitability rating (an asinine phrase chosen intentionally to help remind us that it's virtually impossible to summarize a collection of people with a single number) really a proper reflection of its suitability for this task?

FIGURE
4.2

Wetworld Partner Evaluation Matrix

Criteria	Importance	Rating	Total
	(1 - 5, 5 = critical)	(1 - 10, 10= superb)	
Development			
Knowledge of our engine & toolset	3	1	3
Engineering staff qualification	4	6	24
Design staff qualification	4	8	32
Art staff qualification	1	4	4
Staff Experience in new development	1	2	2
Experience in AAA development	5	7	35
Experience in remote development	5	8	40
Experience building RPGs	2	1	2
Experience building shooters	4	7	28
Experience in Playstation 3 development	3	0	0
Experience in Xbox360 development	5	5	25
Experience with PC Development	4	9	36
Experience with PSP Development	0	0	0
Experience with Wii Development	0	4	0
Multiplayer Experience	5	9	45
Operations			
Physical Proximity	1	6	6
IT Infrastructure & equipment	3	4	12
General Studio facilities infrastructure	2	3	6
Financial Stability	2	2	4
Salary range competitiveness	2	9	18
Company communications culture	4	5	20
Quality of recruitment practices	2	6	12
Available in our time frame	5	9	45
Ability to bring in additional help	2	9	18
Aggregate MetaCritic score	4	7	28
Cost Effectiveness	4	9	36
Ability to retain key staff	3	10	30
Project Management			
Production management experience	3	8	24
Sr. Management Team's experience	2	4	8
Quality of Project Planning Process	2	4	8
Quality of Risk Management	5	8	40
Openness about problems faced	4	9	36
Quality of your current business relation ship	1	4	4
Total			631
		Suitability Percentage	65.05%

Partner Evaluation Worksheet

Finally, it's mighty easy for someone with a personal agenda (maybe even you) to end up manipulating a table like this one to prove a preconceived belief.

Use a matrix like this one as a helpful thought experiment, or a way of establishing a common language and framework for thinking about how to evaluate developers, but don't get too married to the specific data it can generate.

4.2.2 *Warning Signs When Evaluating Teams*

It pays to measure twice and cut once before entering any kind of a deal, but particularly so for an expensive software project where the cost of even a small mistake can be measured in lost product sales that far exceed the value of the contract itself. Try to apply a healthy dose of extra skepticism to any candidate before settling on a particular developer. Look for warning signs. The following should set off alarm bells:

- Anyone who hasn't shipped products before shouldn't be on your list. This might sound harsh, but you're much better off letting some other project train folks on the job. There's just too much material that can only really be learned the hard way, and since the hard way often involves failing, you're better to let them fail on someone else's dime. Development houses made up of industry veterans who may not have shipped a product together under their current umbrella are probably okay, but first timers are very risky.

- Beware of developers who want to jump immediately into discussions about money without first trying to understand the details of the project. It's a sign that they'll agree to anything rather than give you good feedback on the game you're trying to make or the parameters of the project.

You should be concerned about anyone too willing to sign up to meet impossible deadlines or deliver against plans that are clearly unrealistic. Eagerness is great, but a small team who will agree to build a "*World of Warcraft* Killer" with a small team of 15 people in 10 months need to have their head examined. A few simple probing scenarios will let you know if the team you're talking to understands the challenges of software development well enough to know what it can realistically accomplish with its particular resources. Since biting off more than can be reasonably chewed in a given time frame is by far the most common issue that gets teams into trouble, it pays to devote extra scrutiny to this matter. The best teams get excited about their game and want to make it great by shooting for the stars. This is fine and noble, but it can't be allowed to cloud their judgment.

- Don't let yourself get trapped into only visiting with the top brass. You need to interact at least briefly with members of the team across all available layers. If this isn't appropriate politically, then you need to have artists, engineers, and designers on your team get in there to interact with the group. If the person trying to sell you on a team is trying hard to shield you from the people who will do the work, you need to understand why. Bringing along several people

who occupy different levels to participate in breakout sessions during your due diligence visits can be a good way to accomplish this goal.

- Watch for the bait and switch. Are there a few top people who are absolutely critical to your project surrounded by a bunch of junior folks? If so, and there are other projects in the studio, then it's a safe bet that these senior folks are officially "on" all of those projects. The resulting lack of focus can be a killer, and it's a dishonest business practice. Even contractually specifying people by name probably won't help you if a shop is determined to run this way. The only real way to avoid this type of problem is either to hire studios sufficiently large to have enough experienced people staffing several projects or to be the only project at a studio.

- Beware the absentee leader. Too often, the dealmakers may have already spent their time in the salt mines and believe their job is just to close the deals and then hand the work off to others. There's nothing inherently wrong with this practice, but you want to understand clearly what it is that you're getting for your money – and then spend time vetting the skills of those junior folks who will actually be doing the work.

- Any company too willing to share information with you about competitors or other projects they're working on even though they're under a nondisclosure agreement will likely be similarly loose-lipped with your proprietary information. This is a bad business practice and should immediately raise red flags.

- Look for a track record of "broken hearts." If a development house has a history of its relationships with former partners going sour, the same is more likely to happen to you. One or two failed relationships in the past doesn't make for a serial divorcee, but a team that regularly ends up in an adversarial relationship with its publishers or partners likely has issues dealing with authority and could prove difficult to work with. Ask around.

- Beware the fly-by-night. If the outfit hasn't been around long, you need to perform extra due diligence. If a place feels shady, it probably is.

- Look for signs of financial distress. Almost every small developer has cash flow issues from time to time – that's why they're looking for work. But you don't want to get into a situation in which you are forced to keep a failing company solvent. Don't let yourself be positioned such that to avoid risk to your project you have to pay out money beyond what you'd expect.

- Beware the "deal heat." You probably got into this business because you really like video games or did at one time. You're probably excited about your newest project, and if you're about to do a deal with a developer, you probably have fairly strong reasons to believe that the developer is as gung-ho as you are about the game you're about to make. Read Jack Welch's commentary on deal heat in *Winning*; he warns how easy it is for even experienced veterans to get so excited about a deal they've worked hard on that they let their judgment slip. Take a few deep breaths, double-check every element, then get a second opinion from someone who is not emotionally involved in the game – in your success or in your personal happiness.

Interview with Luke Wasserman, Senior Producer, 2K Sports

"Forming and Maintaining External Partnerships"

FIGURE
4.3

Luke Wasserman is a senior producer at 2K Sports in Marin, California, where he finds and manages teams that create top-performing sports games. Luke has served as a franchise development director at Electronic Arts, where he was involved in the creation of several versions of the top-selling *Need for Speed* franchise. He has also worked in production at PDI/DreamWorks and Columbia TriStar. He can be reached at *luciuswasserman@gmail.com*

Q: Tell us a little bit about your background and current role.

A: As is the norm in life, one thing led to another and I ended up beginning my career in traditional animation, working on Saturday morning cartoons for Hanna-Barbera and then Columbia Tri-Star. While at times demoralizing, working my way up from production assistant allowed me to experience production from all of the various levels, roles, and perspectives. I cannot emphasize how important this was to my growth and evolution as a producer. At some point it became clear to me that digital animation was the future of animated entertainment, so I transitioned to a new job that would expose me to this burgeoning world. Game development was then the next logical step. Currently I am a senior producer at a major publishing and development company overseeing multiple internal and externally developed projects.

Q: When you're helping internal game teams determine who they need to partner with, how do you evaluate their needs?

A: I start with questions. What type of project is it? Who is the target audience? What is the budget and timeline? What are the projects' priorities, quality targets, and special needs we should be accounting for? Not all projects are created equal. All have different

challenges and goals, and it's important to recognize this and build it into the partnerships that are established for the project.

Q: What are some of the best sources for finding new development or art production teams? How do you recruit partners?

A: Contacts. Current and previous colleagues and partners are incredible sources of information and leads. Also, who have I worked with before that I would like to work with again? Good experiences and relationships should be leveraged and fostered.

Internet and research. Who has made great products or art previously that may have some relevance to my project? Seek out houses that have done good things that are in some way important to your project, especially if they have previously developed great products for a particular platform or genre of a game.

Q: What are the first things you look for when you begin to evaluate a potential development studio?

A: Repeat business. For a studio with any history, this is a good place to start. If they have companies who have worked with them a number of times, this is a positive sign. How long have they been around? How many projects have they delivered and to what quality level? I review this previous work, judge the quality and nature of the work with regards to my current project and needs.

Next I look at their current projects and availability. I gather information on the number of projects in development and the timelines. How will they deal with multiple projects running in parallel? Are there any finaling conflicts? How could those be dealt with? This shouldn't be an issue if the projects are staffed and planned appropriately, but it also goes to the core management philosophy of the company. I don't want to have my staff pulled off to help another project and vice versa. Have an open discussion about this concern.

Check out their previous projects and specialties. Talk with them about the past projects. What have been the company's good and bad experiences and why? The "why" part can reveal a lot about a company's perspective on its partnerships and its own internal organization. Is there an area, genre, or platform that they excel at?

You'll need to evaluate their man-month cost and budget. One doesn't need to go into specifics immediately, but it is good to know if the company will be interested in the general range you anticipate for the budget.

Do they demonstrate passion and enthusiasm? If they aren't excited about your potential project or the work they do, they probably won't be bringing that to your development.

Look for a complementary skill set. Do they complement your internal company's strengths and weaknesses? Do you want to fill a gap in your own bench or enhance an already existing strength? I am generally inclined to improve my weak areas through this external partnership and leverage internal strengths and expertise where they exist.

I tend to ask general management questions such as what is the company's management structure and philosophy? Who are the leaders and how do they plan to be involved in the process? What are their backgrounds?

What are the IP security risks? Is the facility secure and who is allowed inside and able to see what? Do they have the appropriate infrastructure and structure in place to provide protection for your project? Is all the software they use legally licensed? What type of equipment are they using? Will it suffice for the project's needs?

Investigate financially stability. Due diligence needs to be done. I like to ask the potential development house to provide tangible information in regards to their financial status and history: bank statements, letters of credit and credit line, debt structure, and so on. A company financially imploding in the middle of the project is something to avoid at all costs. Will a delay in payment, because a milestone wasn't satisfactorily met on time, cause issues with the company's survival and/or people getting paid? Any other specific financial, corporate, and staff information that will convey the studio's stability and situation is important too.

Q: What are some warning signs that indicate you might not want to partner up with a particular developer?

A: Previous work. There are many reasons why quality levels or creativity may not be achieved, but this is the best gauge to what the company will deliver for your project. If a company consistently delivers garbage, there should be no reason to expect your project to be any different.

Do they have a string of work, all from different companies and no repeat business? This should speak to you on a number of levels.

Are the leaders people who you'd want to work with and have driving your vision forward? Generally folks are on their best behavior when they are being courted for work, so if you glimpse less than appropriate personality traits and behaviors early on, this could be a large warning sign. How do they treat their team? Get a sense of this by asking questions about how previous projects went and why. The answers may be revealing.

Q: What types of characteristics do you think team leads who are going to collaborate internationally need to cultivate?

A: Characteristics that are important for a lead to cultivate are quality, efficiency, timeliness, openness, and communication. These are the basic pillars that support success. Enthusiasm for the product is also hugely important. They are the champions for the project and should be instilling this within all those who touch it.

Q: We know a track record of successfully completed projects is a good indicator of future success. Are there any cases you can recall when you were surprised by an untested development house?

A: While track record is certainly a key indicator of future success, there are instances this can be misleading and it needs to be viewed from different perspectives. For example, if a

team has only had the opportunity to deliver games that generally are not products that critics respond well to, Metacritic ratings will not tell the tale. Shipping "Mary Kate and Ashley" games, no matter how fun and solid, will not necessarily provide strong Metacritic numbers. Look at the games for what they were and if the goals for that project were fulfilled.

Q: We've seen India, Vietnam, and China explode with game development and art production teams. What do you think will be some of the next frontiers for game teams to start exploring?

A: A personal dream of mine is that we start leveraging the design talent around the world. At the heart of games is design. We have leaned heavily on India, China, and Vietnam for delivering art assets and full game experiences, but much of the time the vision is generated by the internal team and then exported to lands afar for execution. The game design creativity and fresh, interesting perspectives that remain untapped are huge.

Q: When planning for games with downloadable content, MMOs, or other kinds of games with a long support period, how should teams change the way they think about relying upon external partners?

A: Support for games post-launch needs to be part of the initial planning, design, and scheduling. Things can evolve and change, but it needs to be part of the plan from the beginning. External teams can be a huge factor in this success. Contracts should account for this work in such a way that a minimum amount of deliverables and support is agreed upon for post-launch, with the flexibility to add to this as appropriate.

Q: What strategic reasons might you have for choosing one particular vendor over another?

A: There are both long-term and short-term strategic reasons to go with one vendor over another. Are your strengths and weaknesses more complementary of one another? Is your plan to build up an area internally, but in the short term you need to acquire strength in that particular area to succeed? Do they have expertise you want to glean and learn from? Or is this a company that you may want to acquire? This is a good way to forge a relationship and try before you buy.

Q: Is there any other wisdom you'd like to share with game developers out there who are planning on partnering up with external houses on their next project?

A: Be open about the strengths and weaknesses of your internal setup. If you know that providing assets, reference, design, and feedback in a timely fashion has historically been difficult for your company, you need to plan around that and not pretend like it won't have an impact or rear its head. Self-assessment is just as important as assessment of the external vendor.

Q: Any personal anecdotes or entertaining stories dealing with cross-cultural communication, overseas travel, or distributed development that you think would amuse our readers?

A: I once had a freelance storyboard artist who had a deadline approaching disappear just prior to scheduled delivery. Through sleuthing I was able to discover that she had gone to Korea to visit her family. More investigation provided me a contact in Korea that led to another contact, which led to another, etc. Eventually I was able to get ahold of the storyboard artist's mother. Needless to say she was surprised to pick up the phone in Korea and hear me asking when I could expect to receive the work from her. I got the storyboards on time. Be tenacious.

4.3 How Developers Can Find Partners and Publishers

I recognize that much of this book has examined the problems and rewards of distributed development from the perspective of a team leader who is part of a central planning group. Folks who fit this description most likely already work for a publisher or for a fairly large and well-established development house. It's unusual, if you are part of a development team of, for example, 50 or fewer people, that you'd have the resources to plan and execute a full multiplatform project. But because distributed development is as much a partnership possibility for smaller developers as it is for publishers, let's take a minute to examine the project from a different perspective. If you are a smaller development house trying to find partners to work with, what should you be looking for? How should you approach finding deals? What are the pitfalls you need to beware of?

First, know your strengths. It is a very rare studio that is good at everything. In the realm of game development, this maxim is true at companies both large and small. But smaller studios need to narrow their focus even more aggressively. It takes a stable full of experts to really be widely talented enough to take on anything, no matter how smart a few of your key leads might be. So start by identifying your strengths as well as your weaknesses. Consider the core disciplines first, and stack rank them. Are you stronger in art or engineering? Gameplay or content? And so on. How does your collective console experience compare to the time your employees have spent working on PC or handheld titles? Although there's no reason to be perpetually held back from trying new things – you don't want to become a prisoner of your past successes – it'll serve you in good stead to pick a fairly narrow focus and work to hone it. Besides, it'll help you narrow your list of potential projects, publishers, and franchises that might be a good fit.

Second, consider your contacts in the industry and the world at large, and start to cultivate them. Who do you know at other studios? Where have you or your key leads worked in the past that might be looking for new partnerships? Online sites such as *Linked In* are a great way to dig around to find out where old colleagues

have landed. Don't be shy about reaching out and letting people know that you've got a great team available who specializes in whatever it is that you do best. You can also publicly post this sort of information as a part of your company's profile on *Gamasutra*, *Linked In*, or even on a *Facebook* group dedicated to your studio.

Third, write directly to the information aliases for publishers and other studios that do work of the type you might be interested in. Believe it or not, these e-mail addresses do get actively monitored, and genuine leads do get passed along to key decision makers. This isn't necessarily the fastest way to get a deal going, but it can work.

Fourth, consider issuing a press release about your company – about its forma-tion, a recent key hire, or a recent product with which you've had success. (Be sure to run this last possibility past your previous publisher first.) Work with a news aggregator or post the release directly to sites such as *Evil Avatar*, *Kotaku*, or the other games industry hangouts online. Follow this up by sending these sorts of press releases to the editors of *Game Developer* magazine, your local newspaper, and other gaming news sources. This kind of scattergun approach takes time, but it can work to generate interest among a broad audience.

Fifth, join local, national, and global game development groups. Attend their meetings when possible, offer to speak at your local chapter, and generally work to get your company's name out there in the collective mind of the industry.

Sixth, attend trade shows such as GDC, DICE, and E3. Visit with everyone there who will listen to how great your team is, and describe the kinds of things you're work-ing on. Ideally, bring samples of your work – demos, concept art, pitch documents, or past games – and show them to folks. Needless to say, it's important that you spend your time visiting with the right people at shows like these. But if your company hasn't yet shipped a product, and doesn't have any key industry connections, then getting your name out there to anyone who will listen will still have some value.

4.3.1 *On Agents*

In addition to the previously discussed methods, consider working with an agent. However, consider this method of lead generation very carefully because the costs can be much higher than they may seem. Typically, agencies agree to represent your studio and talk to their vast wealth of contacts on your behalf, help you to negoti-ate deals, and to generally provide moral support. In exchange, they won't ask for money up front but instead for a percentage (e.g., 15%) of all the money you make from any of your future projects. Then they'll ask you to sign a contract where they represent you exclusively (you're expected to be exclusive, not them) for 5 years or more. Be careful. Their exact responsibilities are often only vaguely defined, but your responsibilities when it comes to paying them will be spelled out in bullet-proof legalese. They usually take a slice of your earnings from milestone payments, back-end royalties, and even from any future sale of your company. You'll be forced to use them (or at least pay them) for any sequels, and there are often numerous

tangling fees that are required to be paid to the agency in perpetuity. It's possible that this type of relationship will turn out to be worth it, especially if your company lacks the experience to attract attention on its own or the ability to self-promote. But the projects you get are less likely to be chosen based on any strategic value to you, may or may not help to build your brand over the long term, and since the costs end up being a percentage of any future money made, scaling up your team quickly becomes very pricy. For example, on your first million dollars in revenue, you would "only" pay the agency $150,000. But once you've become successful and your company revenue is 5 or 10 times that, you can suddenly find yourself paying a small fortune to an agent for very little service. Be very careful with the contractual obligations you sign up for here. Pay a lawyer to represent your interests, and pay attention to the advice he or she might give.

In addition, there are a few hard-won rules to keep in mind before entering an agency agreement.

Venue Clause

If things go wrong, which territorial laws will apply? California? British Columbia? Texas? If there is a suit filed, where will it be tried? Decide now so that if things blow up the matter will already be resolved and you won't first have to fight over where you're going to fight.

Specific Performance Benchmarks

Don't sign any deal that doesn't hold your prospective agent to specific, measurable performance criteria. Ideally, this includes a specific number of deals required, documented new relationships brought to the table, or a certain total amount of revenue from new deals within a particular time period.

Caps

Set caps on total commissionable payout. Even if these caps are high, they are still better than being forced into a runaway payout. Set time clauses as well, at which either party is free to walk away. Set these to be short. If the relationship is going well, it won't be difficult to agree to continue things at their current rates. But if you aren't getting out of the association what you'd hoped, this will make it much easier to walk away or renegotiate.

Not Worldwide Exclusive

Unless your agent is a former U.S. president, or someone who can call in UN troops to save the day, you don't want to agree to worldwide rights. Use agents within their sphere of influence. Also, reserve rights by territory for those who have something to do with your successes in those territories.

Let Them Eat Only What They Kill

I suggest following an "eat what you kill" rule for agent commissionable income. Unless they bring a deal to the table or actively work on your behalf to close a contract, they shouldn't be automatically deriving commission from that deal.

No Sequels or Derivative Clauses

Don't automatically give up a percentage of your profits on sequels or derivative products. Unless your agent somehow closes a deal for you for that new product or is involved in some way in securing it, beyond having been involved on the original contract, there is no reason why he or she should be profiting from sequels.

4.3.2 *Why Developers Need to Self-Promote Early and Always*

All this shameless self-promotion may at times seem smarmy, or at best just tedious, but it's essential to finding projects, especially when your studio is small and not very well known. Once you have a proven track record of shipping at least a few games, the hard work of getting "discovered" by future partners will get much easier. Word of mouth is still very powerful in this business, and if the titles or elements of the game your team worked on are strong, publishers and partners will eventually come looking for you.

It's worth issuing one more specific warning to new development houses, even though it's likely that the warning will be ignored by all but those who have been around the block enough times to nod knowingly and remember: Plan for at least 4–6 months to pass between the time you start talking to potential partners and the time when you have a deal inked and a payment incoming. It really does take that long to put together a proper deal. Many teams have optimistically thought that they could shortcut this process, only to end up drowning in their burn rate while waiting for a deal to finally come together.

4.3.3 *Warning Signs for the New Developer*

You're eager as can be. You've got good people on your staff, and you've got your business cards and a cool website. You've got a plan and the smarts to execute it. You've been to GDC, shown a few samples of your work, and it pays off. You get a call from someone representing a publisher who is interested in talking with you about having your studio build something for them. Congratulations! Now be careful. Here are a few things you need to consider carefully:

- Particularly if you're an unknown developer with little or no track record, there are often elements inside of the major publishers who will willingly sign you up for jobs that could easily kill your company. This isn't necessarily malice

on their part, but publishers understand that a young and hungry development house is eager to prove itself. It's likely that there won't be enough time, money, or support to build the project effectively (especially in the first offer they put on the table). Don't let your eagerness get in the way of your better judgment.

- You need to work with your publisher to carefully understand your role in the project and what kind of support and resources you can expect.

- Beware of any entity who is pushing you to do a lot of work without pay. Reputable publishers understand that good developers cost money, and even if they aren't willing to pay a lot for certain jobs, they will typically offer some funding for a project in which they are genuinely interested. A good rule of thumb is that if they don't want to pay you to work on something, they probably don't really want to publish it.

- Be very wary of hiring up staff for any project that hasn't yet made it through the contract negotiation phase. Until there is a deal in ink, you run the very real risk of bloating your payroll only to have the project disappear. Graveyards are full of teams that made this type of mistake.

4.4 How Developers Should Evaluate a Development Deal

Once you've assembled a quality team and properly marketed yourself, it won't be difficult to find a publisher that is interested in paying for what your team has to offer. After all, the publishing industry is based on soliciting and purchasing creative works from developers and then selling them for a profit. So, if you've got a good game team and are willing to do something they need done, it's a match made in heaven! Time to start coding!

Not so fast. Since we're taking some time to look at things from the small developer's perspective, let's cover some of the contractual pitfalls that almost every small developer falls into at one time or another. Once you're aware of those areas of your relationship with a publisher that require special attention, you'll be better prepared to negotiate a contract that benefits everyone involved in the deal.

Many startup development houses worry that asking too many questions or trying to negotiate the contract too vehemently will anger the publisher and endanger the deal. Obviously, a lack of tact and diplomacy will make any amount of negotiation more difficult, but failure to push back gently and clarify important details of the contract won't make you look accommodating. It will make you look naive. Honest intentions, goodwill, and a shared passion for game development will get you to the table. Clearing up contractual issues that might cause relationship difficulties, or even kill the project later, will identify you as a smart project leader who can actually get games across the finish line.

4.4.1 *The Assignment*

Is the goal of the project spelled out clearly enough that someone who is familiar with the industry (but not involved in creating this game) could understand what you're trying to build? Are the specific tasks that the developer, the publisher, and any other parties will undertake spelled out as explicitly as possible? You need to ensure that responsibilities are clearly articulated. Ask yourself, Who is responsible for testing the product? Who is in charge of localizing it? If there are publisher-side community management tasks, they should also be detailed in the contract, and so on. Finally, you'll need a mechanism within the definition of the work that spells out what process is to be followed for change requests. Unless there is some limit to the number, the complexity, or the increased implementation time that can be spent on change requests made by the publisher, it's very easy to get yourself into a situation in which your studio ends up spending far more time on the project than you'll get paid for – situations in which you finance change requests out of your own pocket in order to try to appease a publisher, just to get your milestone payments. This can easily become an untenable position that breeds friction in the relationship. Get your change request procedure and contract extension mechanism in place up front, and everyone will be better off. Make sure the following three items at least are spelled out clearly:

- Task definitions
- Dates
- Dealing with change requests

4.4.2 *Pay*

Typically, you determine how much your team is owed for a project based on the number of people employed and a fixed cost per man-month rate. Currently, for most developers, this is between $8000 and $16,000 per head per month. Obviously, such a wide cost spread represents the different levels of experience that different teams offer, as well as how much money the publisher has to devote to a particular project.

For most "work-for-hire" projects, these per-head, per-month costs represent the total recompense for the work the developers do on the project.

It's very valuable to think of the work in terms of man-months as per-month costs, because it helps tie the costs to the project schedule. It also makes it fairly easy to calculate how much extra funding needs to be appended to the contract in the case of change requests, project extensions, etc.

It is common to try to lay out all payments associated with explicit milestone criteria that are defined at a very high level. To understand how this is usually structured, let's take a look at the sample milestone list and payment schedule shown in Figs. 4.4 and 4.5.

Milestone #	Deliverable	Payment	Estimated Date
M1	Advancement of Payment/Execution - Contract is signed	$220,000	2/21/2010
M2	Project Planning: - Storyboard of gameplay prototype created - 1st pass Visual prototype style guide created - High level Game Design Approved - Game Walkthrough Doc created & approved	$150,000	3/24/2010
M3	1st Playable Prototype: - All tech plans vetted - Asset list for Art, Design, Sound & UI for complete game - Build demonstrating core gameplay functioning on target hardware	$200,000	4/24/2010
M4	2nd Playable Prototype: - Look and feel of game are demonstrable - All high gameplay risks have been proven out, design solutions have been agreed upon - Visual style is present in at least one "beautiful corner"	$200,000	5/16/2010

FIGURE
4.4

Sample Early Milestones

First, there are numerous checkpoints in this schedule that are so vague that any developer should be worried about signing up for them. M4's "Look and feel of game are demonstrable" is a prime example of an item that could easily end up coming back to haunt you since a determined publisher's agent could easily argue that he or she didn't think the "feel" of the game was good enough. Other milestone criteria are less than ideal because they rely on external groups to satisfy their conditions. For example, the approval criteria for M11 states that "all text [must be] localized and locked." As a developer, this should concern you since it holds your payment hostage until the developer is satisfied with the performance of a publisher's localization team, over whom you have no leverage whatsoever.

FIGURE

4.5

M10	ALPHA - All alternate control layouts implemented - All game modes available & winnable - Start Menu functional - Save game & profile save features ready for pre-cert - 90% of strings complete and ready for localization	$150,000	6/22/2010
M11	BETA - All game modes and content in place and locked except for bug fixes - No outstanding high priority bugs - ESRB Rating received and implemented into FE - All Final text, graphics, music, sounds, in place - All text localized and locked	$125,000	8/4/2010
M12	ZBR (Zero Bug Release) - All bugs are closed - Product bug count remains at zero for at least 3 days without any new check ins	$200,000	9/25/2010
M13	Approved for Manufacturing - All versions of the product have been approved by first party certification and are now in manufacturing	$175,000	10/28/2010

Sample Final Milestone

Particularly at the beginning of a project, everyone generally has the best of intentions. Developers are excited about signing a deal that will let them get paid to do what they love, and publishers have high hopes that the game will be a hit that will help build their portfolios, maybe increasing shareholder value along the way. In this spirit, it's very easy to want to quickly agree on some milestone definitions with only a verbal agreement that if things need to change down the road, it'll be no problem. ("Hey, we're friends here and we all just want to make a great game,

so let's not let this legal crap slow us down. We can always amend the milestone schedule later if we need to.") It's important to resist this temptation. Work to get better, clearer definitions for exactly what constitutes each milestone, and then lock down the procedure for acceptance (this process is discussed in more detail later). You'll still probably end up with some milestones that need amending, given the inherent vagaries of game development, but it's worth spending time up front to try to minimize this sort of thing.

One of the most essential issues all parties should agree on before a contract is signed is the fixed man-month rate at which change requests and overages will be billed out. This protects the developer, to be sure, since it's very easy to end up having a milestone take weeks or even months longer than expected because the feature set grew in size. In cases such as this, payment isn't usually issued until the milestone is complete, which means it's easy to run up hundreds of thousands of dollars worth of work for which the publisher hasn't compensated the developer. Getting a fixed man-month rate established and codified in the contract and deal terms makes it easy for everyone to understand the cost of adding new features or of a changing schedule.

Also, be sure that before you sign a contract, you understand any subtractions to pay based on payment processing. Many publishers will charge a 3% processing fee, or similar, on payments to developers. With operating margins as narrow as they usually are for startup software companies, this can end up really hurting you. ($30,000 per $1 million is a lot of processing cost, especially when every penny counts.)

Finally, many contracts are wisely structured such that there are final payments based on performance metrics, typically on-time ship, Metacritic rating, conversion rates, or some other measure of product success. These criteria offer a superb way for both the publisher and all developers to know explicitly what is important for a particular project as well as a great incentive to make an excellent game. Just make sure you aren't negotiating away too much of your payment, such that it ends up hostage to performance criteria over which you don't have full control. (If, for example, you're building just the multiplayer component of a game, the final Metacritic rating is only partially in your hands.) Strive for performance-based motivation bonuses that accurately reflect the work your particular subteam is doing.

4.4.3 Royalties

Delicious back-end royalties are another mechanism for deferring a developer's compensation and tying it to performance. Royalty deals are becoming rarer, especially for inexperienced teams, with most publishers preferring a straight "work-for-hire" model in which they pay only for the man-months used. Obviously, as a developer, you'd prefer to collect royalties in perpetuity on every copy of the game sold or any microtransaction items a customer buys. Royalties can create a long-term revenue stream for your company, and once you begin stacking up back-end royalties from multiple top-selling products, you can end up regularly putting real

wealth into the company's coffers. Such stacking allows smaller developers to evolve into bigger developers, to self-fund their own pet projects, etc.

Typically, milestone payments in any royalty-bearing deal are considered "advances against royalties," which means that any earned royalties are ignored until they exceed the total amount paid the developer in milestone payments.

If your game is successful, once the milestone payments have been exceeded, your royalties will start to kick in. Royalty rates are typically graduated based on the number of units sold and offset for some minimum and maximum number of units. For example,

Earned Royalty Rate (Initial Offer)

10% from 500,000 to 700,000 units

18% from 700,000 to 1,000,000 units

15% for 1,000,001 + units

Royalties cap at 2,000,000 units

Royalty payments cease 72 months after the ship date of the game (currently November 21, 2009)

In this (generous) example, the developer would recoup no royalties until the game sold a half a million units (a whopping success for most single-platform titles). The developer's royalties would increase to 18% of net profit (usually subject to fairly complex calculations that serve to hold back some profit for potential returns, etc.) up to 1 million units. Thereafter, one often sees royalty rates decline based on the theory that the developer has already made plenty, and the rest should go to the publisher. There is also, typically, a cap at some number, such that on a runaway surprise hit (e.g., *Brain Age*) the publisher doesn't end up paying out hundreds of millions of dollars in royalties. Finally, royalties often have a duration so that the publisher doesn't have to keep paying ever-diminishing payments to a developer years down the road based on minuscule profits from back-catalog sales of old titles. Obviously, it's in the developer's interests to negotiate each of these details to more favorable numbers. For example,

Earned Royalty Rate (Developer's Preference)

15% from 100,000 to 700,000 units

20% from 700,000 to 1,000,000 units

18% for 1,000,001 + units

Royalties cap at 4,000,000 units

Royalty payments are made in perpetuity

As you can see, the developer here would start earning royalties much sooner and at a higher rate. The developer would continue to earn royalties at these higher rates all the way up to 4 million copies, and the royalty payments would never "time out" based on the passage of time.

The fact is that most game deals don't end up paying developers much in the way of royalties. The royalty clauses are there to offer a carrot and out of the noble intention of all parties to make a hit. But few games ever sell the kinds of numbers described here, and it's rare to see the advance milestone payments ever recouped. But this shouldn't stop you from trying. Royalties like this can and do happen each year. So work toward them, but be realistic about the odds.

4.4.4 Delivery and Acceptance

Generally, a development contract needs to spell out what constitutes an acceptable delivery of work. This is a matter separate from the specific content of the work and instead usually deals with the medium on which delivery of assets will take place, how long a partner has to review or dispute the quality of the deliverable, and so on. This type of issue is best illustrated with an example:

> *2.3.2* **Delivery.** *Developer will develop and deliver to Publisher each* **"Deliverable"** *(as listed and detailed in the Deliverables Appendix), including the Schedule, Specifications, and all Game Definitions. "Game Definitions" shall be derived from mutually agreed upon game design documents and other product specifications. Delivery shall include functional software running on target consumer hardware or a development kit for same. Developer will make any Subcontractor's personnel available to consult about the game upon reasonable request.* **"Game Code"** *means the object and source code comprising the game, including the game engine and any tools required to develop the Game.* **"Game Content"** *means those items created for the Game (even if not included in the final build of the Game) that may be perceived or experienced by the person playing the Game including, but not limited to, code, character likenesses, artwork, designs, sounds, graphic files, music files, user interface, names, dialog, storyline, plot, and any other materials which are part of the game experience.*

> *2.3.3* **Acceptance.** *Unless otherwise agreed upon in writing, Publisher will evaluate and accept or reject any Deliverable, in writing, within ten (10) calendar days of receipt.*

The first key detail in a section such as this is the clause describing the specifics of what the developer needs to deliver. (Source code? Working build on a platform? Design specs? The sample requires all of these on every milestone.)

The second critical item is how long a partner has to review your submission before requesting changes. Since a developer typically doesn't get paid until the milestone delivery is approved by the publisher or partner, it's certainly in the developer's best interest in ensure that acceptance procedures are very clearly spelled out. A 20-day delay in milestone approval will not only risk delays to your game but also can easily force small developers into missing payroll.

Of course, in a case in which the relationship is on a good footing, the project manager on the development side should be in close enough communication with the producers and test leads responsible for testing delivery that any delays are clearly understood, and there are no critical surprises. Even so, developers need to make sure they communicate with those in charge of delivery acceptance as early and as often as possible so that expectations for what you'll be delivering are clearly set and easily met.

For publisher's agents or anyone else responsible for verifying a milestone acceptance, remember that officially "failing" a milestone and sending it back to your developer for changes (without issuing payment) is one of the heaviest, bluntest hammers in your toolbox. Don't use it unless you really need to send a message that the developer's most current submission is putting the entire project, and the relationship, at risk. Remember that for most developers a missed milestone payment can easily put payroll at risk. Also, when people don't get paid, they quite rightly quit. So be very sparing with outright milestone failures, and never let it be a surprise to your developers when you're forced to hold back payment.

4.4.5 Intellectual Property Rights

Another question to ask yourself, and your partners, before you sign a contract is, at the end of the day, who owns what? Can you use the technology you create for this game on later games made for other publishers? Who owns the intellectual property for this title? If any patents are generated based on the creation of this game, who owns the rights to those? You need to ensure that all of these details are spelled out before you begin production rather than waiting until you've created something awesome that suddenly everyone says is their own. Let's take a look at another sample bit of boilerplate contract that can serve to satisfy these needs:

> **6.2 Ownership of the Products.** *Except as described in* **6.3** *below, the Game, Game Code, Game Content, Specifications, Trademarks and all similar items are the sole property of Publisher and its assigns to the maximum extent permitted by law. This work is made as "work for hire" and Publisher shall be the sole owner or licensee of all patents, copyrights, trademarks, and other intellectual property rights.*

In this case, the publisher has sole right to the game (as is normally the case). The phrase "work for hire" effectively means that the developer doesn't own the moral rights or intellectual property rights to anything the developer creates under this contract.

> **6.3 Developer IP.** *Section 6.2 above shall not apply to Developer IP (defined in Appendix A). Developer IP shall be listed in the Game Appendix, and mutually agreed upon by Publisher and Developer. Developer shall retain all right, title, interest, and ownership in the Developer IP, and no title to or ownership of any Developer IP is transferred to Publisher.*

This section allows that the developer may have some existing intellectual property (usually a game engine, proprietary tools, or similar), the rights to which are not transferred to the publisher. It is also possible that this IP could consist of story or characters, which are then effectively being licensed out to the publisher for use in a particular product. Clarifying these clauses in an appendix to the contract makes the overall contract cleaner and greatly reduces the risk of conflict after the game has been created.

> **6.4 Future License to Use.** *Developer hereby grants Publisher a perpetual, nonexclusive, worldwide, transferable license to use and distribute Developer IP as a component of the game and any sequels. Should Publisher sublicense the Developer IP, Publisher shall pay Developer a fee to be agreed upon at that time, but not to exceed $250,000.*

This final section provides that the publisher may use the developer-owned IP for this particular project (and for this product's sequels), but not for other products, without paying the developer a fee.

These are a few examples of ways to specify the rights of each party to what gets created during the course of the project. Including such language in a contract protects existing property, future intellectual property, and your relationship with your publisher as a whole.

4.4.6 Credit

Everyone wants to receive credit for their hard work, and after producing a major title, you're likely to want to shout from every rooftop about your great success. But beyond basking in the well-deserved pride of the creator, letting everyone know about the contributions your team made to a successful title is critical to the overall success of your company. As a startup developer, you should always be working hard toward getting your brand better known. With this goal in mind, you'll want to negotiate for the following:

- Your company logo on the box and in print ads
- Mention of your company in official publisher press releases
- Your animated logo to appear at the game's startup and on TV ads
- Your team members to be mentioned in the credits

Your publisher, with its own brand management to worry about, likely won't want to "dilute" its brand by having competing logos popping up in key marketing areas. You'll have to negotiate for these items, and again, ensure that what you're getting is explicitly spelled out in the contract. Note also that so-called "moral rights" dealing with credit differ from country to country, so highly distributed teams that span several countries can wind up with complex rules about who must be credited for their work.

4.4.7 *Future Relationship*

From rights of first refusal on future projects your studio might undertake to capping increases in man-month costs for sequels to the current project, there are dozens of ways that a contract for one game can end up casting a long shadow over future projects. These details are typically a mixture of good and bad for your company – good because they indicate the potential for future profitable enterprises with this particular partner but bad because it is far too easy to agree to something now that becomes a burden as fortunes change throughout the years. My best advice here is to very carefully understand each of these types of contract clauses and, as with all legally binding documents, consult a skilled attorney before signing.

4.4.8 *Key Employees*

Usually, there are only a few obvious superstars on any development team who, by virtue of experience, passion, or natural aptitude, are a disproportionate part of what "makes" the team. When hiring a partner, it is common to want to ensure that the key players whose reputation and skill sold you on the idea of working with this team in the first place be applied to your project. It is quite common to include a contractual element that mandates that certain key employees remain on the project, and that if they leave or die, they quickly be replaced with someone of similar caliber. This type of contract clause protects, first and foremost, the publisher. Unfortunately, it can often limit a developer's flexibility with regard to finding additional work or allocating resources.

For publishers, ensure that you leave the developer enough flexibility and wiggle room to apply resources where they are best suited. After all, if you only needed a few critical team members, you could likely have just hired them directly.

For developers, make sure that if you agree to it, you really can commit to keeping a particular person on this project for its entire length. This is one of the areas in which smaller developers commonly play fast and loose with in their agreements, but publishers know it, and failure to adhere to your agreement constitutes a breach of contract. Even if no one ever takes you to court over it, or even calls you on it, it's a dishonest, deceptive business practice that can cast a pall over the relationship. Also, if you are brought to court over the breach, it could cost you your company.

4.4.9 *Use of Subcontractors*

In her fascinating book, *Shock Doctrine*, Naomi Klein describes a situation in which the U.S. government subcontracts out key functions of state building in Iraq to Halliburton and Bechtel, which in turn subcontract it out to a U.S. subcontractor, which subcontracts it out to a Turkish company, which then subcontracts it out to an Iraqi company, which in turn takes the work but fails miserably to accomplish

the mission. At each level down the ladder, the monetary pie given to those who actually do and manage the work gets slightly smaller, such that at the bottom of the ladder the Iraqi workers are paid a pittance to do the work for which Halliburton and Bechtel were paid a fortune. Klein uses this example as part of a broader argument against the outsourcing of government functions. But her example is reminiscent of some of the worst excesses of the "pass through" projects one occasionally sees in the games industry. A publisher hires a well-known development house to build a product. The development house hires a lesser known, cheaper developer, who works at a lower man-month rate. The less expensive developer then outsources components of the work to someone else, and so on.

These days, most agreements will require the developer to explicitly inform the publisher about any subcontractors they employ. The publishers and partners want this spelled out contractually to prevent being charged a high price for lower quality work. Developers typically would prefer not to have to agree to these sorts of conditions because it reduces their flexibility.

Generally, everyone involved in the contract should be more than willing to agree that any use of subcontractors has to be mutually agreed upon before they can be engaged. There is no honest reason for anyone to want to hide their use of subcontractors.

4.4.10 *Termination*

Tragically, some marriages end in divorce. Even most of the serial divorcees never expect that their third, fourth, fifth marriage, etc., would also end in divorce. Human beings are, by nature, optimistic. It's our optimism that allows us to pick ourselves up and try again, even after experiencing a major setback. But optimism is poor armor if it's all you have when things start falling apart. So you need to at least consider the worst-case scenarios between you and your partners up front and make sure you are protected. Let's look at termination clauses:

*11.4 **Termination.** Publisher may suspend performance or terminate this Agreement if Developer materially breaches this Agreement and fails to cure within 30 days after written notice (which will be prominently labeled to indicate that it is a notice of breach).*

Developer may terminate this Agreement if Publisher fails to make any payment required hereunder and fails to cure within 20 days after written notice.

Publisher may also terminate this Agreement without cause on 30 days' prior written notice. In this case, Publisher shall pay a pro-rata share of any completed and accepted Deliverables completed prior to the date of termination, including the current Milestone Deliverables then in development.

Neither party will be liable to the other for damages resulting solely from terminating this Agreement according to its terms.

As a developer, you want to, at the very least, ensure that although the publisher or partner can cancel the project at any time, for any reason, they are at least required to pay out through the next milestone. For a developer, the chief concern in a case in which the game vanishes, as so many of them do, is to have enough money coming in to pay your people's salaries until you can find new paying work. Try for a termination clause that obligates your partner to pay out the rest of the current milestone, and the following milestone, if you can manage. Also try to orchestrate the language of the deal such that you retain ownership of any IP or technology you've created up to that point. This will at least give you something you can shop around for other potential clients.

For a publisher, the agreement is usually structured such that you can walk away at any point, for any reason, or for no reason at all. Be sure to include in the contract what, if any, IP the developer gets to keep in the case of project termination, as well as the process for the proper return of any hardware or software development aids you may have loaned out.

4.4.11 *The Value of an Appendix*

Unlike in the human body, contractual appendices serve very valuable functions. Although in the body of the main contract every change has to go through the publisher's legal department (and should do the same on the developer's side), using an appendix for details that are particularly likely to change over time, but don't fundamentally alter the structure of the deal, can be a valuable and efficient way of ensuring terms stay clear and everyone is properly protected. Common types of appendices include the actual product schedule and milestone delivery timetable, details on key employees who are required to remain on staff for the project's duration, and "development aids" or other partner commitments.

By pushing some details into an appendix, you can frequently get a deal signed when some important elements are still "TBD" (to be determined). Of course, often the devil is in the details of a particular project, so it's possible that your appendix could end up completely changing the scope of the work you need to do or end up making a good deal seem bad. However, since an appendix has to be mutually agreed upon before it becomes binding, there's no risk of being forced into something.

The core structure and legal details won't change when you change the appendix, so it allows for flexibility when either side might need it. An appendix can typically be much more easily amended than the body of the contract, so both sides are able to avoid legal red tape and get on with the business of producing games.

4.4.12 *Strategic Value*

Previously, I discussed the importance of ensuring that the projects you sign up for have strategic value for your company overall. This concept might seem like

a luxury, especially when you're first looking for work. For some, it is. A starving team often feels like they need to take any work offered, and in the beginning this might be the case. However, this isn't a habit you should retain once your company has established itself in the field. If possible, you want to be able to pick your projects in such a way that they help build your studio brand according to the overall strategic direction established in your business plan. Perhaps your goal is to become the number one racing game studio on handheld platforms. In that case, taking on work for a golf game might not make much sense. Perhaps you're trying to hone your engine and technology to eventually compete with one of the established names in that area, such as Unreal. In that case, you'd want to only take on projects that would let you use that engine and also retain the rights to any improvements made to it. In a case such as this, it might even be worth giving up on royalties so that you can get more credit for your engine and retain greater rights of ownership. Studios that carefully consider these types of strategic trade-offs when determining what projects to take on, and what terms of the deal to focus on negotiating for, are the studios that end up becoming wildly successful.

This list is far from comprehensive because every deal and associated contract is different, and only the publisher and developer(s) involved in a particular project can know what the most important negotiation points are for them. But hopefully this section has at least helped give fresh-faced developers a sense for how to approach finding work and of the many different factors that must be considered before signing a deal.

For our industry to mature and prosper, we need to move away from some of the more predatory aspects of the publisher–developer relationship that have often been standard in the past few decades. Publishers have become slightly more honest due mainly to the Internet and the rise of a more educated population of gamers. These gamers pay attention to the news behind the games, which has helped draw attention to some of the more egregious and heavy-handed tactics that were once so frequently employed. For developers, events such as GDC and publications such as *Game Developer* magazine have helped with education. At the same time, there are also many more mature game development teams than there were a decade ago.

If there is one key message I'd like to impart to new development teams who are excited about rushing headlong into their first deal, it would be this: Just wanting to "make fun games" simply isn't enough. You need to also employ shrewd and careful businesspeople and make your moves carefully if you want to be successful. Remember, its only the very successful who have the luxury of making the (fun) games they want.

Let's summarize a few of the points we've discussed. You want to make sure the following elements are all covered in some way:

Agreement Checklist

- Man-month rate
- Back-end incentives (royalties or performance bonuses)

- Credits
- Ownership of IP
- Termination rights
- Delivery and acceptance
- Project definition
- Milestone appendix
- Key team members specified
- Development aides provided

Although this list isn't exhaustive, these are the key elements of any agreement that you need to make absolutely certain are spelled out before undertaking a project.

So far in this chapter, we've examined the parameters that define a successful two-party relationship (with a little extra attention paid to third-party subcontractors). However, modern AAA franchise titles tend to be distributed between significantly more than just two parties. Let's round out this chapter, then, by discussing the ways the two groups we've been focused on fit into the larger picture of the game development life support system.

4.5 Roles and Responsibilities

Who are all the teams you need to have in place? Who manages them?

For the final part of our chapter on forming external partnerships, let's take a look at nine of the most common external groups or teams required to ship a AAA multiplatform title (Fig. 4.6). Obviously, smaller games for the Web or limited PC releases may get their products built without using all of these groups, but almost any retail title or PS3/XBLA downloadable game will need support from all nine in order to launch successfully. Later, we'll focus almost exclusively on the software development group, but let's take a moment to address the critical contributions provided by the nondevelopment teams involved in distributed development projects. How does each fit into the world of distributed development?

FIGURE
4.6

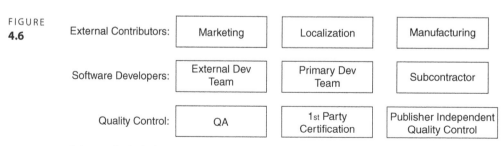

Primary Stakeholder Groups

4.5.1 *Marketing*

Let's start with a group that is typically considered far more removed from the development process than many would argue is ideal. Marketing seldom gets directly involved in the distributed development process until the end of the project. As product launch approaches, it can be very helpful to have the marketing product manager be in direct contact with one of the development houses in order to work with them to generate marketing assets. If the marketing for a game is hot, and the team is doing their job, then the public should have an appetite for screenshots, video clips, and even information in magazine and webzine interviews. Sometimes farming the creation of these assets out to a subdevelopment partner can ease the burden on crunching teams. The development partner can even be a story unto itself in cases in which the developer's status gives the publisher some much-needed street-cred. Marketing is almost always internal to the publisher.

4.5.2 *Localization*

A publisher's localization team is responsible for getting the text and speech assets, the manual, and sometimes other forms of content translated and implemented into the software. Localization teams are typically also responsible for conducting quality assurance on the translated software to ensure that any mistakes are caught and remedied. Occasionally, localization studios are externally hired teams that are separate from the publisher or developer. In either case, aside from issues of contract and payment, functionally localization teams are another distributed arm of your development structure. Almost all of the advice contained in this book applies to localization in much the same way as it does to other types of content creation houses. We'll talk more about localization specifics during the finaling phase in Chapter 5, but here are a few early localization-specific bits of advice:

- Open communication channels with the leader of your localization team early. This should be an experienced "Loc PM" who is the contact point for all other groups that need something from localization.

- Plan early for localizing content, or don't do it at all. Ensure that one of the engineers on your primary engineering team has shipped a localized game before, and that he or she is architecting for it from the onset.

- Ensure that text strings are stored in separate "string tables" rather than embedded in other types of content or code. Ideally, these should be text format files that can be edited with off-the-shelf tools or a custom database built for the job.

- It can be helpful to have experts on staff who are proficient in the various languages your product needs to support. Obviously, this isn't always possible, but don't overlook the value of additional spoken languages when reviewing resumes.

4.5.3 *Manufacturing*

The group that prints manuals, presses optical media, and puts everything in a box seldom gets much attention from the development teams with which this book is primarily concerned. They are a critical part of the process toward the end of the product development life cycle. Since distributed development tends to have many moving parts, and some versions of the product may end up shipping at slightly off-set times, it can be useful to set up a regular guidance call with the manufacturing team, especially as your project approaches alpha. Learn what other major projects are on their radar and where possible compressions in the manufacturing schedule might be possible.

4.5.4 *Quality Assurance*

QA, or "test" as it is often called, is not part of your software development team. This is an absolutely critical rule to keep in mind for project leads in every part of the distributed development organism. The quality assurance team should be as close to the project as any designer or engineer on the game, and during the final third of development the QA leads should be the first number on any good producer's speed-dial list. But they cannot and should not *ever* be thought of as part of the development team. Their role is too critical to expand beyond its already given parameters. QA will often be run by a publisher, but there are independent QA companies that can be hired to help test a game. The following are tips on maintaining a positive relationship with QA during a distributed development project:

- Don't let things get adversarial. Strive to have a friendly, professional, and respectful relationship with QA during the course of the project. Keep your teams mindful of this. It is too easy for developers to denigrate "testers" when they need to instead appreciate the critical role QA plays in shipping high-quality products.

- However, don't let things get too chummy either. You need your QA to always be focused on being able to accurately report the status of the project's quality. Your development teams will almost assuredly be too emotionally close to the problems to be objective, so this leaves the entire burden with QA.

- You'll want an experienced QA lead dedicated to each platform. They don't have to have necessarily shipped a game on that particular platform before (although it helps), but they do need to at least have shipped one game before.

- Consider having embedded testers on-site within key development houses during certain product phases, especially leading up to alpha, beta, and submission to certification.

- External QA companies are less likely to get too involved in the project than are publisher-run QA teams.

4.5.5 *Publisher-Independent Quality Control*

Sometimes called "worldwide QA" or by various acronyms that change regularly and aren't standard throughout the business, this is a group of experienced testers who are often employed by major publishers to ensure that projects aren't "passed through" by local QA teams that become too involved in the game to properly evaluate its problems. Because they typically only see near-finished products, these teams often have a great sense for the types of problems other game have recently encountered when trying to ship. Typically, there is a minimum amount of time that such groups must play a game without encountering a "must fix" bug, before it can be allowed to pass through to first-party certification.

4.5.6 *First-Party Certification*

Although PC games can be put in a box and sold in almost any condition, Microsoft, Sony, and Nintendo all have formal certification processes that titles are required to go through in order to be authorized for play. The first-party certification teams are advanced testers who have an (often excruciating) set of guidelines regarding what is and is not allowed and how various cases need to be handled. Many of these tend to be highly technical, involving controller disconnect messages, reset button behaviors, and other interaction with the hardware. The (laudable) goal is to provide consistent and high-quality experiences for the user that help set and satisfy user expectations. Certification guidelines change regularly, so it is essential to ensure that someone from each development team involved in a given product be charged with staying on top of the "Cert Guidelines."

4.6 Summary

We've discussed how to identify and evaluate partners, as well as warning signs to consider. Through a few examples, we've looked at how to structure a development deal and the most common types of milestone-structured processes. We've talked through some of the most important things to consider when signing a contract for a new deal, and, finally, we took a quick look at some of the non-software development teams that play a critical role in shipping games. Next, we'll discuss how to start up the project, establish a shared vision, and divide the workload.

Interview with Sergio Rosas, President and Founder of CGBot

"On Running the First Art Outsourcing Company in Mexico"

FIGURE
4.7

Sergio Rosas is the president and founder of CGBot, a high-quality boutique art outsourcing company located in Monterrey, Mexico. He has more than 14 years of experience as a games artist and art director. He began making games at Origin Systems and has since worked at Human Code, Digital Anvil, Ion Storm, and Midway. Sergio served as art director on the critically acclaimed *Thief: Deadly Shadows* and *Deus EX*, as well as *Area 51: Blacksite*. He can be reached at *sergio@cgbot.com*.

Q: Who are you?

A: I'm Sergio Rosas. I've been working in games for a while now, about 15 years. I run an outsourcing company based in Mexico called CGBot.

Q: Is your company unique in Mexico?

A: It is unique. We're the only outsourcing company in Mexico that I'm aware of. Most art outsourcers are in China, Vietnam, or elsewhere in Asia.

Q: Where are you in Mexico and what makes Mexico uniquely suited for your clients?

A: We're located in Monterrey, Mexico, which is very close, about 2 hours from the border. It's a huge city with a great talent pool from the university there. It's great because it's in the same time zone as many of our clients in the United States. My last name is Rosas, I have a Mexican background, and I speak Spanish. As an art director I was doing tons of outsourcing to China and I thought, I don't speak Chinese; why are we doing this? So I looked into it, decided it was a great opportunity to be different.

Q: How many clients do you typically have at one time, and how do you configure your teams to work with clients who all have different needs?

A: We have a large list of clients, about 30. At any one time we're usually working with 3 or 4 of them.

Q: Your clients range from high-end AAA console products all the way to games for the iPhone. How do you run a studio that builds content for so many different levels of fidelity?

A: This goes back to my experience. When I started making games, the high-end games were about as visually complicated as iPhone games are now. And when I started outsourcing was just when we hit the next-gen wave. So I've got experience that runs the gamut. It's interesting trying to train up a team to be able to work at many different levels. To be really good at iPhone-style games and AAA games takes some planning. What I do is I find guys who I think of as my ninjas. So I find a really great high poly modeler character guy, an amazing texture artist, and these guys are the leads at their specialty. Then we build a team of kind of generic artists who are led by these ninjas. The ninjas train the rest, make sure their quality is high, and clean up after them and teach them.

Q: You mention training. I understand that you are affiliated with the university there in Monterrey. How do you work with the university, what does that do for the community, and what does that do for your team?

A: When we first got to Mexico I started hiring people the way I did in the United States. Show me your portfolio, and if it's good then you get a job. And that worked. I found the best of the best of the best in Mexico. And then that was it. I'd found them all. No more existed, and they weren't coming out of school knowing what I needed them to know. So I had to train them, and that was very costly. I'd hire people who were decent artists and I would spend 6 months training them, and they were useless for that 6 months. So my next approach was to contact the schools there, show them what I needed, and help them design a curriculum and become partners with them. And now we're partners with four really big schools in Mexico. They find the cream of the crop who want to work in the elite of video games in Mexico, and they send them to us. We train them at the school, then they get trained internally with us, and then the best of the best of those guys get job offers.

Q: So are the universities excited about working with you then?

A: They are super excited about working with us. It's a great thing for them when they can show "here's how a student started, and here is the quality they were creating by the end of the program." In certain situations the students are able to work on actual games in a very limited capacity, and for the schools it's very exciting to be able to say that their students get credit on a shipping iPhone game, for example. They can say, "if you come to this school you get real experience shipping real games."

Q: When you have different partners in different parts of the world, how do you work in a nimble way to collaborate with them?

A: We have a team that is a pool of artists. Every one of our artists is trained into a process of how to be a lead if they need to. It's a very open Scrum process, so you show up to a Scrum every day and you are required as part of your career path that as a certain level artist, you have to be able to run a Scrum. So everyone on the staff is trained in the Scrum process. Now, it's not exactly the same traditional Scrum you use to create games. We use a modified version tailored towards building art for games. It's a bit simpler, based on the original Scrum. It's very flexible, agile. So the team is a pool of artists, and in the pool there will be a lead for each project we're working on, and then a lead atop that making sure the whole process is working. Each lead is the ninja for that team, my best people, and is responsible for making sure people are on time, delivering to quality. And they may have almost the entire studio on their project one day and no one the next day, depending on our client's needs. So we're super nimble.

Q: When you work with partners who don't use traditional outsourcing setups, who aren't handing you specs or reference material, how do you work with them? Do you guys provide art direction and vision as well as traditional outsourcing?

A: Because my background is creating video games, I have experience shipping games as an art director. So I've trained my ninjas in how to do that, as well. Many of our clients don't know what they need, so unlike the traditional outsourcers in China or elsewhere, we provide them with a deeper level; we can help them figure out what they need, and they know that we know what's up. And that's really fun when we get to flex those muscles, be more creative, and solve some of those problems. Some of our clients are just programming teams, no artists on staff. And because they've worked with us before they know what we can do. They'll come to us and say, "Hey, we want this to be a cool space game. Can you do it?" And that's all the art direction we get! On the other side of the spectrum, when we work with experienced art directors who need a quality turn-key solution, they'll give us front and side views of every model they need, very precise lists of exactly what they need. Whereas other clients might not even know how many assets will go into a level, they'll just tell us, "make a Temple of Doom level" and we do the rest.

Q: Are there cases where you've worked with teams where the pipeline wasn't understood up front? When people come to you, do they typically have their pipes worked out, or do you work with partners to help develop asset pipelines?

A: Here, too, we get the whole spectrum. Some clients come to us and their whole idea of a pipeline is to e-mail assets back and forth. Other clients have very structured processes and tools.

Q: What is the best way? Do you think distributed development works better when everyone on your team can check their work in the build?

A: The best way it works for us is to get as much integration with the team as possible. We've had teams set us up with a Perforce server where we check in our work directly

every night, and get their build every single night. We see what they see and they see what we see. That probably works the best because we can put stuff straight into the build, see what works, tweak it. A lot of times if you just hand over the assets over the fence, then there may be some number of reasons why things are broken on their side; they may not be seeing what we're seeing at all. So as much integration as you can get is ideal. Sometimes that's a pain in the butt up front, or costly. But I really recommend it, especially for longer term projects. That said, we have clients all over, and some for security reasons don't want us integrated that tightly. So we cater to each individual client.

Q: What other kinds of tools do you use regularly?

We have some tools that we like to use, like communication forums instead of e-mail, for example. Some clients initially prefer e-mail, but imagine that you're doing a project with just 10 assets and feedback on all of them are coming over e-mail; it gets disorganized quickly. So for big projects, you can imagine. And then with e-mail too, there's a filter problem. Who is getting the e-mails? Are they getting them distributed to the team on time? And so on. But with communication forums, you don't have that problem.

Q: What kind do you recommend?

A: We use a highly modified version of a public web forum software with some particularly high security standards. You set up threads, people post pictures of assets or 3D renderings and get the clients to make comments directly into the thread. The entire team can see right away, and the feedback never gets stuck in some producer's e-mail bin. The communication is quick and fluid and remains organized. We find that the more communication we can push to the forum, the better. Sometimes our clients end up posting to the forum something like, "Hey, here's my MSN address. Let's just use that." And while that seems to be a logical, super-cool thing to do, it actually breaks down communication because then there is no record of what was discussed. A really green artist, for example, with a lot of motivation to impress, might end up calling directly and ask the wrong question without realizing that he's asking the wrong question. Or he might get his answer but fail to relate that to the rest of the team. When it's kept on a forum like I'm describing, it has less of a chance of getting lost. And if you've ever worked on a big team, you know that information gets lost. But for an outsourcing team where an artist might be working across several different projects over the course of a week, information getting confused is a real issue.

Q: Are there other tools you use for real-time communication?

A: There are some great tools that we like to use. We set importance on communication tools and technology that help us communicate; we're constantly looking for new software or tools that tighten up communication with our clients.

Q: Are there any particular ones that you recommend right now?

A: There's a tool called LogMeIn which is a free tool that lets you see someone else's desktop or share yours. You can have an instant meeting where you're looking at exactly the

same thing. It's great. There's another tool called Jing.com which essentially takes a video capture of your desktop and gives you a link to it. You can share that link, like a YouTube link, and there's an instant streaming video of whatever you captured. Of course Skype is awesome for instant phone calls and for video conferences that are cheap. This is really useful for discussions where there is a lot of hand waving. You know, there are times when we're working on animated effects for a cloud or something, which unfolds in 3D over time. It's very difficult over a forum to explain that "on frame three I need it to be a little more" But a quick video conference can be all you need for that kind of discussion. So that's very handy. Also, for the producer, it's very handy to have a client on Skype. It's almost like you're in the same room. I do recommend these real-time tools just for the producers, though; communication at every level of the team can be a problem like we discussed. Some folks aren't trained for that kind of real-time communication with a partner.

Q: What are some of the hardest roles to fill when you're running a studio like yours?

A: I think the most difficult is the PM or producer role. There's a certain level of responsibility that is really hard to find. Because there is no industry like this in Mexico, the closest that you can find often is someone who has done web production or television, maybe. A lot of the questions this person needs to be able to ask aren't obvious. Finding someone who can understand the problem and know the right questions to ask is hard.

Q: When you guys do a deal with a partner, how do you cost out your work?

A: Most typically, someone comes to us with a particular piece of work they want done, we work to understand what they want, estimate how long it will take, and give them a rate based on our per diem.

Q: What scares you most as a small business owner making a living in distributed development?

A: Estimating things right. We rely on metrics, measure everything we've ever done, and spend a lot of time looking at how long it takes us to accomplish things. But estimating wrong can be a real problem. Especially when you've got a full set of projects, with all of your man-days accounted for, so you don't have any spare cycles. And with art in particular, sometimes it's hard to tell how long it will take to build a full level that a client will like. And so it's sometimes difficult to deliver on time to the level of quality everyone expects.

Q: When people come back to you with design changes after you've done work, how do you deal with it?

A: When there is a design change we typically accommodate it; there have been very few times that we've had to go back to the client and tell them, "this is a requirements change. It wasn't part of the original deal." We try to be accommodating, but there are times when it's an extreme requirements change, and if that's going to force us to miss a deadline, then we just work to communicate that to the client and let them know that we may not

make the deadline if they insist on the change. But only in really extreme cases do I have to go back and suggest that we renegotiate the deal. We're pretty tight-knit with our clients, so this doesn't happen often. We scratch their backs and they scratch ours.

Q: What do you see as the future of distributed development?

A: I think that it's a really good thing or I wouldn't be doing it. I think that it's the smart way to run teams. I don't think it's about running 200-man sweatshops anymore that crank out mops and buckets for you. I think you're going to start seeing more specialty teams. The team that is really great at high-end characters, or the team that is the best in the world at building cars, or the team that is really great, as we're starting to become, at being the emergency team. I think we're going to start seeing a rise of these smaller specialty teams that are really good at one particular thing. So there may be a place for the really giant outsourcing companies, but I think that specialization is the real benefit of distributed development.

Q: Final thoughts?

A: You know, earlier we talked about crunch, and what a problem that's always been for our industry. And I think that distributed development is the solution. It's a way of making people accountable for what they ask for, and at the same time, it's a great way to not have to grow your team to be huge, then lay off a bunch of people. It lets you find specialists and bring them on when they are needed. So I believe it can be the answer to crunch.

Getting off on the Right Foot

5.1 Making Sure You Have a Shared Vision

An unborn video game is a complicated thing. Much like an unborn child, it will one day have a unique, distinct personality. It will have a look that is immediately recognizable to those who love it. But unlike creating a child, the genesis of a successful game takes a lot more than two people and is a bit more involved than an hour of fun in the bedroom!

For starters, once you've managed to identify all of the prospective "parents" and have secured commitments from all of their important leaders, you all still have to come to terms with exactly how your offspring will look, sound, and function when it is eventually born. Also, without extra care and attention to ensure that everyone involved has a shared vision, you risk shipping a game that no one wants to play.

5.1.1 *How Do You Best Establish a Shared Vision?*

Ideally, you're able to solicit help in establishing your vision from a wide array of team members. This breeds far more buy-in and passion for a project than situations in which one or two designers lock themselves in a room, only to emerge with "the design" for the game. The best games tend to be the result of many impassioned discussions between many different team members – the kinds in which everyone feels like a contributor.

Although the core vision holder for a title can periodically be found in one charismatic or visionary front man around whom a team can rally, such as *Mega-Man*'s Inafune, *Halo*'s Jason Jones, or *Doom*'s Carmack/Romero combination, it is more common that a small and dedicated cadre of designers is responsible. Although there is PR value in the idea of the auteur frontman, because it might

doi: 10.1016/B978-0-240-81271-7.00005-9

appeal to gamers or increase the valuation of a particular studio, relying on a single individual sets a dangerous mentality that only one "great man" can make decisions. We'll talk more about solutions to this type of problem later, but even if you find that there is a single human at the creative center of the game's vision, it is still incredibly important to ensure that the vision is understood and widely shared by several or many influential leaders on the project. There are just too many decisions that flow from having a clear vision to allow one person to bottleneck things.

There are a few helpful guidelines you can use to communicate what your game is supposed to be. You can start with broad genre definitions such as "this is a real-time strategy game" or demographic descriptions such as "this is a casual puzzle game for the elderly." This kind of a beginning is enough to get you started. Ultimately, though, you're going to need to go much farther, even before the game is fully designed. Ideally, you'll have something more evocative to serve as an "elevator pitch," something that can vividly describe your game in one or two sentences.

The best of these elevator pitches will immediately help prospective buyers to have a clear idea of what the game is and is not and how it differs from the competition. The following are examples:

"It's *Independence Day* meets *Grand Theft Auto,* set in Johannesburg where the protagonist grows an alien arm that lets him fire hugely destructive alien weapons!"

"It's a reality TV cooking show party game in which each of four contestants has to pick ingredients, stir them in a pan, and try to sabotage each other by throwing gross things into each other's skillets!"

"It's a street racing game set in the slums of Mumbai, where the vehicles are all cobbled together from parts of other non-racing vehicles, like windsurf boards grafted onto tractors!"

"It's like space invaders on acid!"

Beyond having a pithy phrase or three to help excite prospective buyers and communicate what matters most about the game, everyone involved needs to be able to answer the following questions:

- How does the product differ from major competitors?
- Who is the authoritative voice for how a given feature will work?
- Are there existing examples of features in other products that serve as a template? (For example, "We want a system of escalating danger communicated to the player like the 'wanted' system in *GTA.*")
- What is the core experience around which the game is built?
- What are examples of the game's visual style?
- What kinds of content does the player interact with?
- What happens in an average 30 seconds of gameplay?

Assuming that your team has a core of creative types who are leading up the main design of the product, or that the design is at least clearly understood by some, you'll need to devote plenty of attention to creating materials that can help clearly communicate the design to other members of the team. Especially when using a distributed team whose members cannot easily pop their heads into one another's offices to ask questions or spitball ideas, the amount of energy you may want to spend on these materials could be substantial. Some example materials that are very helpful include the following:

- One- or two-page text documents describing 30 seconds of gameplay

- A mock box for the game that conveys key features and visual style

- Pre-rendered video or animations showing off important gameplay mechanics

- "Ripomatic"-style videos with content pulled from other games and movies demonstrating key features

- "Feature briefs" of approximately 1 page in length that describe and analyze the functionality of the core features and systems

- Screenshot mock-ups that demonstrate important user interface elements

- A creative "razor" statement that encapsulates the core of the game (e.g., "Command your units to conquer the enemy.")

- Storyboard sequences demonstrating key player and NPC actions

- Demonstration of game flow/game structure

- Playable prototypes

Now the problem is that even if you've created all of the preceding materials, and done a great job doing so, you probably still won't have anything close to a shared vision. All you've got is some functional tools that can help you to communicate the core cabal's vision.

Once you've put together all of the preceding material, your next step is to package it into a coherent presentation. I also recommend getting a compressed package together that you can send out to assorted individuals who will work on the project at various stages. Even those who aren't actively involved in creating the game, such as ancillary marketing personnel, licensees, business partners, and individuals porting the game to cell phones, will need an overview of the game; you won't always be able to spare a human resource to meet with them in person. Preparing a 1-page summary of the game, a 3-page overview of major features, and a 30-page PowerPoint presentation will save you time later on and keep all important players on the same page with your vision.

With regard to your core teams, get ready to hit the road to start discussing, presenting, and teaching everyone what your game is all about. There's no substitute for an in-person Q&A at the beginning of a project. Usually you'll want to break this sort of thing up into two or three sessions per group of people; give them time to think about and digest the game in 2-hour chunks rather than locking yourselves

in a room to talk until their eyes glaze over. During this phase, you should also be ready to listen to feedback and to collect the good ideas that might arise when fresh minds start digesting your concept.

If you're working on a large project, there's no way that you alone will be able to communicate the entire game to the entirety of your team. Focus, instead, on doing the following well:

- Make sure that the entire team is enthusiastic about building the game and sees the potential of the top key feature or two.

- Try to create a saturation point in one or two of the local leads at each site so that there is an expert the team can go to with questions – someone who knows at least 80% of the game well.

Make sure people feel free to ask questions and know who to go to in order to get more information when they need it.

You'll notice that this section comes first in a chapter dedicated to how you can get off on the right foot with your team and keep your ideas intact. This isn't accidental. I sincerely believe that good scheduling and great development practices are essential, but nothing is more important than having everyone in your extended development family understand exactly what game they are making.

Interview with Bill Byrne, Professor, Art Institute of Austin

"Setting Project Tone through Visuals"

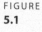

FIGURE
5.1

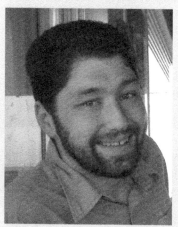

Bill Byrne is a multimedia digital artist and a freelance editor and motion graphics specialist. He is also a professor of digital media design with the Art Institute of Austin. He has worked in television, film, and advertising for clients ranging from Electronic Arts to NBC and Panasonic. Bill can be reached at *wb@billbyrne.net*

Q: Bill, what is your background and what do you do?

A: My name is Bill Byrne. I'm a professor of design and digital animation at the Art Institute of Austin. I'm originally from New York. I studied at the School of Visual Arts, photography and related media. I worked in advertising for a number of years, got involved with games as a freelance motion graphics editor helping teams put together videos to convey what their games were all about, and now I teach at the Art Institute of Austin.

Q: So let's talk about how to establish a shared vision, especially among a bunch of different teams who all need to be focused on creating the same product. Can you tell me what kinds of techniques you've used in the past to help teams reach a shared vision?

A: One of the techniques which I think really helps make or break something like a game is to make sure that everyone involved has the same adjective list for how to describe what they want to build. It can work like a menu of what's called for, in a sense, to help build a checklist. Then, the things that you're identifying as being important have to be the kinds of things that people have an emotional attachment to. So, for example, when working on the piece I built for *Need for Speed* I used a lot of movie clips to build a ripo, which is always effective, because people know what they're seeing and have a strong immediate reaction. Typically when I'm on a project like this, I get a list from a producer or creator of the game of what the most important components are for them. This helps you pare down the key elements that you really need to focus on, and then I like to look at current films and clips that are around right now that people will respond to immediately.

Q: So let's say you were asked to build a ripomatic for a game that was, say, a shooter set in a Waterworld-type environment, where the player could turn into a fish. And you wanted to emphasize fast tactical combat, exploration, and dynamic escapes. How would you approach this?

A: The first thing I would do would be to get hold of all the clips I could find that worked with the setting, since that's such a key part of what you describe. Find every adventure-oriented water or underwater movie. Get *The Abyss*. Get *Waterworld*, that style of movie. I always recommend Google Image searches. Look at sea urchins, at different scenes in *Finding Nemo*, etc., just for a sense for what your color scheme could be. Then look at recent combat games, and other recent hits that tell you what the state of the art direction is. Think about how you can transpose that to this kind of environment and message that you're trying to convey.

And if you're combining a bunch of different sources like this then you need to use graphic techniques that can tie them all together. Interlace, color treatment, vignetteing. Because the main thing that helps these kinds of pieces work is that they are believable as a unified whole. The graphics and text can bookend and help unify a piece.

109

On TV, with commercials, when you have a client who has no budget and needs a new commercial, you can take something existing, or clips from a few existing things, and do a new graphic wrap around it to make it feel like something new and coherent. And with the availability of graphic software now you can make this kind of thing work really well.

Q: That sounds good if you're starting on a ripomatic. But once you've got a style identified, color palette figured out, a collection of clips that have the right kind of action, and so on, how do you pick music that will help set off the action and help convey the central tenets of the vision? Is that important?

A: I actually need music to cut to from the start. Sometimes I can put something together in *Soundtrack* or *Garage Band* so I can have placeholder in there. Music gives you structure for the edit, and I like to have beats to cut to. As far as matching the right music for the piece, most of the time the client involved will have an opinion. You should always start with the client version first. If they don't have something in mind, then put something in that will just sit there, like a little bed, until you come up with the perfect choice for the song. Again, I like to use something that is in the public conscience, something people have a direct attachment to. If you're using something older, it needs to have an immediate association for the audience. So, for example, in the ripo for the *Need for Speed* piece, we started with Motley Crüe's "Kickstart My Heart" because immediately it got you in exactly the right mood. Starting with the right music says so much and immediately tells you what kind of imagery to associate.

Q: What is the role of motion graphics or titling to help facilitate vision in a video piece? What roles do typography and logos play?

A: The ripomatic, or any other video, works best if it looks and feels like the real thing. So when I worked in advertising, we would use all of the logos that made a piece feel like an actual television commercial, even when it was just being used internally. We wanted it to look as real as possible. When you're doing a ripo piece for a game, you're usually trying to make it feel like a movie trailer. And you want to use graphics, logos, or type treatments that improve the brand. The package is so much of how people judge a product, so you want to pay attention to the way the text looks and how the whole thing feels.

Q: When you think about using a ripomatic to help communicate vision to teams that are highly distributed, maybe in India, China, Europe, and the United States, so that they may not have a shared mental picture from a particular song or film, how would you approach it?

A: Definitely that makes it tougher, but what matters is that they get the big picture, even if all the nuance doesn't comes across. I can't imagine that you'd have to explain the appeal of car crashes to anyone.

Q: What about other types of pieces, non-ripomatics? What are other approaches?

A: I've also worked on many animatics, which is a very *Crusader Rabbit*-style of minimal animation. I did a project a long time ago for, I think it was a candy for kids. An animatic is mostly a storyboard with basic movement.

Also, you can do a spec spot. What you do there is find a product that's out there and a style that you like. Then do a cheap digital video production and work to match the elements of that style that matter to you. It's a little mini-shoot that you use to get shots that your ripo might be missing, or in place of a ripo. Get a cheap camera and make something that looks like what you need. You can't do this all the time. You need to keep cost down. If it's something that requires ten thousand extras then, no, you can't do this. But some ideas lend themselves well to a quick live action sequence.

Q: What do you think the distributed games business can learn from the advertising business and other mainstream medias about how to establish and promote shared vision for product development teams?

A: Games are becoming bigger and bigger productions. More elaborate scenes, live actors sometimes, and as the productions become more complex, gaming needs to borrow techniques that worked from Hollywood, on TV, and in commercials. That's the kind of process the games business needs to scale up their productions.

Q: As an educator, and helping to set curriculum, can you tell me a bit about how places like the Art Institute help train your students to work in distributed game development and how you train them to help communicate product vision to the people on their teams?

A: We do everything we can to re-create projects for the students which are very practical and real world. The projects that I get hired to do are the same kinds of things that we translate into our lessons. Later on, as the students get more advanced with graphic design, we bring in outside people to comment on the work, so students learn what it's really like out there. If you keep things too theoretical, too academic, it just isn't appropriate for teaching artists the skills they need for the real-world job market.

Q: What advice do you have for game producers out there who are trying to help several different teams all have a shared vision for a game they all need to work together to build?

A: Find common ground that brings everyone to the same starting point. Use the pieces like we've talked about, which provoke a clear emotional reaction, and make sure it's the right reaction.

5.2 Defining Project Parameters: Scheduling Goals, Techniques, and Milestones

5.2.1 *Types of Scheduling*

There may be a hundred different formal scheduling methodologies for managing the creation of software. However, currently in game development, there are really only three major families: waterfall, Scrum, and agile. In fact, this trio is a trick because it's becoming rare to see a project or team that still uses a top-down, waterfall-style of scheduling for game development and production.

What are these three models? There literally have been thousands of books written on each of them, and we've neither the space nor probably the interest to go into much detail on any. Here's what's really important for you to know when thinking about how to go about scheduling a modern game using distributed development.

Waterfall scheduling, or the "top-down" style of scheduling, is the sort that relied on *Microsoft Project* to turn project managers' lives into an inefficient hell on earth throughout the early 1990s. It's a type of scheduling that might work beautifully for constructing a building or a bridge, a known project created out of known materials, using a design that's been tested hundreds of times. In other words, this type of scheduling, where a central planning resource (project manager) dictates a giant schedule for the entire project based on a bunch of known quantities, is fine for projects that are inherently not R&D heavy. That disqualifies almost all of the games that have ever been made. Typically, only the highest level goals should be scheduled in this way. (For example, "We need to ship on this date, which means we need to be beta 8 weeks beforehand.")

As a result of this method's ineffectiveness, teams moved to lighter, more agile forms of development, in which the people doing the development work are heavily consulted and in which major goals are kept in mind. The smaller goals and monthly tasks are allowed to evolve and adapt to the changing needs of the project, as new information comes to light. Work items bubble up from the people doing the developing rather than being pushed from the top down. This is most commonly called "agile development" – so named because as a system, it isn't afraid of regular course corrections.

The third common type of scheduling used for games is Scrum. Think of this system as a formalized type of agile development based on 2-week "sprints." There's a formalized leader, usually called the "Scrum master," who leads very short daily meetings that are typically centered on a whiteboard or a wall, along with a collection of Post-it notes. The team quickly goes over what they expected to complete the day before, what work is outstanding, and any new blockers that have arisen. It's quite similar to unnamed agile forms of development but with a few more formalized details.

If you're unsure about these topics, I recommend reading a good book on the matter. My favorite is *Agile Project Management with Scrum* by Ken Schwaber. This detailed volume from the venerable Microsoft Press gives a good generalized overview of both formal Scrum and more agile forms of development.

I strongly recommend that your project use a form of agile development that is driven from the ground up by small and functional workgroups that report progress to local leaders. For a large distributed development project, there should likely be 10 or more workgroups with their own agile/Scrum system for tracking progress. Resist the urge to mandate internally a particular model down through to the individual group levels. Let each group retain a level of autonomy that will foster ownership and problem-solving skills. Let the subleads or Scrum masters work with the production (producer, project manager, or development director) for each team to discuss their progress and the details of their schedule.

If a particular group is consistently missing their schedule and failing to deliver the wins they committed to, then it might be time to drill down to determine where the process is breaking down. Even then, though, the best managers use local subleadership. You can't possibly manage each subgroup from the top, and you don't want to castrate local leadership (unless things are going seriously wrong).

As a final word, I warn briefly against a certain brand of "process"-obsessed zealotry that has become too common in the past few years among the mid-management layer of game development houses. Specifically, many folks who have been burned by how difficult it can be sometimes to ship good games, or people who have had their fingers slammed in the car door of shipping one too many times, have developed a religious love of one particular subsect of the project scheduling techniques described previously, from Scrum to "lean" to whatever the process panacea du jour may be. When you work with folks like this, try to find a way to channel their very well-meaning desire to impose a particular process on a team into a positive instead of a negative, and work with them to understand that it may be possible to pull the best parts of whatever process they are in love with into whatever technique the team as a whole, or their section of it, is using. Get these people involved in setting process, but counter them with the very pragmatic who can keep the ship steered in the right direction rather than having all the sailors distracted by resetting the rigging every time a new process fad comes along. Don't let slavish adherence to a particular process get in the way of your team's effective operation.

5.2.2 *How to Structure Milestones*

In Chapter 1, we discussed how project milestones flow from one to the next, when to get QA involved, how to deal with milestone integrations, and other mechanics of how to execute smoothly on a milestone process. But how do you know what

each milestone should consist of? When should certain features come online? How long is each milestone period? How do we plan out milestones in advance and still retain a sense of agility in our development?

If you're in charge of the entire distributed development project, how do you decide which teams share milestone dates? Does the same person approve or track milestone tasks across all teams? What role does local leadership play in defining milestone goals and tasks?

If you're a developer working with a publisher under an arrangement in which you only get paid for each successful milestone completion, then you've got an additional set of concerns because a milestone that fails might mean you're forced to miss payroll. Frequently, deciding if a milestone task was completed successfully, if it "passes" or "fails," can be subjective; it's quite easy for a simple disagreement or misunderstanding to blossom into a full-blown problem.

Let's take a look at several ways to answer some of the previously mentioned questions and how to avoid or resolve milestone "failure" problems.

First, how do I plan a high-level milestone task list? The first time you should be considering global milestone planning is during the early part of your preproduction phase. Since you now know what your game needs to be, after successful completion of your concept exploration phase, you can start penciling in key features and experiences that need to be included. Your initial milestone planning documents should be high level, and you should plan on their being fluid. After all, your teams are still doing much exploration with regard to how they'll accomplish certain tasks. You want to make sure your planning accounts for the changes that are sure to arise.

Don't forget that it's also quite reasonable to have milestone tasks that involve scheduling time for further exploration. For example, a task for one of your later pre-production milestones might be "Evaluate new destructible objects system, and determine costs to integrate off-the-shelf solutions vs. rolling our own." Then, once the portion of your team (or the individual) that is investigating this task comes up with a conclusion, you can assign the actual implementation tasks to a later milestone.

As discussed previously, these sorts of definitions can be problematic as part of a contract, but they are very useful when planning the project internally.

At this early phase, when thinking about your rough milestone layout and key tasks, it's sufficient to think in broad strokes. If you know your intended ship window, then you can work backward from there to create some large "buckets" in which to put major tasks. Focus on 6-week milestones, with a buffer around major holidays.

For example, let's say that it's September 2009. We're creating a postapocalyptic shooter RPG with a 12-month development cycle, launching on five platforms, set to release the following Christmas. (A daunting task!) We already have an existing shooter engine that runs on the PC and Xbox 360 (not the PS3).

The engine will require heavy modifications in the graphics department because our shooter is set in a *Waterworld* type of environment made up of floating platforms. We plan to deliver 12 hours of focused, single-player gameplay and a random encounter system that allows for another 30 hours of exploration and "grind." We aren't focused extensively on multiplayer but will offer two free-to-play MP modes for Xbox Live and the PS3. We also intend to offer two downloadable content packs within 8 months of launch to keep players excited about our title.

First, let's think about our large buckets:

October 30, 2009 (M1)

December 15, 2009 (M2)

January 30, 2010 (M3)

March 15, 2010 (M4)

May 1, 2010 (M5)

June 15, 2010 (M6)

August 1, 2010 (M7)

September 15, 2010 (M8)

These are approximately 6 weeks apart, and that's good enough for now. When we know more, we can determine exact dates, schedule around weekends, and so on. We have eight total milestones, plus a little time for certification and finaling at the end. (Scared yet?)

Let's assume that we believe that we can safely remain in pre-production until the new year and plan to hit the ground running after that. Let's add a few knowns to our list:

October 30, 2009 (M1) Pre-pro

December 15, 2009 (M2) Pre-pro

January 30, 2010 (M3) Production

March 15, 2010 (M4) Production

May 1, 2010 (M5) Production

June 15, 2010 (M6) Alpha

August 1, 2010 (M7) Beta

September 15, 2010 (M8) Final

What else do we *know* we'll need? Well, we've talked about the importance of a "first playable" or "vertical slice." We know we'll need to see some visual targets for what the final product will look like. At some point, we'll need to

have our multiplayer game modes up and running. An example of a crafted event sequence (of the type that makes up our 12 hours of main gameplay) will need to be demonstrated so we know our tools can do everything we want. Also, we have to prove out this idea of a "random encounter system" that we believe will demonstrate our 30 hours of exploration and "grind." Let's grid this out and pencil those in; see Figs. 5.2 and 5.3.

Now we've got a good look at what our first six milestones look like, or at least at some of the major components that fit into them. We can notice immediately that the Engine/Tools category is criminally light. This means it is time to work

FIGURE
5.2

	(M1)	(M2)	(M3)
Phase	Pre-pro	Pre-pro	Production
			1st look random
Single Play		1st Playable	Encounters
Visuals	VTAR pre-rendered		VTAR in game
Engine /	Scripting tools		
Tools	understood		
		Design specs	
Design	Feature briefs complete	complete	
Multiplay			MP 1st look

Milestones 1–3

FIGURE
5.3

	(M4)	(M5)	(M6)
Phase	Production	Production	Alpha
Single Play			
Visuals			All visuals shippable
Engine /			
Tools			
Design			
Multiplay	1st MP game mode		2nd MP game mode

Milestones 4–6

with our technical directors to determine what features are going to constitute the heavy-lifting tasks.

We can also notice that we are front loaded, with much more clarity (even at this rough stage) surrounding the next few months than later in the project. It's noteworthy, too, that audio and other major game areas aren't listed yet. Our next revision should include these details. This example is quite appropriate for a first look, but after this initial draft we should work with our leads to get more detail in the major work areas. As we're doing that, we should also try to develop a theme that captures the essence of what we're trying to see in each milestone.

To do so, we'll need to talk to our audio director and have our technical director look through the sound libraries and features that the engine already supports. After doing so, let's say that we learn we can play a soundtrack from disc easily enough, and we also have some dynamic scores for key game moments. The publisher tells us that it's got a large collection of licensed music and sound effects that we can use, royalty free. Let's add an audio column to our milestone chart and capture a few of these details, as shown in Fig. 5.4.

FIGURE
5.4

	(M1)	(M2)	(M3)
Audio	Eval. music & sfx libs	Audio target 1st look	1 dynamic event scored

Audio in Milestones 1–3

Similar additional discussions will expand both our milestone plans and our overall understanding of the project. As a result, this sort of early milestone planning is best done over a few days and constantly refined over a few weeks. It requires input from most of your senior people, and much of it is based on best guesses.

One of the inherent difficulties with milestone planning at this point in the project is that you don't yet necessarily know what the "special sauce" that makes this game great will be. In our previous description, we covered genre, setting, game modes, and so on, but we did not discuss the key features that make this game stand out from the crowd. Can the player transform into a fish instantly and swim away from danger? Is there a cover mechanic that has not been seen before? Are piloted vehicles going to play a major role? Is the hero psychic, with a repertoire of ever-expanding powers? Is the game narrative doled out by having the player play through the game as a sequence of different characters? Now, maybe your game doesn't have a gimmick such as these that it will need to hang its hat on, but odds are that there is some key experience you intend to form the basis of your marketing message, your commercials, for reviewers, etc. It's equally likely that at this early phase, you've not proven out through prototypes exactly how this feature or device will work. That's okay, but you should create a category for that special feature (or

features, if there are several) and begin planning how they will be proven out, how they will evolve, and what happens if the prototype proves unbuildable. Since it's a safe bet that you don't want to have a first playable without this "secret sauce" in it, the earlier you get started, the better. (We'll use Fish Mode as our example because it's a fun feature to imagine.)

Our milestone overview can now begin to look more detailed, as shown in Fig. 5.5.

FIGURE
5.5

	(M1)	(M2)	(M3)
Phase	Pre-pro	Pre-pro	Production
			1st look random
Single Play	1st playable 1st look	1st Playable	Encounters
Visuals	VTAR pre-rendered		VTAR in game
Engine /	Scripting tools		
Tools	understood	1st playable support	Water rendering tech
		Design specs	
Design	Feature briefs complete	complete	
Multiplay		MP prototyping	MP 1st look
Audio	Eval. music & sfx libs	Audio target 1st look	1 dynamic event scored
	Main character design	Main char. +1	
Characters	rev.	opponent	
			Random encounter
Worlds	Environment concepts	1st playable area	sandbox
			FE flow & features
Front End		FE style mockups	detailed
Extensibility		Evaluate architecture	
Fish Mode	Prototyped & playtested	Integrated into 1st P	
Theme	Kickoff pre-pro	1st playable	Kickoff production

More Detail in Milestones

Now we have a decent introductory picture of what our first three milestones look like. We know that the major push in the first 2 months is to get a first playable version up and running so that we can make an informed decision about "greenlighting" a move into production. Of course, part of that means getting the core game mechanics necessary for moving around the world sorted out, getting the camera to behave in a way that approximates what we want to ship with, showing a first look at an environment that at least tries to capture the glory we're imagining, putting in enough sound effects to add impact to the gameplay, and conveying any critical user feedback that we expect audio to provide. Our audio team will also need to get a representative basic audio score playing to help communicate the game's emotional tone.

In short, in these first two milestones, you'll need to push to get a quasi-polished playable version of your game up and running so that all the decision makers in your food chain can make the most informed decisions possible about the project as it moves forward. Because our example case is based on a brutally short development cycle, we're going to compress what you might ordinarily want to spend 6 months on into approximately 18 weeks; see Fig. 5.6.

Your understanding of the later milestones will necessarily get a bit fuzzier the farther out you go, but it's still helpful to have some rudimentary road map of where you'll need to be, based on rough deadlines. If nothing else, this mapping will help constrain the team's design ambitions to something close to a realistic scope.

Obviously, "constraining design ambitions" will be unpalatable to purists, but totally unfettered designers can't possibly result in anything but a stillborn mess. In real life, your publisher has economic deadlines. You must actually ship this game at some time if you're going to get paid. For products with ambitions of grandeur, fantastic! You may (it is hoped) have considerably more time than our hypothetical 1-year shooter, so you can be more ambitious. However, I suggest that it is always valuable to think about the project as a whole and keep in mind that you will ultimately have to polish, debug, and ship (or cut) everything that you set out to build.

5.2.3 Dealing with Multiple Platforms Simultaneously

But wait! What does any of this have to do with distributed development? Isn't this just a generalized discussion of how to perform early milestone planning?

Thus far, we've been concerned with thinking about the project as a whole and not with ways to break up the team. We've also remained largely platform agnostic. Why? Thus far, we've concerned ourselves with tasks and major goals that we need to accomplish no matter how our team is divided and regardless of the platform. In a sense, the previous milestone plan could work for almost any version of the game, from a handheld (perhaps minus the multiplay and the extensibility) to a PS3.

FIGURE
5.6

	(M4)	(M5)	(M6)
Phase	Production	Production	Alpha
Single Play		E3 Demo from 1st play	
Visuals	Visual polish		All visuals functional
Engine / Tools	Runs off disc		Feature complete
Design	50% of scripting functional		All key events in play
Multiplay	1st MP game mode	Polished 1st MP mode	2nd MP game mode
Audio		50% events tagged	
Characters	1 shippable character		All characters in game
Worlds	1 shippable environment	All areas playable	
Front End	Skeleton FE in place	FE skinned	Loc & Cert passes on FE
Extensibility	Implement DLC support		Spinoff DLC design team
Fish Mode	Ability upgrades functional	Fish mode demo polish	
Theme	Running on target HW	Consumer Demo	Feature Complete

Adding Still More Detail

Now we must progress to a level of granularity that will force us to start thinking about platform specifics and team organization in detail. I suggest starting with team organization. What good decisions can we make about how to divide this work?

Let's say we've got an internal staff of 35, including all developers, artists, a QA manager, a designer or two, and you. We know that PS3 and Xbox 360 are our two lead platforms, and we believe that we can help leverage the marketing

and development spend by extending our offering to the Wii, the PC, and the PSP as well. We've considered and discarded the idea of doing a Nintendo DS version due to the content and subject matter and also due to how poorly shooters fare on that particular platform. As a result, an ideal team organization starts to form immediately.

The PSP is too dissimilar to really re-use much more than the core design concepts and some of the branding elements. It's also too large to handle internally. Thus, our next step is to find a development house with expertise in shipping a shooter on this platform. How? Start by looking for top Metacritic-rated shooters on the PSP. Contact developers you know and ask them about their experience level. Also, see Chapter 4 on how to find development teams.

Multiplayer is the next obvious chunk of your game to consider. The expertise required to create great crafted content is quite different from that required to build addictive multiplayer game modes. Moreover, due to the way game flow and the front end are typically structured, it's an easy place to segregate much of your code and content. You can often have multiplayer and the campaign evolving in different directions for a while and still integrate them back together with relative ease. Let's set aside our PS3 and Xbox 360 multiplayer modes for consideration as a possible externally developed section of the game. (Even if we end up wanting to build the game modes using internal resources, it may still make sense to externally develop the multiplayer maps, for example.)

How about the extensibility for this product? Since it doesn't begin until later, but we know now that we want to get it spun up before the project is complete, it might make sense to employ a group that will be dedicated to creating our downloadable content.

Finally, what to do about the PC and the Wii? Although dissimilar in many ways, they share a unique problem set: Both require us to tune gameplay to a different interface model (keyboard and mouse and the Wiimote, respectively). Beyond just needing to tune these differently, there are front end navigation and information layout differences for these two platforms that we'll need to consider. Both have a large range of peripherals we may also want to support beyond the standard interface models of the PS3 and Xbox 360. Finally, these two platforms can't easily share an online multiplayer feature set with the lead consoles. Let's look quickly at the most obvious of these differences to see if we can find common ground that could be grouped (Fig. 5.7).

As can be seen from Fig. 5.6, any similarities seem to extend only insofar as both platforms stand out from the similarities between the Xbox 360 and PS3. Although the problems the PC and the Wii have are similar in category, the solutions aren't readily shared between the two platforms. Worse, a midrange to high-end PC can handle the same 3D assets (models, textures, number of bones per character, etc.) that the HD consoles can handle. A Wii can't come close. All the assets will have to be carefully downrezed or built with an extra Wii-centric LOD in mind. As a result, there's little hope of having the same group work on these two platforms. However, we can isolate the list and move both sets out to various contractors (Fig. 5.8).

FIGURE
5.7

	PC	Wii
Interface	Mouse & keyboard User-definable keysets	Wiimote
Peripherals	Specialty gaming mice USD joysticks & gamepads	Classic controller Gamecube controller Wiimote + Nunchuck
Front End	Mouse driven Unique MP FE Unique options screens User-definable keysets Server/host options? High-max resolutions	Pointer-driven FE? Need big buttons Low resolution = less info per screen
Multiplayer	MP matchmaking Anti-cheating critical Metagame/achievements? Different lag tolerances? Network configuration options	MP lobby & matchmaking? Same game modes? Same couch modes?

Platform Similarities

What does our problem set look like now? Let's take a look!

- The PS3 and Xbox 360 clearly need to be kept in lockstep. The PC gameplay and almost all assets need to be the same as well.

- The PSP becomes its own project with an initial milestone bucket list derived from the main platforms. We've found a veteran handheld team for this one.

- The PC interface and unique multiplayer problems get farmed out to a small, four-man team of engineers with PC expertise. No design or artwork here that the core team can't resolve.

FIGURE
5.8

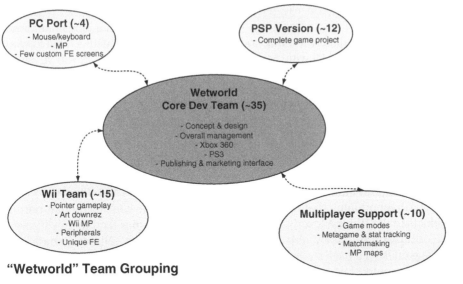

"Wetworld" Team Grouping

Team Assignments and Rough Staffing

- The Wii needs a dedicated group of artists to downrez the assets, an FE design and art team, and an engineering group to handle the core changes to gameplay resulting from the pointer as well as unique MP characteristics.

- With only 35 total staff on our core development team, we'll probably need to consider an external art house to support our efforts on characters and environments once we enter our highly compressed production phase.

But wait! We're not quite done. Now we need to understand exactly when each of these groups needs to get engaged and how their high-level milestone schedules differ from the topline schedule we looked at previously. Since we don't want to bury our core team or our QA staff by having milestone deliverables from all subgroups due at the exact same time, we're going to want to stagger our milestones slightly between our four top-level functional groups listed previously.

What do we know about our start dates?

- Our PC group doesn't need to get cranking until there's a piece of software to port. It seems premature to get them spun up until February or March. (Give them a month to get familiar with the code base and the problem set, and they should still be able to get the PC version ready for alpha. Start too early and you create a lot of work with needless integrations.)

- Our PSP team needs to hit the ground running, ASAP. They are building a complete game, which can really only borrow its high concept, some "skinning" elements, and the audio from the other versions of the product. The handheld play characteristics, interface mechanics, engine requirements, etc. are all wholly unique among these versions. (They need not be unique among PSP games, just unique compared to our other platforms.) Even the work of proving out the core features (e.g., our

delightfully misguided conceit, "Fish Mode") may work quite differently on this platform. Get these folks started as soon as possible. They've got a long road ahead. Get started by immediately locating and beginning negotiations with a team to work on this version. Get an LOI with a signing payment in place as soon as you've agreed to the broad terms of the deal so they can begin development even if it takes a while to get the final contracts for the full product sorted out. Use sectioned amendments heavily in order to allow the PSP team's planning group to adjust milestone dates based on the particular characteristics of their unique product.

- Unfortunately, our situation with the Wii is likely to end up closer to the PSP product in its divergence than it is to the PC. But we can fight to avoid that, so let's try to keep it in line. Get a Wii team together to focus on controls and interface early on, but make a commitment to start from the PS3 and Xbox 360 assets. (It's worth mentioning that many folks are coming to the conclusion that porting products to the Wii is a loser's game. Only Wii-native games tend to do very well. The observant will likely also notice that only "first-party" Nintendo-built Wii-native games really sell in high numbers. At least this is the case so far. A savvy producer would start asking some hard questions about what the company's goals are in creating a Wii version and then work hard to make sure that the ROI will be worth the time before charging headlong into development.)

- Our multiplayer team needs enough core gameplay in place to start work; they probably don't need to get engaged until our second milestone and likely won't be really cranking until after the new year. Once they get going, they can likely operate with relative autonomy, taking occasional drops from the mainline team and content drops from the content teams.

An initial ramp-up plan for each team might look like Fig. 5.9.

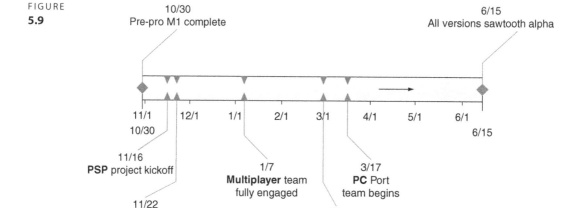

FIGURE
5.9

Simple Team Start Schedule

Note that these dates are all approximate, and that "fully engaged" suggests that you'll want to have started the teams slightly earlier – just not necessarily running with all hands on deck until the date listed. There's a lot of value in having one or two technically proficient experts on each team getting started 2 or 3 weeks before the rest. They can get the development environment set up properly; work through the kinks with data transfers, building, tool version mismatches; and so on. These are the sorts of early-stage process problems that are seldom solved by the addition of more people, and they can easily end up forcing a full team to lose lots of productivity. So send a few scouts ahead in the weeks before you intend the full team to start. They can clear the path for the rest of the platoon.

5.2.4 Devising Collaborative Schedules: Scheduling from the Ground Up

Thus far, we've concerned ourselves with the initial, high-level scheduling, the kind that looks an awful lot like the despised "top-down" methodology that ruined so many projects in the 1990s. But there's a key difference. Although it is true that a core cabal in the heart of the team have devised the schedules we looked at so far, hopefully with input from all key stakeholders, we haven't looked at detailed schedules for any particular work. For example, although we may have dictated that "50% of the game content needs to be playable" at a specified time, we've not actually determined what that content is or presumed to dictate how long it will take to create any given piece. That's the province of the team, from the ground up. It's this kind of ground-up scheduling that will let you know how much you really can create inside the time frame to which you know you must adhere as a matter of production necessity. Our next step, then, is to work closely with the folks in the trenches to answer the last and most important of our pre-production questions: "What can we actually build in the time we have?"

You'll need to do this planning hand-in-hand with creating your first playable/vertical slice. Why? Because the only way for people to really know how long it will take to do something is to do it at least once. When estimating a task they've never done before, the almost universal tendency is to underestimate the amount of time required to do a thorough job. Perhaps people are inherently optimistic. Maybe they're just so excited about the project that they want to get as many cool features in as possible. Maybe they don't take Murphy's law into account. Possibly they just don't want to disappoint their leads, project managers, or publisher. For whatever reason, it's a rare person who can accurately estimate how long it will take to execute a new task.

Annualized sequels or other types of products that are thoroughly understood may provide their own shortcuts to this process but only if almost nothing about the team, tools, process, or design for the final product has changed since the previous iteration. In real life, this is almost never the case.

The best way to begin is by having your team jot down informal time sheets for how they spend their days. There's probably no need to get more granular than once per day, and there is little need to note more than a single sentence entry. "Debugged bone exporter" or "modeled and textured gas pumps" should be sufficient. This makes it easy for those who are responsible for the schedules to go back and look at how much time various tasks really took. By the time you've got a polished vertical slice or single level of the game up and showable, you'll have a good sense for how long it takes to create content and implement and debug features.

There are two things to be cautious of here. The first is that you don't want the time sheets to end up looking like a draconian exercise in job justification. Although this might seem like a silly fear, anyone who has ever worked with a team, especially those in distributed development roles, will understand how strong the tendency is to see wicked motives behind "The Man." Consider yourself forewarned. Don't make this an exercise in filling out your "TPS report," so derided by the hapless characters in *Office Space*. One good way to minimize this danger is by rigorously keeping to the chain of command with regard to gathering scheduling information. Have local leads generate and sort information from their teams on how long it takes to execute on particular tasks. You're also more likely to get good information this way. People invariably fudge things a bit when reporting information to anyone more than one or two levels removed from their day-to-day operations, either underestimating out of a desire to whitewash what they perceive as bad news or padding out of fear of being held to too difficult a schedule.

The second thing to be aware of is the tendency to want to shave time off the cost of scheduled tasks because "they'll get faster the second or third time around." It's true. Things will get faster as your tools get better, your pipelines get streamlined, your team gets more experienced, and the amount of design churn is reduced. However, there are many other factors that increase the time costs, from the need to localize assets to all of the reworking of UI required for certification guidelines, sickness, holidays, team resignations, and so on. It's foolish to factor in too much of a per-task experience savings. The time gets eaten up elsewhere, and conditions are never perfect. They're always just as messy as they were when you were doing that first level for pre-production, but in different ways. So strive for efficiency, seek it ruthlessly where you can, but don't build schedules that require it.

5.2.5 *What Does Good Look Like?*

There are many different reasons why publishers publish certain games. The most obvious reason is to launch a hit title, sell millions of copies, and make a lot of money for their shareholders. But sometimes there are other reasons, or the strategy in place to accomplish the former can be more complicated than might seem obvious at first.

For example, sometimes a publisher needs an entry into a particular market to put pressure on a competitor. Although a publisher is not going to be disappointed if the game is phenomenal and sells millions, high sales may not be the primary goal. The goal might be to match a feature set with a competitor to keep that

competitor pouring resources into that particular genre, allowing the publisher to continue to dominate a different genre unchecked.

Perhaps the goal is to raise the portfolio's overall Metacritic. Although many of the top-selling games are very highly Metacritic rated, many are not. Also, there are plenty of very high-quality products that do not sell very well because of their genre. However, they can elevate a publisher's average Metacritic score. (Think of it like a theater that puts on an obscure Shakespearean drama once a season but otherwise sticks to *A Midsummer Night's Dream* and other known crowd pleasers. They know their version of *Titus Andronicus* isn't going to pack the seats like the shorter romantic comedies, but it's important to maintain some semblance of being serious artistes, if only to attract top-talent actors and actresses.)

If the publisher is also one of the big three first-party console manufacturers, then it may have yet another goal. It may be that it is trying to increase sales of its console, or that it is trying to make its console more appealing to a certain niche demographic. (Think *Viva Piñata* or *Blue Dragon* on the Xbox 360 or *Madworld* on the Wii as examples.)

For franchises that have been in play for a number of years, it may be that the franchise needs to go into "maintenance mode," where the goal is to keep the number of units from declining too precipitously, or to delay the onset of franchise fatigue long enough to build up a new IP that can supplant the dinosaur product in that sector of the market.

Perhaps the goal is to build this game on the cheap. Maybe it's a licensed product based on a movie and you are contractually obligated to have the game on store shelves on a particular weekend, no matter what. Maybe it's a new IP project, where quality is the ultimate goal, regardless of how long it takes. Maybe it's a technology showpiece, tied to a particular new hardware peripheral. Maybe it's a hype product that is never intended to go to market but is instead designed to make your company a more likely target for acquisition. Maybe the game's primary goal is to help test and improve a commercial engine and toolset.

The point is not to list all the possible motivating factors behind developing a piece of software. The point is that you absolutely need to recognize what the driving goals are behind the game you're making. There is no need to get paranoid and see CIA-style plots behind every closed conference room door, but be aware of what matters most for your project.

What does success look like for this game? If you understand this question, then you'll be much better armed when it comes time to make difficult trade-offs, and you'll be better able to apply your distributed resources effectively.

5.3 Kickoff Meetings

As we saw in our Wetworld example discussed previously, when you've got several different teams spinning up at different times, you need to establish a shared vision so infectious that everyone onboard catches the fever and is ready to make a great game. Also, since you've already made it through the concept discovery phase, all

those great materials, videos, mock boxes, and all the rest are ready for you to use. They've been proven to excite sample customers and your own executive group. Now it's time to plan how to get your distributed partners onboard. That's where kickoff meetings come in; you've got to get your "thought leaders" together and turn them into disciples for your vision. Now that you know what to do, the next logical question is when?

5.3.1 *When You First Discuss the Possibility of Working Together*

Ideally, the very first time you visit seriously with a team or company leader, you'll have some idea of what game you're about to build. But this isn't the time for any sort of full disclosure. Retain a little mystery, if only because you're not yet sure if you're going to collaborate or end up as competitors. Besides, this preliminary meeting should be well before you have many of the essential details hammered out. The point is to feel out your prospective partners' capacity, interest, complementary skills, relative pricing, and so on. This first visit is more about laying the groundwork for the deal and trying to determine if you'll be likely to make sweet music together than it is about deep diving into the project design. Even if you are incredibly excited about the game you're going to make – and you should be – this still might not be the best time to pull out all the design documents and launch into an explanation of the advancement system.

5.3.2 *When You Hammer out the Terms*

You'll need to go into much more detail when it's time to really determine contractual specifics, if only because all parties need to understand clearly the work required and who is responsible for what. Ideally, there's been enough enthusiasm communicated and enough project detail developed that all of the principals involved believe in the game they're going to be a part of building. But this still isn't a proper kickoff meeting. These discussions will still be tied up in costs and schedules, and they will be too bathed in the promise of the golden gleam of profits to be deeply game-focused. In any case, it's quite likely that those doing the principal negotiation here are involved in multiple projects and are not the folks who will be down in the trenches. Thus, although the "deal heat" can get warm here, it's probably not from the game itself.

5.3.3 *When the Project Is a Go and the Contract Is Signed*

Here's your first chance to really delve into the exciting, high-level details covering the promise of the game. Once everyone has a signed contract in place, make sure that you expand the circle of your discussion to include all key leads. Get together in person,

ideally on-site at the publisher or core developer's headquarters. What matters here when selecting a physical location is that it be one that is as inspiring as possible; it should be a place that conjures to mind the glory and pride associated with past hits and communicates attention to detail and the fruits of a job done well. At this point, you want everyone focused on what a high-quality piece of work this needs to be and deriving excitement from thinking about how the greatness of this game will help add to their own personal greatness. If you work for one of the major publishers, have this first kickoff meeting at your company headquarters, if possible. If you run a small development house, find the most inspiring room in the office – the one with the posters for the game that was your first bucket of money. Move the statue of your main character from your last E3 into the room, and do whatever else it takes. The point is to choose a physical setting that practically cheers with the fanfare of past success and the promise of the future success this new game is going to bring.

During this discussion, plan on spending 3 hours or more going over the game. You should review all of the helpful concept materials you have and play the first playable or prototype in whatever state it is currently. You're fully "opening the kimono" on the state of development here. You're asking all of the key leads to participate by understanding the current state of the game, digesting as many of the plans and ideas as possible, and offering their own input on how to address current or pending problems. Break your meeting up as needed to keep people from getting fatigued, but keep at it until you've covered every salient area of the product and of the development plan as it stands.

Note that you don't want to sequester parts of the discussion that may not have immediate impact on this particular team. In our Wetworld case, for example, I'd encourage you to have the Wii team try to at least understand the core shape of the PSP product. Even if they never need to know it, this process helps people understand the scope and breadth of the product launch plans and of their publisher's ambition for the game. In addition, you never know when an idea from one version will find fertile soil elsewhere or when some asset type can end up being shared. These synergies may not always be immediately apparent to any one individual. Having people understand what different parts of the organization are working on can bear unexpected fruit.

Finally, you've gone to much effort and expense to gather the key players together. All the substantive matters you discuss are critical, but equally critical is using this time as a chance for people from different teams and locations to establish some common personal ground. These are the relationships that will need to function smoothly when the going gets tough, later on in the process. In my experience, shared meals and other relaxation activities, especially after a difficult day, accomplish this goal better than almost anything else. Plan on making a night of it, and have dinner, drinks, or whatever form of after-work entertainment you believe is appropriate ready in order to help people establish a rapport with one another. This too is a critical part of a leader's job. As management guru Jack Welch puts it, "Leaders celebrate!" What you're celebrating today is the successful kickoff of a game that everyone present has the best intentions of making great.

5.3.4 *When the Bulk of the Staff Starts to Come Online*

It's way too easy to stop there. You met with the leads, your people met their people, everyone talked about the game and had a few drinks. Aren't we done?

No! One of the most common problems I see is leaders who are too removed from the rest of the team, from the troops who actually get the work done. These troops likely haven't even been assembled into their platoons at the time of the kick-off meeting. Thus, you need another meeting, and it's the most important one.

You probably can't afford the time or money to fly everyone on each team to a central location. So once the local teams are in place and have a basic understanding of the type of game they are building, it's time for your thought leaders – those who are relevant to your interfacing with a particular local developer – to head out for a few days to communicate the product vision to as many people as possible. Put on your thousand-watt smile, bring your collection of the best presentation materials you've assembled (and hopefully a cool, playable prototype), and get ready for your toughest audience yet.

To most of the team, this will be the real kickoff meeting. Your goals here are threefold. First, you want to spread that enthusiasm we've already talked about. Ideally, everyone you visit will get infected with that enthusiasm by the end of your trip. Second, you want to communicate as many of the important details as possible to those who will be working on actually creating the product. Third, you want to solicit feedback and get to know the individual contributors on the various teams.

The first point, the spreading of enthusiasm, must be genuine. People can smell a phony, and since your team represents "The Man," some of the more jaded, cynical types will already be inclined to see you as a fake. This is an unfortunate part of human nature that has been reinforced by too many ugly development cycles and too many bad external producers at publishing companies. You've got to overcome this mentality (or it's got to be overcome by whomever it is on the core team who you think could be the most persuasive). I've watched kickoff meetings so marred by incompetent presentation skills, mumbled-though PowerPoints, or just plain incoherent ideas that nearly the entire team walked out of a meeting thinking, "What the heck was that? This game is gonna be terrible if those guys are in charge." Make sure you practice your presentation beforehand – a lot. Also, don't be afraid to replace your spokesperson if he or she can't communicate clearly and infectiously. This is not the time for an amateur-hour presentation or a muddled, rambling design overview. You need a crisp, enthusiastic, likeable person who can get people fired up and smiling about the game.

The second point, communicating key details, is important also but less so than the first. What matters here is that everyone on the team has a clear idea of what really matters about this game. The "details" part of your kickoff discussion needs to allocate time accordingly. In the Wetworld case, you'd spend most of your time talking about what makes the run and gun mechanics great, how Fish Mode is the coolest thing ever, and why multiplayer is going to keep your audience playing for months down the road. Don't get caught up in explaining the intricacies of the RPG

back-end system or minor plot details. Only a few people will be responsible for implementing those features or building that content. These are the kinds of details that can be communicated through design documentation and discovery later. Keep your discussions high level enough that your audience will not get lost in a morass of fine print. There are details that help advance an overall understanding of what's important when making decisions about the game, and then there are just plain details. Avoid focusing on the latter. Besides, this is not the time for a 3-hour presentation on the game. Everyone's eyes will just glaze over. Keep it short, particularly if your audience is large and varied.

Finally, you need to be listening here as well. Your teams will have ideas for how to improve the game, they'll spot holes, and so on. Perhaps even more than the specifics of the ideas they have about the game, however, what you need to be listening for is their overall demeanor and tone. Are they excited? Good. Are they realistic about the time frame and their abilities? Good. Are there rifts here that are so obvious that you can sense them in a kickoff meeting? Not so good. Who are the informal leaders who command the team, despite a lack of official title? Are they on board or cynical? This is your first real chance to identify strong and weak points in the team, so listen and look.

Leave ample time to take many questions because you can learn a lot from what people ask and how they ask it. This is more important than your covering every detail in a one-way presentation. You'll want to establish this meeting as an open chance for dialog, not a monologue. Also, ideally, have a chance for mingling, with food and drink, after discussing the specifics of the game. Visit informally with the team, and take questions here too. Don't let yourself get surrounded by just the formal leaders of the company; listen to the voices of the folks in the trenches. Now is your chance to learn what they really think about the game and what is going to motivate them to do great work over the coming months.

5.3.5 *When Key Team Members Meet (Art Directors' Summit)*

There is a particular cross-functional subgroup that needs to have an additional kickoff meeting of its own. These are your art directors and key art leads. I encourage you to get those who are responsible for the look of the game together, across teams and continents if need be. They've got a lot of heavy lifting to do in order to keep your game looking consistent. This is particularly important across platforms with such wildly divergent graphic capabilities. How do you establish a "unique visual signature" that reads clearly to the user on a PSP, a PS3, and a Wii? Well, it can be done, but it's going to take a lot of coordination. Without your art directors, it's unlikely you'll succeed here.

Moreover, organizing the creation, review, polish, and finaling of art assets is a huge component of any game production. That's why you need to get all the folks who are responsible for this work together early. Let them spend a day or two making sure that they all understand and agree on what's most important from a visual standpoint.

There's a lot of shared vocabulary required in order to talk productively about visual assets. This can also be a touchy area since there's much subjectivity.

Finally, very few smaller studios can afford top-quality art directors. This isn't a jab at all of the fine boutique development houses out there – it's just a point of fact that there aren't enough quality art directors in the first place, and they can often command top dollar for their services. If you are lucky enough to have a high-quality art director on staff (or can identify one on any of the teams with which you are collaborating), you will want to arrange a chance for them to help spread their knowledge and train and mentor as many artists as they are able. This requires a deft, delicate touch. But then, that's why good art directors are so rare.

5.4 How to Keep Balance among Internal and External Teams: Avoiding "Us versus Them" and Other Common Problems

If you put six smart people in a room together, they're likely to form bonds of comradeship and begin working together to solve problems. If you put three on each side of a river, looking across at one another, they're likely to form tribal factions and eventually start wars against one another. Competition for scarce resources throughout history has evolved *Homo sapiens* into a highly social, factionalized, brooding species that easily forms social groups and just as easily forms enmities to other social groups. It will require vigilance on your part to ensure that your distributed teams don't develop a similar mentality.

One of the most common problems resulting from distributed development (a situation in which teams have to rely on one another's work products, and collaborate, without the benefit of daily, face-to-face interactions) is the development of a festering hostility between groups. "Those guys don't know what the heck they're doing!" one of your artists exclaims after opening a file recently checked in on the other side of our metaphorical river. Odds are good that a similar sentiment has been uttered more than once on the "other side" as well. Although it's possible that no one knows what the heck they're doing, what's more likely is that a pent-up attitude of "us versus them" has taken root. Once this happens, both sides start to make a big deal out of mistakes (which everyone makes, and which they would likely fix quietly and gloss over if they were made by the person in the cube next to them). Once this mentality has set in, hallway griping will begin to create a negative feedback loop, spreading the adversarial mind-set to other members of the team. Before long, snarky e-mails will start to irritate the situation. Once things get really bad, teams may start working at cross-purposes, sabotaging one another's work, or become openly hostile.

Perhaps the major root cause of cross-team disdain comes from a displaced sense of "ownership" (e.g., "This used to be *our* game, and now these guys in

Vietnam are in there messing it up!"). Work hard to ensure that everyone involved understands that ownership in a success can be shared among an entire team. Or, as the old saying goes, "success has a hundred fathers." If your game is a hit, there's plenty of glory and reward to go around. Try to keep your team focused on the external competition rather than inventing competition within. This can be particularly easy if there is an entrenched competitor out there. ("We're gonna kick Tony Hawk's ass this year!") Foster this more productive kind of us versus them mentality – the kind that keeps everyone on your team in the same gang.

How do we prevent this negative attitude, and how do we fix it once we detect it? First and foremost, lead by example. People pick up their attitudes from their leaders. Never say anything disparaging about your partners. This seems obvious, but you'd be surprised how often negativity starts at the top, particularly in companies with a corporate culture of superiority. It's easy to find yourself doing it without meaning to, when frustration builds and the pressure of deadlines mounts. Be mindful of the words you use to describe your partners; make sure to always describe them as equals, even when they are sub-contractors. Never say things such as "Tell them what to do." Instead, say "Visit with them about how to" These may seem like silly, "feel-good" suggestions, but they are not. Language is the basis of our common understanding. For a superb discussion of the profound psychological effects that the right phrasing can have on a group, read *The Magic of Thinking Big* by David J. Schwartz. It's an updated version of the same message communicated in Dale Carnegie's famous *How to Win Friends and Influence People*, which you should also read if you care about these kinds of topics. (If you don't, you shouldn't be leading people in any endeavor.)

Second, when you do hear members of your team (any of your teams, anywhere) denigrating members of other teams, quietly pull them aside and explain how important it is that this sort of negativity be stopped. It may be easy to be perceived as an uncool boss in this context, like Steve Carell's misguided character in *The Office*, constantly trying to instill a sense of camaraderie that simply isn't present. However, your alternative is far worse. There are ways to say "be nice" without coming across as Pollyanna. Find them.

Third, as discussed later, it is critical that you keep a regular "exchange program" running. I suggest that it's very worthwhile to have a member of each team in almost constant rotation through the others. In the Wetworld example, have one of your core team engineers who is an expert on the message and notification system go live with the multiplayer team for a few weeks. Have an artist from the Wii team spend 3 days with the PSP art leads to look for opportunities to share front-end elements, and so on. The primary benefit of these activities is the transfer of knowledge, but a strong secondary benefit is the relationships that are formed. It's very easy to develop an irrational antipathy toward a group you've never met. It's more difficult when there are faces, smiles, hopes, and friends in that group.

5.5 Tools for Keeping the Team in Sync

As mentioned previously, I have some distain for reviewing specific pieces of software technology in a volume such as this. There are better forums for chronicling the ins and outs of a particular version of a particular package. Few types of information other than the daily newspaper get so quickly dated. Besides, so many publishers have adopted custom, proprietary solutions that there's almost no way of covering the specific suite of tools your particular project is likely to use. So in the main, we will leave this matter to online forums. However, there are goals that one should keep in mind when considering different types of tools. We focus on these because they will remain more or less constant, even as the specific packages and version numbers change.

5.5.1 *Source Control*

There is a wide array of shareware solutions to the source control problem. Some are even considered decent. I'll admit, however, that choosing a free source control system is likely to at least raise publisher eyebrows. *Perforce* (http://www.perforce .com) is by far the most widely used version control and asset management software for professional game developers. It uses an atomic check-in model that sets it apart from the reigning champ of old, Microsoft's *Visual Source Safe*. The greater suitability of the former for large projects with many binary assets (art files, levels, audio files, etc.) means that even most of the game teams inside Microsoft now use *Perforce* or a variant thereof. This is not a good place to try to cut costs because a catastrophic failure here can easily wipe out man-months of work, even if you are using proper backup techniques.

However, if you need to look for a more cost-effective source control solution, some teams have reported success with a free, open source software such as *Subversion* (http://subversion.tigris.org). You'll need client-side software as well. Teams have reported some luck with *TortoiseSVN*, which seems to tie into *Subversion* well. Backup frequently if you're going to try to cut costs here. Whatever your solution, you'll need to ensure at a minimum that it allows for the following:

- Ability to deal with branches
- Proxy servers
- Remote/VPN access

5.5.2 *Using Source Control across Multiple Sites and Teams*

There is an entire branch of arcana associated with how to best use *Perforce* or other source and version control software across different physical sites. Most of these types of software handle the fundamental problem of access from other networks well enough, usually dealing gracefully with VPN-connected machines and with latency or low bandwidth-type problems.

However, game assets can often be quite large, and synching a 30-gigabyte check-in to dozens of machines can be a very slow proposition. Since this problem isn't shared (at least to nearly the same degree) by teams located on-site with the primary version control servers, it's easy for these teams to get careless about check-ins and end up updating a large check-in several times in the same day. As you can imagine, this behavior can easily consume all available bandwidth for a remote studio.

Movie files are the worst offenders. Audio files tend to be the next most serious. Depending on how your pipeline breaks up chunks of data and the type of game, world art files can also be quite large.

The ideal solution to this problem involves setting up proxy servers at remote sites that can monitor the authoritative version control server for changes, pull down the change list, and only then allow local users access to it. This solution doesn't resolve the large size of the files being transferred, but at least it only has to happen once per site. Conversely, the proxy server collects check-ins from the local users and then updates the master server as often as desired and allowed by the available bandwidth. The disadvantage of this type of solution is that the hardware and additional software licensing costs can quickly add up to significant sums. In fact, this solution is typically so expensive that the publisher or partner who is footing the bill for project development often has to pay for it because it can often be beyond the reach of small development houses.

In addition to installing proxy servers, you can do the following to help alleviate the problems associated with high bandwidth use necessary for distributed development:

- Use branches for local teams, and plan integrates carefully.

- Use "client spec" masks to avoid having people sync data they don't need.

- Train content creators to save check-ins until the end of the day or week, or use a private branch.

- For particularly large data drops (e.g., 1 TB of localized movies), consider over-nighting an external hard drive.

However you plan to handle this problem, you would be well served to get IT and Operations from all the different locations acquainted with one another, and regularly conspiring to come up with and monitor the efficiencies of the solution.

5.5.3 *E-mail*

Waxing eloquent about the glory of e-mail for facilitating communications in business is hardly timely at this point. However, there are a few things to consider with e-mail.

It is possible to create a custom domain for everyone on the project, using either an exchange server's custom setup or a free software suite such as *Google Mail*. With these types of tools, it is possible for you to create a user e-mail account for everyone in all branches of your distributed tree. This can offer a parallel e-mail address that is separate from their corporate or studio e-mail. Thus, for example,

instead of having half a dozen different e-mail domains on the project, you can arrange things such that each project member has a project-specific account – for example, tfields@wetworld.com. This helps establish a sense of ownership and of being part of a team. It can also help keep project-specific e-mail separate from the mass of other mails that inevitably fill a work e-mail box. Finally, this can also offer an easy way to gain access to some of the other team-specific features offered by, for example, Google's suite of communication tools, including everything from shared documents to an easy teamwide chat channel.

5.5.4 *Subgroup Aliases*

Be sure to set up custom aliases for various subgroups in the project, especially those that cut across company lines, such as AllLeads@wetworld.com, Engineers@ wetworld.com, Audio@wetworld.com, Help@wetworld.com, and Ops@wetworld .com. Some obvious categories will present themselves at the project's onset, but others will need to be more fluid. Make sure you understand the process for getting these created and also that it is easy to add group aliases as needed to deal with shifting subgroups.

5.5.5 *E-mail Archiving of Critical Information*

E-mail is a lousy forum for storing mission critical instructions. It has improved dramatically as search capabilities have improved. However, particularly in the fluidity of a distributed development environment, people come and go, and knowledge stored only in e-mail gets buried, auto-archived, or lost. Post critical information on shared document spaces where it won't get lost in the shuffle and where new people who may not have been on the project when the e-mail was initially sent can access it easily.

5.5.6 *Flagging and Tagging*

Find and encourage your teams to use the flagging and tagging features of modern e-mail services. This can make it much easier for discussions to remain organized and save man-hours that might otherwise be spent searching for the right information.

5.5.7 *Etiquette*

The larger teams become, the more important it is to censor inappropriate or spam conversations. An e-mail that wastes 2 minutes of 200 people's time has just cost you half a day in productivity. A good personal rule of thumb is to re-read and double-check what you're about to send out for every five people who

are on the e-mail list, and be cautious with your use of "reply to all." If you're reading this book, you're likely e-mail etiquette savvy enough to avoid making e-mail faux pas very often, or you wouldn't be in a leadership position. However, definitely keep an eye on more junior team members who might not understand why it's inadvisable to forward off-color jokes to everyone@wetworld.com or similar. When these issues do arise, quietly explain to the perpetrator in a one-to-one e-mail why he or she needs to be more careful in the future.

5.5.8 *Instant Messaging*

Windows Messenger, *Google Chat*, and other instant messenger (IM)-type applications are superb ways for team members spread across different building floors or continents to quickly ask questions of one another. These mechanisms tend to be very poor at storing information, and they can lead to unclear discussion because sentence structure and clarity often fall even below the minimum standards set by e-mail. Encouraging all the members of your distributed development groups to share their IM accounts with one another can aid productivity hugely. Instant messaging aggregator services such as Trillian or Palringo can even allow teams that use different types of IM software to communicate by allowing a user access to several different IM networks simultaneously.

5.5.9 *Video Conferencing*

Another technology that can be used to keep teams in better contact has been trumpeted as being just around the corner for years, but somehow it still seems to have failed to achieve any real, widespread use. The technologies keep getting better and cheaper. Many laptops that retail for less than $1000 ship with built-in webcams. So why is video conferencing so infrequently used?

Even in development offices in which every conference room has an expensive video conferencing system, I've seldom seen distributed development teams that really made great use of their facilities.

I suggest that this neglect has more to do with cultural and social issues than it does with the quality (or cost) of the technologies. People feel awkward being on camera, and a phone call tends to be quicker.

Given the availability of the technology and the millions of nonverbal communication cues that can be interpreted visually when visiting with someone "face to face" (even on a screen), I advise that you at least try to work a recurring video chat into your regular updates with remote partners. If nothing else, getting to communally laugh about how silly you all look on TV will help break the ice. The benefits of face-to-face communication without having to travel thousands of miles to get it are difficult to overstate. Seeing another person on a regular basis helps build trust, which will serve everyone in good stead when the project reaches stressful phases.

5.5.10 *Shared Documentation Space: Wikis, Sharepoint, and Google Docs*

Most teams use shared document spaces of some sort these days. Variants on wikis, as made famous by Wikipedia, make it easy for many users to access and edit shared information and are an excellent place for living design documentation and technical information to reside.

Sharepoint, Microsoft's most advanced solution for securely sharing documents, offers great flexibility for file types, embedded content, and a host of other advanced features at the cost of being particularly cumbersome to set up and interact with. *Sharepoint* also tends to be a difficult solution to share with users outside of a particular domain, meaning that cross-company security tends to make administering *Sharepoint* in a distributed development environment troublesome, requiring support from operations people to allow new groups and users access.

Google Docs is somewhere in between the two solutions. It's a very easy way to automatically share documents with folks you regularly e-mail. However, this software has a few limitations. First, you have to be using a Gmail-based account to have this software integrated easily into your workflow. Second, the way *Google Docs* opens some files in its own native version of *Office* can be awkward. This feature can be overridden, but it's often still a hassle to view or try to edit a *Word* or *PowerPoint* document in the less fully featured Google version of the *Office* suite. Finally, I've found it distressingly easy to end up sharing the wrong document with the wrong person using *Google Docs*, and correcting the error can be awkward and nonintuitive.

Whichever solution your project embraces for shared document spaces, you'll want to ensure the following:

- The ability to allow different users access to different sections (i.e., the management section should be restricted, etc.)
- The ability to embed rich media of various types (videos, audio clips, etc.)
- The ability to access remotely via VPN (for employees who are traveling, on-site with a vendor who doesn't have access, etc.)

5.5.11 *Defect Tracking*

Especially in the final throes of the finaling process, your teams will live or die based on their ability to successfully integrate their defect tracking software ("bug database") into the distributed workflow. Almost all publishers tend to use a customized version of one of the major commercial bug-tracking databases. The following are fields that you'll want to ensure your template allows:

- History
- Assigned To
- Translation Required

- Status

- Platform

You also need to ensure early on that the speed at which remote teams are able to access the database is acceptable. This is often a major problem that is ignored until one of the remote teams accessing the database via a web-based client or over a slow VPN connection begins to get buried in bugs. I've seen teams forced to remote desktop into a workstation on location with the defect tracking server in order to get fast enough access to interact with their database. This sort of solution puts unreasonable amounts of friction on an already difficult process. If you must have different defect tracking servers at different locations, do so, but recognize that this adds tremendously to the burden on your test leads.

Work with project leads, test leads, and your operations team to experiment with a fully inflated bug database full of dummy data early on, and test speeds on target users' machines with people who have finaled games in the past. Make sure your process is smooth. Even an added 5 seconds to refresh information on a bug can be a lot when you're searching through 2000 a day, looking to assign them out to an already exhausted team.

Many of the available bug tracking tools do work as project/task planning software as well. *JIRA*, by Atlassian, is one of the more common of this type (http://www .atlassian.com/software/jira). One commonly held desire is to try to manage all the tasks in a project through defect tracking software. The idea goes something like this: "If we put every team member's tasks into the database, along with the times they're supposed to be accomplished, then it's very easy for a manager to track progress; a team member always knows what they are supposed to be working on. No 'hidden' tasks get onto the list without management getting visibility, and everyone gets used to working in the same database we'll be using to final the game. It'll be awesome!"

It is possible to use this type of a process with *JIRA* or other similar tools, often to great effect. However, there is a tendency to start to rely on a type of central command approach to doling out tasks that can be troubling. When team members stop thinking for themselves and start working from task lists, you lose a huge amount of the value they bring to the project in the first place. Worse still, such a tool can often end up acting as a crutch by which less experienced or overly confident project managers or development directors end up interfacing with the tool and not the team. The final risk with this method of task tracking is that it makes it very easy to start thinking about tasks instead of goals, which is a cardinal sin in a project lead. Remaining goal focused until you've got a great piece of software that just needs to be debugged will help ensure that you make the best game you can rather than get lost in the weeds of a task checklist.

5.5.12 *Asset Review*

Some of the more full-featured suites of game asset management and development tools, such as the venerable *Alien Brain* or Southpaw's *Tactic* software, boast features that are specifically designed to help distributed development teams store,

share, and review art assets. Typically, these types of software have integrated viewers for common file types and often have features that allow reviewers (art directors and the like) to attach comments or instructions to a particular asset or "assign" an asset to a particular artist. Although many of the features embedded in software such as this are redundancies of the essential features found in source control software and asset creation tools (*Source Depot* + *Photoshop* and *Maya* can do pretty much the same thing), the added abilities for review may come in handy to those teams that can afford the often steep price tags and that are looking for an "off-the-shelf" workflow solution to asset creation, review, polish, and lock.

5.6 Summary

We've covered a lot of ground in this chapter, from how to establish a shared vision to how to determine optimal ways to distribute the work between your different teams. We discussed basic milestone planning from a high-level goals standpoint and also some of the tools that you'll need to be sure are in place at the beginning of your distributed development collaboration. In the next chapter, we'll discuss ways to keep things running smoothly, once you're off to a good start.

Interview with Everett Lee, Production Director, Sony Online Entertainment

"Production Methods for Game Development"

FIGURE
5.10

Everett Lee is a 10-year veteran of the games industry. He has worked on MMO titles, shooters, racing games, and action arcade games and been credited as an animator, producer, and designer. He currently works for Sony Online Entertainment. Previously, he built games for Microsoft's Turn 10 Studios as well as Wolfpack, Digital Anvil, and Acclaim. Everett can be reached at *everett@everettlee.com*

Q: Tell us a little bit about yourself.

A: I've been working in the games industry for a little over a decade now. Animation, design, and production most recently. I'm with Sony Online Entertainment right now, have been with them for about a year, and we're working on a new MMO game.

Q: Do you think there is one production methodology that works best for all studios?

A: Not really. It depends on the studio itself. You have a mix between large and small, mostly senior groups, or mostly junior groups, and some hybrids. So you have to adapt your methodology to the studio or the team.

Q: So let's say you've got a fairly senior, experienced small company, and you're trying to help them determine how to structure their project planning, scheduling, and production processes. What would you advise?

A: Small senior teams tend to work well a little looser. Your methods don't need to be as strict. Most of them will usually know what they're doing. They're probably well disciplined or they wouldn't have survived this long in the industry. A team like this can be a bit more agile and you don't have to track things as closely on a small team, since you're working shoulder to shoulder with everyone every day. When you've got a more junior team with hundreds of people, though, you've got to keep a tighter rein on things, and really work on making sure that everyone has more visibility upwards.

Q: You mention agile development. Tell us a little about how you think about agile, Scrum, or some of the more formalized development methodologies. Are you a big proponent of any of these in particular?

A: Honestly, I'm agnostic towards the specific process itself. It's the time estimates that matter. We've found in the past that understanding the work involved, the pipelines, the unknowns, and the risk involved is what's important. What matters are the time estimates you can apply to them, and how accurate those estimates are. Once you have accurate estimates, whether you waterfall it out or work agile doesn't really matter in the long term. It's the short term that changes a little in terms of what you get immediately, as opposed to what you get long term and have to adjust for. For example, waterfall would work great if you knew what you could count on from a more junior team, but it requires a little more maintenance, while agile development works great when you're in pre-production or prototyping, need to change gears quickly, and need to make sure that you have something playable and presentable every month or so. But neither is inherently better than the other. It just has to do with the maturity of the team and how predictable you are in estimating your work.

Q: You mention predictability in scheduling and estimating times for various tasks accurately. What sorts of skills are required to do that properly?

A: You need a great understanding of your codebase, your pipeline, and asset creation both from programming, art, design, or audio. Audio tends to be a little more self-contained

because the input is consistent and the output is contained. It's just like the movies. But code, art, and design tend to be black boxes from project to project. So for those, it's about getting people who have a great understanding of how to do the work to provide estimates or to look at the historicals and refine your estimates based on that kind of data. There's something called the personal software process which focuses on helping individuals become better at this kind of scheduling.

Q: What is the personal software process?

A: Personal software process is fairly introspective. You record tasks as being easy, medium, or difficult based on your estimate and then track how long it took you to do it. You pay careful attention to how far off you were in your estimates and reflect back at the end of the task on why you were off in your estimates. It teaches you about yourself and how to become a better estimator.

Q: Do you use this just for your own tasks that you're responsible for implementing, or can team leads or subleads use this technique for their teams?

A: You can use it across a team, but it requires a level of reporting that most people can find intrusive, so it works better on a personal level for personal improvement. That said, I've not yet been able to get this process widely adopted across a team, ever. Some individuals latch on to it and get better themselves, though it seems to be more widely used and to greater success in other types of commercial software than it has for entertainment software.

Q: Let's talk about scheduling predictability and how to achieve it when dealing with remote or distributed teams that you've never worked with before. What kinds of production processes do you think work well when managing distributed developers, outsourcers, or teams that may not be on site?

A: The risk averse way to approach this is to start always with a small contract for something that isn't critical path, and that you have good time estimates for. Farm this out, see how well they do on quality and timeliness. Then ramp up their responsibilities while measuring their abilities, keeping a close eye to make sure you're not getting a bait-and-switch when an A team is quietly switched out for a B team or something of that nature. You need to make sure they don't start slipping deliverables as they move on to bigger tasks. Also, have strict acceptance criteria for guidelines for what is required of the work. We've found better delivery of the assets on a standards, quality, and assets based contract, rather than contracting for a particular period of time.

Q: So you're not a fan of paying for man-months? You'd rather make it delivery based with a quality component?

A: Yes. You want them to have skin in it themselves. Paying by the time work takes just gives people a financial incentive to work slowly.

Q: When working with team leads remotely, in order to schedule these kinds of deliverables, is there a particular method you prefer? Does agile development work when you're working with distributed teams?

A: Teams all have their own methods for scheduling. They won't necessarily latch on to yours for the sake of preserving their culture.

Q: So when you find a team you're comfortable with, do you have them manage their process and then incentivize them as you've described?

A: Yes. The best results come in when you set firm deadlines for when we expect delivery and then use placeholder assets until the assets have been delivered and approved for use.

Q: You're speaking primarily of asset creation. How about your experience with distributed code development?

A: Haven't had too much luck with that, to be honest. Have you ever outsourced code and then plugged it back into a project (not a separate SKU) and had it come back to you on time and on quality, and get it integrated without a major problem?

Q: For discreet chunks of a game, yes.

A: So, for a login server, or a multiplayer component of a game, for example. Yeah, that's almost a separate SKU at that point, I guess.

Q: Let's talk more about how to incentivize remote teams when you're working for a primary developer or a publisher, like you are. What are some techniques you can use to make sure that everyone has a lot of "skin in the game," as you put it?

A: Bonuses. Set bonuses for not having to send things back and forth, for quality delivery on the first time. Financial incentives, publicity, like offering to credit them first on the list of external developers, box logos, whatever, if they meet whatever quality bar or delivery time metrics you've set up. Then, also, developing good relationships so that they know you've got expansion packs coming up, or downloadable content, or something that they can work with you on again. Or, if you work for a large company, you can use other projects within the company as a carrot for external teams who want the stability of knowing that they've got guaranteed work going forward if they do a good job on your game. You can even establish a "preferred vendor list" which has worked very well in the past for groups like Microsoft's Game Studios. Everyone wants to be on the preferred vendor list, so they'll do excellent work to make sure they are on it. Sony does the same sort of thing, where the good names of good development houses are passed around inside the company, studios in Russia, India, and Vietnam who have established themselves as trusted partners who consistently do good work.

Q: So when you're dealing with multiple SKUs in a franchise and your concern is making sure that all versions of the project ship day and date, what kind of scheduling techniques do you use when you're concerned not just about one team, but about coordinating among several different teams working on different but related pieces of software?

A: First, you've gotta make sure that you've left enough time in your schedule to tie everything up into a nice pretty package. No matter how good your outsourcers or teams are, they don't have the benefit of being on-site and having instant exposure to decisions individual developers make. Someone might decide to change a data format which suddenly breaks all the assets, for example, and without being there on-site, it will take longer to adjust to those kinds of changes. So you've gotta buffer enough time to deal with the unexpected, and then tie it all back together internally. Outsourcing is great for getting you seventy or eighty percent of the way there.

Q: So it seems like in these cases you're not advocating a particular methodology like waterfall or agile, but that you need to leave scheduling up to the individual projects, but make sure that you've got plenty of time on the highest level of the project to deal with the frictions that come from being distributed. Is that an accurate summary?

A: Absolutely. You need to make "content complete" actually mean something, especially when you're distributing the work, to start tapering off the bugs. As long as you're getting in new assets or new code from places, you don't really know how much work is left to finish the project. So until you've hit a meaningful content complete and can establish some bug fix rates, you aren't going to be able to achieve that scheduling predictability I mentioned earlier.

Q: So when you're using distributed development or external or outsourcing as part of your bug fixing process, how do you integrate external studios effectively into the shutdown process?

A: You have the same targets and the same financial incentives you'd use to motivate deliverables earlier in the process. The tricky part, though, is keeping communication moving fast enough. Things fly at such a rapid pace. You're talking about ten content fixes per person per day, two code fixes per person per day, five design fixes per person per day, using large company averages, like Microsoft or Sony. That pace is hard to maintain when you're farming bugs out to externals and are only getting fixes on a weekly drop like you might use earlier in the process. Each build is going to have a thousand fixes coming back, and your regression rates, say 10% for a good team and 20% for a team that is sloppy, are going to be hard to stay on top of.

*Q: Is there a reason you would stay on a weekly build cadence in that case, rather than moving to daily builds using a real-time **Perforce** proxy or similar?*

A: Works great if you have the overhead to manage all of that. Someone has to be on both ends to receive it. It just means you need a large enough external development

support team to vet all the new fixes that are coming in and manage the process. If you do, then great. On the code side, you need to make sure that they are synching and integrating carefully on their own, and that your developers aren't expected to manage collisions, else that'll impact your bug fix rates drastically to support the external teams.

Q: You mention giving credit. How do you work with a marketing group and keep all of your PR focused on the brand while still acknowledging the developers?

A: You can use public postmortems in well-known game developer magazines, for example. Calling people out by name in your public postmortems, to give them credit when they've saved your ass, will help build their reputation. And for an external developer, that's publicity that money can't buy. That kind of affirmation from a peer, a testimonial of sorts, is priceless. Marketing and PR are going to tend to be product focused, to sell the units, so unless the developer is somehow part of the story, then you can't depend on them to promote the developer.

Q: Can you think of examples where the developers have become the brand?

A: iD. Valve. Blizzard. To some degree Bungie, though right now they are still mostly just known for *Halo*. That might change, though, depending on what they deliver next. Maybe Infinity Ward for their work on *Call of Duty*. There are certain companies you can count on time after time to deliver. Blizzard and Valve will always deliver quality. iD will always deliver the most technically stunning shooter of any year they release. Epic is always going to have a great showcase for their engine. In Japan, [Shigeru] Miyamoto isn't a studio but is definitely part of the brand. Kojima's *Metal Gear* team, likewise.

Q: Any parting words you'd care to share with our readers about how to manage game projects more effectively?

A: Understand the scope of your project. Always be willing to cut, no matter how much it hurts. It's the only way to meet your expectations of quality and deliver on time. But it's easier said than done.

Six

Maintaining the Organism

6.1 Establishing and Maintaining Trust

There is a reason why a 50th wedding anniversary is such a rare and special occasion. It's easy to get married. It's difficult to stay in love (or even together) for decades. In software development, too, eventually your honeymoon period is over and all of your distributed development partners have stopped thinking of your game as an exciting new opportunity. Instead, they're seeing it as a real job, featuring lots and lots of very difficult work. How, then, do you keep all of the plates spinning smoothly? How do you maintain a distributed development organism once all of the parts are in play?

It's my experience that the simplest answer to these types of questions can be summed up in one word: consistency. How do you eliminate as many nasty surprises as possible? How do you make the support each team gives the others well understood and routine instead of asking people to step outside of their comfort zone to ask for help from strangers? How do you make sure that external groups are getting paid on a schedule, with no surprises? How do you make sure dependencies are being met in the correct order so that no one is left with nothing to do, waiting for someone else to finish their work?

This chapter is about the mechanics of creation: the slog, not the spark. How do you keep a team going through months and months of difficult work after the glow of the honeymoon has worn off?

doi: 10.1016/B978-0-240-81271-7.00006-0

6.2 Progress Checkpoints and Milestone Tracking Progress

Most projects are milestone driven. In fact, it's a strange, small, and rare piece of software that is developed outside of this dominant model.

The milestone process should work as follows: When the project is first contracted out, the production managers, producers, and discipline leads spend their time planning out the big beats of the planned development (as has been described previously). These milestones serve to give the team a high-level road map of their major goals at different phases of the project. As new information comes to light, or as new goals surface, the future milestones are adjusted accordingly. Each individual milestone is refined and agreed upon by all stakeholders as it gets closer, and subgroups on each team sort out the specific tasks required to best accomplish the goals, often in morning sprint meetings or using whatever other project management methodology they've decided upon. When all the goals of a milestone have been met (or close enough that everyone is willing to sign off and move on), the milestone "build" and any additional documentation or work product is handed off to the group responsible for approving the milestone and for issuing payments to external or subcontracted partners. Everyone takes a new look at the next milestone, sprint planning (or similar tasking for individual contributors) kicks in, and the whole process repeats itself up to the finaling phase, when things usually go off the rails a bit.

How can you make this process go smoothly, especially in a distributed development environment?

- Revisit the milestone deliverables with the approvers and stakeholders at the beginning of every new milestone. Clarify exactly what the deliverable should look like for each goal. Discuss how the approval group will be able to test and verify each deliverable. Remove and streamline extraneous goals that don't really matter or no longer apply.

- Focus on demonstrable goals rather than tasks. Task management often generates a belief in faulty assumptions. Let the people who are doing the work determine the best way to accomplish important goals. Task-based milestones can also lead to a sequence of milestones in which all the items on a checklist may get completed according to the "letter of the milestone," but the game fails to take shape.

- When giving milestone feedback, be extremely detailed on what is required to gain approval or what needs to become a deliverable in the next milestone. If you don't believe a group has met its specific goals, this is the time to violate earlier admonishments against suggesting specific tasks. Delve into the work that will be required to accomplish missed goals. If it will unreasonably delay a milestone payment, to a team's detriment, it might be appropriate to give explicit goals for the next milestone that deal with missed items.

- Don't let slips keep piling up. As a corollary to the previous point about pushing items into later milestones, you need to be aware of the snowball effect created by tasks that keep getting pushed forward until a seemingly insurmountable amount of work remains. When you notice this starting to happen, it's time to put on the brakes and have an open and honest conversation with project leads about the schedule, about their goals, and about what all of you can reasonably accomplish given the current operating parameters.

- Never chase the letter of the milestone at the expense of the intent. This is particularly dangerous when milestone deliverables end up becoming a series of tasks, especially when those are per person and not necessarily visible in the runtime software. This problem tends to occur when QA is used as a tool for approving milestones because often individual testers (who may not be nearly as familiar with the project design and goals as members of the distributed development team) are each given a small list of individual items to check off. It's very possible to have every individual milestone item checked off but the spirit of the milestone be missed entirely. When this starts to happen on a project, when milestone approvals start being run in this manner, it's often a clear sign that the production and design leaders at the top have become too buried in details and can no longer clearly see the big picture.

- Avoid overly complex QA milestone approval "checklist" processes. The ultimate leader of a project, be it an executive producer, a line producer, or the discipline leadership group, should easily be able to determine when a particular milestone is complete. If the milestone is crafted properly, anyone on the project who plays the build should be able to clearly determine if the important goals of the milestone are demonstrable. The more complex a milestone approval process, the greater the likelihood that the project is straying into a "project management process hell," which will inevitably distract from the true project goals.

- Don't hold payments hostage for trivialities. I've mentioned before that a milestone rejection is among the most blunt instruments in a project leader's arsenal. Never surprise a team with a milestone rejection; the milestone acceptance procedure should always be transparent. If the milestone has succeeded at its goals, don't delay payment just because a few individual items on a checklist "fail." Use blunt tools such as withholding payments with grace and caution, and always in the spirit of collaborative teamwork. Remember, you catch more bees with honey than with vinegar.

- Broadcast stress points or likely slips early and widely. As a project lead on a subteam or as a development partner, it is your responsibility to ensure that no one anywhere in your food chain is surprised by a milestone task or goal slipping. If you know or strongly believe that something isn't going to happen, learn why not, and broadcast the problem and possible solutions, using appropriate diplomacy and tact.

- Promote team visibility in the milestone process. If your milestones are created properly, it should be very easy for everyone on the team to understand what the milestone goals are and what role individuals play in accomplishing those goals. On a task level, it can be useful to publicly post information (using a Scrum board or similar) that lets people know how the rest of the team is tracking toward a milestone completion.

- Archive milestone builds and documentation. Each team should carefully archive a snapshot of their depot tree, of the build, and of all other milestone documentation for each milestone. This is a useful backup in case of data loss, but it also serves as a good record for how the project was tracking at different points along the process. This archive can be especially helpful in planning for future projects.

6.3 On Equipment and Software Needs

6.3.1 *For Developers*

Do enough research to know what development aides you want to ask for from the publisher at the contract phase. You'll likely get them, even if only on a strict loan. After the contract has been executed, be careful about "going back to the well" to ask for more. If you sincerely need new hardware or software to do the job properly and efficiently, it's reasonable to at least discuss the matter with your partners, especially when one of them is funding the venture. Try to cover your own small expenses, or save them up. If it's critical that you get reimbursement from a partner and need to request additional monies or an equipment loan, you at least won't be seen as unable to plan ahead. It's easier to ask for a lot of equipment at once than to ask for a different piece of equipment every month.

Of course, it's also reasonable for publishers and partners to expect that developers will have the basic equipment and software to do the job they were hired to do. Asking for specialty tools on loan is one thing; showing up to work without your tool belt is something different.

6.3.2 *For Publishers and Those Who Loan out Gear*

For publishers, console development hardware is usually much easier to come by as teams shift around and as older platforms get handed out to external development houses. Then, too, most publishing houses and development studios large enough to be managing a collection of external development teams typically have significant cash reserves for purchasing equipment. Finally, the larger your organization, the greater your bargaining power when it comes to negotiating bulk price

discounts from vendors. Of course, developers know all of this, and some respond by trying to take advantage of it. The following should be considered when loaning out development hardware aides:

- Tag it. Putting visible asset tags on every piece of equipment you loan out helps developers keep straight which hardware belongs on which project, and it makes it easier for you to recover the correct gear when the project or relationship is over.

- Be generous. It costs you tens of thousands of dollars to get into this relationship. It's likely costing hundreds of thousands of dollars each month to keep the teams employed. You'll likely spend millions marketing the product if it's a major AAA game. So resist the urge to scrimp on hardware and software costs. Keep your teams focused on more important things than sitting around watching an hourglass during compiles.

- Get it back when you're done. Assign an operations or IT specialist to work with the developers in your distributed group to ensure that you get back everything you've loaned out.

- Use depreciation tables and consider selling hardware to the development teams. If you anticipate a continued relationship with a developer, consider inserting an option for the team to buy the hardware from you when the game is done. This will be much easier than cleaning and returning equipment, and it can provide your company a tax advantage.

- Remember that hardware that improves efficiency is far cheaper than paying for additional man-months. At, for example, $10,000 per head per month, an hour of lost time waiting for builds each day gets expensive quickly. Look for ways in which extra equipment, more RAM, or better software tools can help improve efficiency.

6.4 How to Know When Things Are Going Wrong and What to Do about It

One of the unfortunate things about being in a position of leadership is that many of the senses, connections, and instincts that helped you be superb at leading a team tend to be eroded by your distance from the actual trenches. Unfortunately, many leaders end up being one of the last on the team to know when there is a serious problem because those who are intimately aware of the low-level situation are reluctant to report it. Every additional layer of management can end up acting as another link in a game of "telephone," such that the warnings those at the top actually get may be substantially altered by the communication chain. Some of the better leaders can rise above this problem, but the issue is compounded because almost everyone thinks that they are one of the "better" leaders; no one wants to believe that they have lost touch.

If we can agree that the primary information on something going wrong may often not come to you directly, how do you look for secondary signs of trouble? How do you confirm (or lay to rest) your suspicions? What do you do about the problem once it's been correctly identified?

6.4.1 Play the Build

First, and above all, if you want to know how a project is coming along, play the build every day. As the veteran producer of *Metroid Prime*, Steve Barcia, is fond of saying "software never lies." Yet it's surprising how many folks in the upper layers of management fall out of touch with this key practice. You should have all of the target platforms available to you, ideally on your desk, and you should be playing the build of each on a regular basis, ideally every day.

If you play every day, it should be much more difficult for you to be surprised by the state of the software, by problems with progress, or by a particular feature not coming together at the correct pace.

In an ideal world, you are attuned enough to what everyone is working such that you know what major areas of the game are changing each day or week. As a result, it should be easy for you to focus your energies on these. Some games, though, are simply too big to play on a regular basis. (Examples of such games are MMOs such as *World of Warcraft,* with thousands of hours of content.) This is a case in which monitoring check-ins to your source control system can provide you with a great road map of major changes as they happen. If you review a check-in log once a day, you'll always be on top of what major areas of the product are changing, and thus you'll know where to focus your efforts. Many clients, such as *Perforce*, can even be configured to e-mail you a change log at regular intervals, so it should be easy for you to keep abreast of the changes being made, even if you don't personally know all of the individuals working on the product.

Some problems don't manifest themselves in the software until it is too late. Massive team rifts, for example, will certainly eventually show through in the game, but perhaps not for months, and they may manifest as an absence of overall quality rather than as something that you can identify during production. Schedule or dependency problems likewise aren't always apparent simply from playing the game. The game can appear as if its coming together, improving every day, but it still might not be doing so fast enough to make a predetermined deadline. Thus, you've got to constantly cross-reference what you're seeing in the software with the rest of your knowns, the opinions of your leads, and the calibrations of your metrics.

However, the bottom line is this: Leaders who regularly play the game and monitor check-ins are more aware of the state of the product than those who don't. It's surprising that it is so common to find distributed development team leads who don't actually play the game daily.

6.4.2 *Metrics*

Many of the more evolved project management systems, from formal Scrum to systems such as *JIRA*, rely on detailed metric tracking and analysis to point out trend lines that suggest problems. This attempt to quantify the process in order to be more aware is noble; however, it isn't a substitute for actual communication with the team or for hands-on time with the software. Burndown charts and the like look fancy, and they certainly suggest a certain level of scientific rigor in tracking that data, but they are often misleading. Bug finds and fix rates compared against historical trends usually serve as a more useful metric. Particularly if you're working on an annual release product in a known franchise, you're likely to get very valuable data by comparing historical trends to current defect stats.

As discussed in the previous sections dealing with scheduling, knowing how accurate your people are with their estimates is another type of metric that can be very useful when trying to spot production problems (while there is still time to do something about them). By paying close attention to the margin of error that your subteams seem to have when predicting how long it will take them to get a feature or set of content implemented and polished, you'll know far in advance where you are likely to need to cut things, rearrange your schedule, or bring in additional help.

Although the specific metrics that prove most useful will vary from project to project, it's always helpful to meet with your leads group (being sure to include your test leads) to determine what ongoing project metrics you should monitor to help divine problems in advance.

However, don't let metrics get in the way of actual observation of the software and communication with the team. Although it may be possible to fly a plane by instrumentation, it's still a poor substitute for looking out the window or talking with the control tower.

6.4.3 *Try to Break Down Communication Silos*

We've discussed how communication issues are generally at the heart of why problems with production are not brought to the attention of those who can (presumably) solve them. Thus, it makes sense for us to look at ways we can try to fix these issues with communication.

First, get out there! It will be awkward as hell at first, but there's no substitute for spending time sitting with the programmers, designers, and artists who will create the game. Try not to interrupt, but instead sit nearby and listen, and play versions of the game on various people's dev systems when invited. Ask the subleads to let you sit in on daily sprint meetings or other department meetings, and try your best not to hijack the discussion. You should try to find out everything you don't know, not share what you do.

Second, go out of your way to find a few people at the lowest levels of each of the teams who are willing to talk to you. Take them out for lunch or dinner if they are available. Again, try your best to listen. Your presence may have an odd effect on the subgroup power dynamic, but it's still better than your being in the dark about trouble that's brewing.

For distributed teams that are far away, this is much more difficult, and site visits are the only way to help break down the communication barriers that render problems opaque. We'll talk much more about site visits later, but for now, recognize that either you or someone you trust will need to be on site regularly with your distributed development teams in order to open lines of communication.

6.5 What to Do When the Job Requires More Work Than You'd Agreed Upon

6.5.1 Find out Why

Where did estimates go wrong and why? This isn't an occasion to spend a lot of time apportioning blame, but it is important to understand which parts of your plan were built on quicksand and which parts of the project are still in good shape. It's quite common for a broken section of the project to absorb a disproportionate amount of resources, and often the first several attempts at fixing the problem end up being woefully inadequate. In other words, understand where you went wrong, because sometimes you may have underestimated a problem by an order of magnitude and not just by a few degrees. Dig deep to determine what is really going on.

If the problem is one of "death by a thousand paper cuts" where nothing at all seems to be where it should, and the project as a whole seems to be bleeding time and resources, then it's likely that you have either a team problem or a major process problem. Delve in, and you're likely to find one of the following common situations:

- Are team leads communicating with one another or is there some departmental schism that is causing a teamwide paralysis?

- In distributed development situations in which the design or technical direction is being set from afar, is this a case in which decision making is being bottlenecked in one or two creative tyrant types? (This is a very common problem.)

Is the pipeline for iterating (or for something else in the creation process) making it take far longer to implement and debug new content and features than seems sane? (Most have experienced build times that suddenly jump from 10 minutes to 10 hours because of some inadvertent complication.) Is there an obvious (or nonobvious) pipeline issue that is affecting a majority of the team?

• Is there a broken project management process in place? Are there too many branches, which makes integrating changes painful? Two-hour Scrum meetings at the beginning of each day that are sapping team willpower and time? Major non-work distractions?

If you can't identify what is affecting your efficiency, spend as many days as it takes to meet with individuals and go step by step through the implementation of their contribution to the game for that day. Usually under close examination, inefficiencies will become obvious.

Once you've isolated which parts of the project are taking up more work time than you'd initially expected, and you've identified what it will take to fix (or excise) them, then you can move on to the next step.

6.5.2 *Determine If You Need Additional Resources*

Now that you know how to fix the problems that are causing you to exceed your projections, it's possible that you'll need help to fix them – to get things back on track. This is where your distributed development diplomacy skills will come into play. You'll need to determine what else you need and where you can get it. Generally, there are five types of resources that can help get the project back on track.

Time

Whatever went wrong, time is likely to be what you lost the most. Unfortunately, pushing out schedules can often have such dire consequences that doing so becomes impractical. (Movie licensed products can lose half their total sales by missing the picture release date by 60 days.) If you're in a heavily distributed development environment, it's likely that there are several other teams marching to hit hard dates too. So extending the schedule should be one of your last resorts because of the ripple effect on other teams and the potential impact on sales.

Equipment

Sometimes throwing more iron at the problem can help unclog bottlenecks that are slowing your whole team. If compiling, building content, creating lightmaps, or automated smoke testing would help provide some relief to the problem, then it's possible that a few thousand dollars in extra server hardware, memory upgrades, or the like will work wonders. After all, if everyone on a team of 50 builds three times a day, and you can reduce each build time from 30 to 10 minutes, you've effectively saved the equivalent of an additional full-time employee. Also, given the cost of

even the lowest paid game developer, it's almost impossible to match equipment upgrades for efficiency savings, if you're lucky enough to have a problem that can benefit this directly.

People

During the beginning of the transition from standard definition console game production to the far more complex world of high definition, team sizes ballooned. Although most managers are aware of the "mythical man-month" problems that we've already spoken of here, there can still appear to be value in throwing people at a problem. Obviously, by people we mean skilled game creators, but often it's seductively easy to focus more on growing the team size and less on making sure that the specific people you're adding to fix the problem are the right folks for the job. This trap is easy to fall into, tends to create significant inefficiencies, and can end up reducing the productivity of your core team in a major way. Finally, the wholesale moving of teams to help out a beleaguered project often has significant morale and cultural integration problems. Try to avoid this solution and focus instead on experts.

Experts

Find a few key experts who can make major contributions to your project or transform the way your team works. The truth is that all people are not created equal, and experience and dedication make some people much more effective than others. These are the people you need to surround your project with at all times. However, when things are in danger of going off the rails, one or two experts can be the difference between an on-time ship and a failure. A senior engineer can often optimize a runtime client or fix difficult to find bugs (without introducing many new ones) far more effectively than throwing a half dozen junior programmers at a problem. A CG supervisor who is exceptional with pipelines can sometimes transform your art team from an inefficient mess into a production dynamo within a few weeks. Of course, an experienced project manager or producer can often parachute into a project that is deeply troubled by communication issues or decision paralysis and make an enormous difference. Find targeted spots in which one key expert can make a major difference; then solicit distributed development partners for experts. Pay these people whatever you need to; they'll be worth five times what they cost.

Money

When you're a developer, having to go back and ask your publisher for more money can be humiliating and can also strain the relationship. Try not to let it. If a project

is taking more resources to complete than everyone had expected, and you negotiated a contract that clearly specifies the man-month rate at which overages will be charged, then your partner isn't likely to be unreasonably irked by the need. After all, your partner wants the project to be completed to quality and has (ideally) been part of the decision-making apparatus that identified the problems standing in the way of that goal. To be sure, money is never a solution unto itself, but it can make feasible the application of additional resources. Just be sure never to use project problems as a way to feather your nest; it's dishonest to try to profiteer off of a crisis on a project you're involved in, and it will do harm to your reputation in the long term.

6.5.3 Even When It Is Difficult or Expensive, Do What You Say You Will Do

Because of the amount of money involved, there will be occasions when your team ends up not wanting to do something that you are contractually obligated to do. Often, this will involve paying someone for something. Maybe it is royalties to a partner. Maybe it is consulting fees to an independent contractor. Perhaps it is a commission to an agent of some stripe. It is common in these situations to start searching for a way out. Maybe there is contractual wiggle room allowing you to engage in some sophistry, claiming that you'd agreed to pay for "development services" but not for "artwork." Maybe there is some sort of bookkeeping legerdemain that you can engage in to hide payments received and "cook the books" to avoid paying out royalties.

Don't do it. When others try to push you to do it, push back. In the modern world of distributed development, honesty and transparency are critical. The ability to stick to your word even when it may be disadvantageous to you will win you far more long-term partners and relationships than trying to be deceptive with your partners for a short-term gain.

At the same time, unfortunately, not everyone feels this way. You'll need to be hypervigilant to ensure that your partners will uphold their end of the bargain. Integrity is not as common as it should be.

People with integrity tell the truth, and they keep their word. They take responsibility for past actions, admit mistakes, and fix them. They know the laws of their country, industry, and company – both in letter and spirit – and abide by them. They play to win the right way, by the rules. – Jack Welch

Live this statement in all your dealings with partners and your reputation will prosper. Live and behave in a contrary manner and your studio will develop a bad reputation that will hurt your future business dealings.

6.6 How to Deal with Product Goal or Design Changes

"Feature creep" is one of the most dreaded phrases in game development not because it is a rare and terrifying condition but because it is an *endemic* and terrifying condition. It's a rare game that can avoid slipping into a phase where its design ambitions start to generate an out-of-control task list. No one likes this situation; designers, producers, and everyone else involved generally want the game to be competitive – to be great. And development directors, project managers, and everyone else involved want the game to be focused, reasonable, and to ship on time. It's a conundrum, and the only ones who escape are those who ask the right questions, demand good answers, firm up their processes, and instill iron discipline.

As your game development progresses, everyone will have numerous ideas on how to improve the product, in whole or in part. How do you and all the leaders in your distributed development organism determine which ideas are good ones? Which ideas should go into the product, and which should be saved for a sequel or left on the cutting room floor? As you approach the conclusion of a game, post alpha, how do you create a process that ensures that every idea is tracked and the work is prioritized, with only those new features or work items determined to be worth the added risk actually getting your team's attention?

- Be open-minded to new ideas, regardless of the source. It's very easy as a project lead to want to stick to the course even in the face of new insights and opinions. Try not to let yourself or your teams become hostile toward change.

- Formal process is required. After some point, all new features or work items should be tracked as bugs. Otherwise, there's no reliable way to help control the vast number of changes that will affect the software. When a change is determined to be important enough to implement, it needs to be formally tracked, every time, regardless of the source.

- You need a triage leadership group that can debate the merits of potential changes. This group should realistically evaluate the risk to the project's ship dates of entertaining any new feature. If it isn't worth it to ship late, then the new feature is not worth including.

- In the final phases of development, even great ideas that induce change usually have a high cost. Work to instill a sense of "shutting it down" into everyone on the team (when it's time to shut things down). This is a mind-set familiar to those who have successfully shipped products on time. Every team across your landscape should be well aware of this change in mind-set and when it needs to occur.

Without a premeditative shift in mind-set and a deliberate focus on avoiding feature creep, it is very challenging to put a game in a box. Ask any creator if they've ever shipped something they were completely happy with, and when the microphones are off, the answer is almost always "no." There is always more you could

do, more polish you could put into the game, more bugs to be fixed, and additional improvements that can take good to great or turn great to a timeless classic. However, without discipline and focus to determine what changes are worth the time, investment, and added risk they carry with them, it is too easy to end up with a bloated, buggy product. So be focused, disciplined, and have a clear process that describes your approach to changes and feature requests.

6.7 How to Gracefully Exit When Required

Sometimes the feature set isn't going to be competitive. Sometimes the funding falls apart. Sometimes the division gets reorganized or the SKU planning changes. Sometimes you have to kill a game.

Alternately, sometimes you have to stop working on a game, even when you'd really like to finish it. If you're a publisher or the core leadership group on a game and you need to halt production, how do you make the best of a bad situation? If you're a development studio, how do you bow out of doing any more work on a game that has become a losing proposition for you? Let's all agree that if you're at this point, you've tried to get things back on track and you've worked with your partners to try to fix the terms of the deal, but it's not going to happen.

If you have to take a developer off a project for nonperformance or because the game as a whole just isn't going to work, there are four critical questions to which you must find an answer. First, how do you extract yourself with the minimum amount of financial pain to your company? Second, how do you minimize the risk of costly litigation? Third, how do you preserve the relationship with the developer? (You just never know when you may want to work together again. Life is long and the world is small.) Finally, how do you minimize the impact on your development partners, including the one(s) you just had to remove from the project? Together, these illustrate the thorny constellation of problems such a situation entails. To make matters worse, the goals described previously are frequently at odds with one another. Here are a few suggestions to make such a transition easier:

- Review your contracts with the developers before taking any action. You need to know exactly what your legal obligations are and the parameters within which you are allowed to operate by law.

- Spend time with wise advisors whose judgment you trust, and spend a little time plotting out the probable financial situation of your partners based on what data you have. You'll want to understand very clearly where the developer is coming from before springing bad news on them; when people are backed into a corner, they can be unpredictable.

- Consider your timing. What else do you need from the developer in order for other developers to keep moving smoothly? If the game itself has exploded and won't be continued, then you'll need to make sure you at least get an archived snapshot of the final state of the project. If the rest of the project is ongoing, how

do you facilitate a transfer of knowledge or assets? Develop a plan to transfer knowledge and assignments to other members of your distributed development team. Engage leaders on other teams to make the transition go as smoothly as possible. Give financial incentive to the developer you're pulling away from to "play nice" with this transfer.

- Consider where you are in the milestone process. Does it make sense to cancel right away, before a team starts up a new milestone that may obligate you to pay out an additional milestone payment for cancellation?

- Even if you believe that a studio working on the project has failed, potentially through incompetence or dishonesty, you still don't want this project cancellation to drive them out of business. A reputation for canceling projects and killing teams will make it difficult for your organization to find good partners in the future. (Remember how bad EA's reputation became in the late 1990s when they bought and then killed off a number of high-profile names such as Origin Systems and Westwood.)

As a developer, why might you have to bow out of a project before it is complete? Perhaps you're pouring too much of your own money into development, and there is no possible way you can recoup your losses. You've talked with the publisher, and there just isn't additional funding forthcoming. Alternately, maybe you've lost a few key leads to defection or attrition, and the project no longer has the staffing for you to fulfill your obligations. Finally, there's the possibility that another deal has come along that is so good that you believe it's worth parachuting out of a current project despite the damage it's likely to do to your relationship with other partners. Tread carefully and consider the following suggestions before making any decision:

- You must consider your contract carefully. Are there any provisions addressing your right to refuse to continue work? (Typically, the contract specifies exactly how the publisher can bail out but seldom addresses the rights of the developer to discontinue work.)

- Are you obligated to pay back any advances against royalties or other development monies? Are you obligated to continue to share any financial risks associated with the project going forward?

- What development aids, hardware, software, or others will you be required to return to partners or publishers? Ensure that these are free from anything that could get you into trouble (pirated software, competitors' data, etc.), that they are replaceable, and that you don't want to buy them. (Contracts often have a clause that allows developers to buy the hardware loans at depreciated rates after a project's conclusion. However, a publisher is likely to frown on this if you are bailing in the middle of the project.)

- If there are other distributed developers in play, how can you ensure that you stepping away from the project won't put them in too much of a bind? Can you quietly start a knowledge transfer to another capable development house? Can you have your people begin documenting proprietary tools or pipeline processes that may become "lost tribal knowledge" when you step away?

- Most important, how can you exit in such a way that you do as little long-term relationship damage as possible? Publishers and other developers don't like it when someone they were counting on to help them finish a game walks away. This is similar to the dislike a team can develop for an individual who quits when the going gets tough. But in a way, it's more profound and potentially has far greater financial implications. The games industry is a very small place. Burn bridges with publishers and other development houses at your own risk. Try your hardest to finish the contracts you start, and if you absolutely must walk away, strive to have open discussions with your partners about how to best hand off your share of the remaining work in order to minimize disruption.

6.8 Finaling and Product Submission

The self-proclaimed inventor of computer solitaire, Brad Fregger, used to say, "When you're 90% done with the game, you're still only halfway there." Although this comes dangerously close to a Yogi Berra-ism, it's still remarkably accurate. It takes a huge amount of energy to close down and ship a product, even when the game itself is complete and fun.

Because the finaling phase is among the most difficult and tends to leave the deepest scars on teams and relationships (both personal and intrateam), we've kept coming back to the topic throughout this book. At its heart, there are five steps required to final a console or PC product:

- Get all the game features complete.
- Get all the content finalized.
- Ensure that the work from all your teams is integrated well.
- Get rid of all the defects you can't accept shipping.
- Ensure compliance with certification guidelines.

Most of the elements described in this book regarding how to keep communication tight between teams, how to organize teams, and how to pick your key staffers for each team have been made with the finaling process in mind. It is here where the most strain will be put on relationships. People get tired, and the stress of impending deadlines can make even the mild-mannered blow up occasionally.

So how do you make your finaling process a sane and positive experience for everyone involved?

Be realistic about what can be accomplished. Situations are never ideal. People don't knock it out of the park every day for weeks at a time. In short, things almost never magically come together at the end. If it feels like far more work than your teams can accomplish in the allotted time frame, it probably is. You need to be clear-eyed and realistic, and you need to cultivate this trait in all of your leaders across every development team and subgroup.

Don't rely on crunch. Just because crunch time is a staple of our industry doesn't make it good or efficient. If a plan for finishing revolves around large sections of your team, or multiple teams, all having to devote a superhuman amount of effort to the cause, then you need a new plan. I strongly discourage even relying on people to be in the office one weekend day per week in order to accomplish your goals. Particularly in countries outside of the United States, workweeks are sacred, if not protected by law. The bottom line is that you cannot and should not rely on grinding teams to death in order to get products finaled. For all the reasons I've mentioned previously, and for many other good ones, this is just not the way to build a sustainable business or relationships with external partners. Use overtime as an occasional speed boost but not as a regular course.

Encourage rest days. Just because you aren't mandating overtime doesn't mean some members of your teams won't be putting in the extra hours. Also, it doesn't mean that managers or studio bosses on every level won't violate the previous rule by mandating fierce overtime. Besides, when folks from one studio are working, especially in a distributed development model, that usually means that conscientious souls in the other studios are probably working too. Consider encouraging a common day when the game officially won't be expected to be running. This doesn't mean, of course, that all other days should be mandatory workdays. However, such days do help studios to understand that they are officially allowed to let people rest and go home.

Use defect tracking databases to guide work. By the time you reach beta, no work should escape running through a defect/task tracking database. You need visibility at all levels regarding what people are spending time on, the relative priorities of each, who thinks they are crucial to fix, which tasks are still hanging around after a week, and so on. By the time you're in the final shutdown mode, the "goal-oriented" milestone items that should have defined the first phases of the project should be replaced by a task and defect level of granular tracking. This will provide a level of explicit intent to each task and add visibility to the remaining work. Guiding your work through the use of defect tracking software helps you and your teams understand just how much work is left.

Broadcast the game's status regularly and widely. Each version's daily status should be communicated and understood by the core team, and leads on related teams should have optional insight into at least high-level data from QA and project management. This helps each team be aware of upcoming deadlines and dependencies that might affect their lives or decisions, even if they aren't directly involved. In the critical final weeks, when each day counts hugely, this kind of visibility can prevent surprises and help manage expectations across teams.

Make cuts early and often. A polished smaller product is almost always more successful than a rambling sprawl of a game filled with bugs or marred by poor implementation. "It's too short" is a sign of disappointment but also proof that the player wanted more. Some ideas take vastly more work to implement than is warranted

by their value to the shipping product. Be smart with cuts along the entire product life cycle, and don't be afraid to put things on the list for a sequel if they can't make it into the original. Simply put, the less content and fewer features you have, the better the rest will be, and the saner your finaling process will become, because the product will be more easily localized, tested, and debugged.

Set aside enough time for certification and compliance. Console certification and publisher compliance testing can be an experiment in frustrating arcana. Every time a controller is unplugged, every time a player drops out of connection in an online game, several certification guidelines have to be consulted and correctly followed. Even with good relationships with the hardware manufacturer and its testing team, and local experts within your distributed development family, you still may well have to fix several complex issues that surface only at the last minute. Leave plenty of buffer for various versions of the product to get "bounced" by a first-party compliance team. Also, don't assume that just because you are ready for a new version to be tested, the compliance team will test immediately. Nintendo, Microsoft, and Sony all have queuing systems that are complex to navigate and can become highly politicized during peak (e.g., pre-Christmas) seasons.

Keep your QA team close, but keep your QA managers closer. Quality assurance is your yardstick for how close your teams are to finishing. You should be on good terms with them throughout the project. Be sure to introduce contacts from QA to the structure of the teams whose products they will test and also with key go-to individuals on those teams, as is necessary and appropriate. During the final shutdown phase, you should expect direct communication between your QA leads for each project or platform and the local production leads for each team or sub-team working on the game. Your QA leads can help tremendously by ensuring that must-fix issues are discussed openly. They can help track down clarification and reproduction cases for difficult to pin down issues, and they are among the most informed of all the groups on the overall status of the project at any given time. Establish tight bonds with QA leads, and strengthen those relationships with external teams so that you can rely on them during the shutdown phase.

Lock down content to be localized early. Translating text into other languages takes time. Translating text, recording it as speech by a competent voice actor, and then validating that it matches the meaning of the original takes a lot of time. Also, since localization houses or studios are usually yet another layer of distributed development complexity, just communicating the status and issues affecting localized content on a major game can add several people to a project. Then, too, since most localization houses work on many different projects at once, they typically have scheduling complexities that make immediate turnarounds problematic, if not impossible. Use a professional "Loc Manager" to coordinate localization services across all teams and/or assign an AP-level producer to be in charge of localization on a particular SKU on each distributed team (if the game is large enough to warrant this). Get any content that has to be localized locked down early, and keep it locked. Set dates for stringtable lockdown (50% locked, 90% locked, etc.) and then

work hard to stick to them. Ensure, particularly, that movie content that needs to be translated or localized is completed as early as possible since timing speech to picture can add further delays (and looks terrible when done badly). Remember that any change to localized content must be multiplied by the total number of languages on the project, so one bug can quickly become eight. Avoid this kind of spiraling by locking down Loc content early.

Run performance tests early and often. Getting frame rate to an acceptable level is a critical concern when shipping any version of a project. With co-development or distributed development scenarios, this problem can be exacerbated because some groups can make changes that affect the performance of systems built by other teams. For example, it's easy for a content builder in Spain to make a change that isn't noticeable except to the multiplayer team in Boston, which is using that asset many times in one particular level. Often, the solution to optimizing runtime performance can involve radically restricting the data structures; changes such as this can have a sweeping impact. It's best to understand these early on by keeping the frame rate acceptable throughout the project and instilling in all teams that a check-in that slows the build to unacceptable levels is considered a broken change and needs to be reverted or fixed immediately. Automate performance testing as much as possible to free up the burden of hand testing huge amounts of game content. Keep the game running fast and test every element early and often so that you won't be surprised if you have to make risky wholesale changes later in the cycle.

Test on-target media early and often. Performance characteristics, seek times, and other behavior can vary hugely when running on professional development kits instead of final target media. Also, of course, different platforms handle things quite differently, even if a vast majority of code and content can be shared between them. You should strive to test on near final media, be it NDS cartridges or burned discs from an Xbox 360. Find problems with the data layout and low-level I/O functions early, while they can still be changed without destabilizing an otherwise stable product. If there is a back-end server component to your game, be sure you have a connection to production-type servers as early as possible; the trap of using dummy server data to get a client into shape can have devastating results if it's discovered too late that the actual server back-end does things differently.

Don't commit to launch dates until after beta, if possible. There is a major difference between knowing what your launch window will be and "street dating" a product. Once you've announced an actual street date to retailers, hitting it becomes critical. It's very difficult to achieve real predictability reg\arding the actual date a highly complex distributed development project will be accepted by certification and ready for manufacturing. Until the software has at least achieved a solid beta status on all platforms, don't commit to anything more granular than a particular month. If you want to be safe, don't commit to a specific week window until you are at ZBR across all platforms. Violating these guidelines means that you will be date bound and invariably will be forced to ship some bugs you'd rather fix, resulting in a lower quality product than if you'd waited until later, when you had achieved greater pre-

dictability. The only way to be truly more predictable is to have fewer moving parts, and that means the reduced churn that goes with a very small number of changes per day. Achieving this means that you've fixed most or all of your bugs.

Remove dependencies between shared platforms early. There are many good reasons to keep code and content the same between as many platforms as possible. Sharing will help you to maintain a level of consistency in user experience. It also lets you focus on polishing one set of assets rather than building several different ones. It helps keep things simpler for QA, and it reduces your overall workload. At least this is the case until the finaling phase, in which dependencies between platforms can cause real problems where making a change in one place can break an otherwise good build.

Decouple platforms from one another at the right time. At some point, you'll want to branch your source tree for each platform. But when? Usually, around ZBR is a good time. You've fixed enough common bugs and your overall defect count should be low enough (zero!) that you should be able to clearly identify any lingering, platform-specific issues that crop up. In addition, this is the time when you'll start focusing more of your energy on certification and platform-specific compliance issues. Also, since mandated behavior can be quite different between different platforms, you'll be dealing mostly with platform-specific code at this point anyway.

Empower the right people on each distributed team. There is a reason why strands of DNA are located inside each and every cell. A certain level of autonomy and a clear and shared purpose make for more efficient organisms. The more central command and control a core team tries to hang on to, the more difficult it is to quickly and effectively close down a project. By this point in the game's developmental life cycle, it should be very clear who the competent go-to people are on each distributed team. Empower these people to make decisions about assigning out bugs, about requesting that certain issues be closed, and about how to best play the individuals on their staff. This will make each team better able to respond quickly and without having to explain their every action to a central group (which is usually far less familiar with the situation than those with boots on the ground). If the right person doesn't exist on a team during this phase, you may need to install one by parking someone from the core team on-site for the finaling phase.

Identify and eliminate bottleneckers. As a corollary to the previous rule, you want to identify and eliminate the bottlenecks that prevent things from getting done quickly. Invariably, there are people on each team who, for whatever reason, become "the only one" in a particular subgroup who can make certain decisions. Try to identify and remove these obstacles. A common situation is when a producer wants every bug for his or her team to come to him or her first and allows no one else to assign them; this translates into hundreds of bugs piling up on that producer's plate while other team members must wait to learn what they should be working on. These sorts of inefficiencies are natural, but they particularly need attention during a finaling phase. Appoint more capable decision makers and find logical ways to divide the work to remove bottlenecks.

Communicate urgency to support staff; engage extras. The stresses of finaling and the unusual hours required to work in highly distributed development settings can put a strain on an organization across all levels. This includes infrastructure teams and support staff. The last month or two of a project can be a good time to hire additional part-time IT support to ensure that teams working late have at least basic coverage. Just communicating the sense of urgency to support staff can help make things smoother for your developers. Even cleaning staff and building facilities personnel need to know that teams may be working unusual hours, and that they may need to step up efforts to remove trash, old boxes of crunch food that pile up nightly, and so on. Alert support staff and hire extra help as needed; it's a cheap way to reduce friction on your hard-working development teams.

Remove distractions. The final shipping phase is a good time to put the brakes on some of the distractions that drain team productivity. Some of these can be inside the software itself or inside the process. Cutting features that are a lingering drain or declaring an end to tweaking that has gone on too long can help focus efforts inside the software. In the process, identify meetings that have outlived their use-fulness or that could be shortened. Are there nonessential efforts that can be put on hold until the game is shipped, and then resumed? Outside the software or the process, this might be a good time to put an end to the tradition of long Friday lunches or a good time to fold up the ping-pong table and put it in a corner until the game has shipped. These sorts of decisions should be made on an individual team or sub-team level, but as a leader of the distributed development process, you'll want to at least communicate this intent. If there are cross-team meetings or habits that are nonessential or qualify as distractions, put them on hold for now.

Set mini-goals; use short sprints. Have your individual teams move to a process of setting a goal for every 2- or 3-day period. Target bug count is a good goal to set (e.g., "Let's push to get below 100 bugs today!"). Getting out a great build for QA and Loc is another useful type of short-term goal. In general, the 2- or 3-week sprints that often characterize the earlier development phases are not sufficiently granular for this final phase. Setting very short-term goals will give people something to rally behind and push for, as well as a sense of regular accomplishment that can be very helpful during this stressful period.

Become change adverse to reduce churn and increase stability. A willingness to explore new ideas and a drive to constantly improve the product are key to creating lasting works that build and sustain franchises. However, in the latter days of shipping a product, you need to turn from these virtues and instill a different one: closure. Experimentation, risk-taking, and unlikely gambles aren't what you need to adequately shut down a game. Instead, you need to strive for predictability and fix rates that help establish a clear shutdown "glide" path. You need to reduce the number of changes being made to the software each day in order to increase stability. Every check-in, no matter how well intentioned, risks creating a new, critical, difficult-to-find bug. This means that even relatively minor changes risk being major impediments to a predictable ship date.

Lock the right people out at the right times. Not everyone needs to be working with the game code and data until the end. The careless, the junior, or those whose jobs are simply done need to be locked out of the check-in process. It may seem harsh or needless to formally lock people out rather than simply tell folks to quit making changes, but invariably you'll have to do this. Dedicated team members often cannot resist the urge to fix "just one last thing" or to jump in and try to help out. But you can't have this because there comes a point when each change adds significant risk and needs to be evaluated by only your top few people. Indeed, in a distributed model, whole teams need to be locked out eventually. It's all part of locking down the software by reducing the rate of change.

Establish good build practices and cadence early. For large projects, you'll need automated builds that are constantly running. You'll need notification to the right people when the build is broken. You'll need a regular, formal build approved for testing, and you'll need documentation on this build to come from the same person each time. You'll need people on each team to know their deadline for check-ins in order to make a particular build. You'll need a known build numbering system that makes it clear to people in which build a particular issue can be found. (Using CL# is the most common system of naming and has many advantages.) Finally, you'll need a regular, fast, and well-tested way of making sure that each distributed team gets the right build (and the same build) at the appropriate time. If you establish these practices early, then they will be comfortable and familiar when it's time to finish out the game. The cadence may increase slightly (from weekly to daily or from daily to twice per day), but the basic rhythm and sense of the deal will remain the same. Doing so will help predictability and reduce communication errors between teams.

Rigorously sanity test each CL that you intend to submit to QA before you submit it. Ensure that each platform team has a particular person who is responsible for testing each formal build that you intend for QA, localization, or other dependent teams. This person should have a regularly updated list of items that he or she knows to test for in order to ensure that a build conforms to at least the minimal standards required for QA to properly do their job. Usually an embedded test manager on each team is the right person for this job.

Rely on your well-honed diplomatic skills. Finaling is stressful. As I've made clear throughout this book, it is the final month or two of a game that will put your distributed development structure and teams to their most difficult test. There will be a natural tendency to blame other groups and teams for problems that arise. Fair or unfair, it is critical that everyone across the process understand that temper flare-ups and abrasive behavior at this phase are simply counterproductive. If you've followed much of the advice in the previous chapters on how to organize and staff your teams, and how to integrate them with one another, then the natural diplomatic ties that you've forged during the previous months will carry everyone through the final phase well.

167

Interview with Phil Wattenbarger, Director of Product Development, Certain Affinity

"How to Run Co-Developed Projects So They Don't Kill Your Team"

Phil Wattenbarger is Director of Development for Certain Affinity, a small games studio in Austin, Texas, which focuses on multiplayer FPS and RPG games. He has been making games professionally since 1992 and has held roles from lead designer to executive producer. His studio experience includes Origin Systems, Digital Anvil, Microsoft, Midway, and Certain Affinity. He has been credited on *Wing Commander, Freelancer, Call of Duty*, and *Age of Booty*. He can be reached at *pwattenbarger@gmail.com*.

Q: Tell us a little bit about your background and the kinds of games you work on.

A: Sure! I've been in the industry since about 1992, primarily working on action games. I spent the first decade of that as a game designer and lead designer, then as a project lead. Then, I've spent the last 8 years or so as a production lead. I'm currently the studio production manager at Certain Affinity, where we do a combination of new IP and work for hire, all action and action-RPG type games. We've got about 42 full-time people right now.

Q: Great. Let's talk about finaling games today. I understand that you've finished and shipped more than your fair share over the last year.

A: Ha. Definitely. I've probably got a bit of a unique perspective over the last year in finaling games as a development partner. We've done quite a few "dev-for-hire" projects, in which we're the development partner working in a co-development situation with a partner. In these cases, they have the majority of the resources for the actual finaling effort. So we're responsible for feature sets and they have the army of QA people, of localization staff, and all the other mechanisms you need to final a game.

Q: So this is a true distributed development model in which a core or central team is responsible for the final product and all its platform SKUs, and you're responsible for running a team that is in charge of delivering certain features and a certain set of content for the game, right?

A: Yes. That's correct. Last summer we worked on *Call of Duty 5: World at War*. And on that project we had responsibility for multiplayer maps. Lots of map creation, but also feature work, code work, all of it multiplayer related. That included game modes and the vehicle features that we shipped with the project.

Q: That's obviously a huge franchise, and it seems that the multiplayer has been quite successful. From your perspective, is multiplayer a good type of feature set to break off and hand to an external collaborator to work on?

A: Definitely. It has been successful, so thanks! There are a lot of different aspects of doing that kind of work. In this case, we started with a successful franchise, a good partner, and a very mature engine that has gone through multiple releases, then a recent big upgrade for *Call of Duty 4* and *5*. So, obviously, technology always evolves, but in this case it was stable and had already gone through a couple of finaling efforts, and was based on a sound foundation. After that, there is the question of content. This was map design and features in our case, and absolutely, this was a good compartmentalized part of the game that could be broken off into a chunk. And, of course, internal development often works that way as well; you often separate out your multiplayer and your single-player teams. Now how easy this kind of thing is to do as distributed development depends a lot upon the tech, on how much of that is mature (as opposed to being developed as you go along).

Q: You've mentioned technological maturity as being important a few times now. How exactly does that help make the process of distributed development go so much more smoothly?

A: Well, in this case we had an engine that has gone through many many years of development, and it's very fine at delivering 60 frames per second of FPS gameplay. It had robust networking technology, robust rendering technology, robust matchmaking technology, all the things that make multiplayer a huge, complex feature set. And that's a great starting point. So we were able to take that great feature set and layer on top of it.

Q: With these sorts of map packs built for digital distribution, it seems like you end up in a finaling phase pretty often. How many of these have you shipped recently?

A: We collaborated on shipping the *Call of Duty: World at War* last summer. And then we shipped two different map packs of downloadable content over the spring and summer of this year.

Q: Three finaling phases inside of a year is pretty rare outside of iPhone, web development, or maybe MMOs. How are you able to work with your partner and work with QA and localization and your team to keep that process sane, and save your team from having to crunch for months and months at a time?

A: It all starts with having a solid relationship and having communications be solid. You need to share clear goals and expectations with your partners, in this case us and the primary developer, Treyarch.

Q: Are the release dates for these set in advance, or is this something that you work with your partners to set?

A: Well, in this case, on a major franchise like *Call of Duty*, dates are set. We knew last summer that we would definitely be on store shelves in time for the holiday. No flex there. So that was definitely working towards a hard deadline. And that's its own unique challenge. For downloadable content we had a little more input into what we thought it would take, but there are still ideal marketing and sales windows. For the final DLC we all knew that it was a crazy ambitious, compressed schedule, but we were up against hard marketing deadlines for getting it out before the next holiday season noise began. So we went back and came up with some parameters, and said, "If we could do it this way then it might be possible." So that was a good example of a case where there wasn't much back and forth on the date, but the parameters for making it successful in a really short timeline were flexible.

Q: When you first get an assignment like this that you might want to undertake with your team, what team members do you talk to and what do you visit about in order to make sure that things go smoothly, especially when you know you're going up against hard dates like this?

A: Ideally you have a full roster of seasoned department leads. Depending on the ambition of the different projects, they will require you to lean on these people to different degrees. By the time we got to our second map pack, which was called "DLC 3" in the marketplace, the engineering was well understood, the pipeline was well understood, so it was down to a content creation problem from a production standpoint. So I could rely on my design lead and my art lead to be able to estimate how much work was going to be done. Since these guys had already worked with the engine and the process, this brought a lot of predictability. It was a shipped product and so there wasn't even a moving feature set at that time, which there usually is when you're trying to ship a game. So this was a known set of technology with a known and well-understood process.

By contrast, the shipping product is different – there you're doing engineering features, art, design, audio, and in those cases you need all of your leads engaged. You need to do a great amount of due diligence, as well, to determine what's there, what's not there. What's expected of you? Is it possible? What tools do you need to be successful? And a lot of other upfront investigation to understand not just the scope of the problem, but to understand what technology you have to work with.

And this goes for the partner itself, too. I'd extend this to say that in the production realm you need to understand the infrastructure that is in place on their side to support you as a partner. What kind of infrastructure do they have in place for communicating with you, and approvals, and all of that?

Q: Do you recommend phone calls, e-mails, or in-person meetings for these kinds of kickoff discussions?

A: If you're talking about kicking off a project, it should be in person, and honestly you're talking about a series of in-person meetings and discussions. For a new relationship, on the partner side, they are going to be doing due diligence trips to find out if you can do the job, if you have what it takes. But I think a mistake that development people could make is to not do their own due diligence to determine answers to some of these questions I've mentioned. From their standpoint, they are trying to decide if you have the people in place, have the process in place to do the job. But I also recommend that to be successful from your standpoint, you need to do a trip to understand what technologies and infrastructures are in place, what their processes for approval, feedback, milestone acceptance are. What's their communications infrastructure? Do they have people in place for communicating full-time with you, the developer, as well?

Q: Let's imagine that you've done your due diligence trips, the relationship has been kicked off, and everyone is happy. You've gone through pre-production, you've done the obvious things you need to do to make sure the project is going to be successful and that all key stakeholders are aligned. What are some of the non-obvious things that you've learned to do through your years of experience that will help keep the finaling process from being hellish on your team?

A: I think that having your development process well understood is one. Whether you're talking co-development or a full game, you need to make sure that you've identified the key questions that need to be answered and that by the end of pre-production you've answered them. What's usually obvious to people is that they need to answer questions that relate to gameplay and what's going to be fun. But on the production side as well, there are a lot of questions that need to be answered. What is your process for development? What are your constraints for time and resources? What is the feedback loop you need to consider from your partner side? How much time do they need in order to be able to give feedback? How much buffer do you need to put into the schedule in order to make sure that their feedback is delivered and considered?

So these are all things that you need to carefully consider before exiting pre-production. Do we know what we're making? Have we answered all the key questions? Do we know about core gameplay? Do we have our process in place? Do we know the phases of production and the gates? Even for a map team, we're going to go through paper design, for example, get that signed off and then we're going to block out. Then we're going to detail.

Then we're going to final. And we know what happens at each of those stages. Have you worked all of that out? If so, then you're ready to exit pre-production.

Q: Once you've entered the production phase, what do you think is the right time for a distributed developer to engage the QA leads on the publisher or core team side in order to start establishing open communication, so as to smooth things out in the finaling phase?

A: Some of it is driven by the partner. If, like we were, you're working with a major partner on a big effort, where you are a small cog in this giant machine, then honestly there is a lot to understand about how you are going to fit into their process. And there is a lot to understand about how they are going to want to have you interact with their QA department. And that's part of the early due diligence, and it's part of what you need to understand by the end of pre-production.

It's not always going to be crystal clear because oftentimes you won't know until you hit that phase, but it means being constantly mindful of how, from the partner's side, they are going to use QA, and how you should be presenting material to be inspected by QA.

Q: In general, do you recommend that distributed development teams like the ones that you run communicate and have open discussions with publisher-side QA and certification? Or should that be run through a central team?

A: I think it works best if you have an open line between your QA and their QA. And ideally, even in a world where they are running QA and certification and all of those kinds of finaling processes as they relate to quality assurance, you still have some of that duplicated on your side, for two reasons.

One, because you want a direct line of communication to their QA dedicated to being tapped into their world. And two, because you need to do your own quality control. Just as with internal development where you aren't going to just throw things over the wall and let QA catch it, when you're external, it's even more important that the work you deliver is high quality. What you are checking in and delivering to your partner needs to be rock solid, and you need to have done your own quality assurance as part of being a good partner.

Q: So let's say you've made it through production successfully, you've reached a beta phase in which all your content and your features are good and locked down. It's time to close out the project. When you first embark on this finaling phase, what are some of the things you think are most important for small distributed development teams to keep in mind?

A: One thing that is really hard to grasp, especially when you're in a case like we were where you're working on a major franchise, huge production, a massive development

team who needs to be successful across multiple platforms and hit the triple-A quality bar that they are going for, is the speed at which that team will move. You need to understand very well that breakneck speed. You in your small cocoon with a few developers are insulated and need to remember that over on that side there might be 150 people working incredibly hard, 14 or 16 hours a day. Your ability to respond and be able to turn around changes on a dime is critical.

Q: How do you set your internal team up for success in that environment? How can you respond quickly and crisply to requests from a partner and turn things around quickly?

A: A lot of it is the steps you took to get there, understanding the gates along the way. Ideally you had those gates along the way to check for completion. And if you've done a good job and have been rigorous, and your internal QA has been rigorous, then hopefully you've entered the post-beta finaling phase in really good shape. You have a checklist. You've gone through your checklist. You've been rigorous about quality control and ideally you're just responding to these ad hoc issues that crop up as you go along.

Q: Do you recommend that teams at this phase begin tracking all issues in some sort of defect tracking software?

A: Yes, and honestly, what we've found that works best is to adopt the processes that our partners use and become part of their database.

Q: So have the core team host the bug tracking database, and have the distributed developers learn to work in whatever system that is?

A: Yes. That's critical. We talked earlier about how to successfully interface with their QA department. This is one of those answers. Understand their process. Adapt to it. This is how they work. It's their big machine, and this is how you fit into it. You need to be very quick and adaptable. Get tapped into their bug triage process.

Q: In an ideal case, who assigns out the bugs to the distributed development teams?

A: It's a really good question that taps into the key problem to solve. I've just said that you need to tap into their process, but how do you keep your own process intact? Because at the same time, you need your internal QA to work, and your internal staff needs to be able to get things done. So one way we did it that worked is to use their database, have them assign all bugs for us to one triage-specific account.

Then you have your own internal process for triaging. Every day we review all the bugs, figure out priorities, and distribute them. If there is a question of priorities or a disagreement then the producer gets on the phone with the partner and figures it out to make

sure we've got it right. It's not unlike the internal process that you'd use for triage and finaling. But in this case someone else is filling your plate with bugs and prioritizing the work. So you need to be really diligent about making sure that the right bugs are on your plate, and be quick to respond if they aren't.

Q: In cases where your team and the QA team may not be in the same time zone or even close to the same time zone, how do you protect your team from having to be on call 24 hours a day when bugs come in from remote parts of the world?

A: Depends on which phase you're talking about. If you're talking about the absolute last phase, where you are going to cert in 4 days, then there is no protection, and your team needs to be on call 24 hours a day and ready to deal with that kind of thing.

If you're talking about earlier in the process then it's all about establishing a rhythm. In our case, recently, we were two time zones separated from most of our QA. And honestly, our teams like to work early. So we established a routine of coming in early, triaging, and assigning everything out. Then we'd have most of the bugs fixed by the time that team got in later in the afternoon. That's the kind of routine you need to establish with your partner.

But remember, again, that with big teams who are going really really fast, they are used to an immediacy of fixes. So in some cases you just need to have some people on call who are ready to come in to fix. And actually, I'd say that's always the case, just sometimes it's not needed and you don't have to rely on it.

Q: What are the first things you look to do to problem solve when the number of bugs your team is responsible for suddenly gets out of control?

A: First you need to look at what changed. Is this a proper reflection of what you're working on, or is there some root cause that might have caused this great influx of bugs? That's where you start.

Second, is the quality of the bugs you're getting good? Or did someone just add a brand new team of interns and you're getting an influx of not-so-high-quality bugs? If that's the case then there is a way to work through that.

If the case is that they are quality bugs and there is no root cause, and you just have a ton of defects in what you're working on, then the question becomes, "What is the trajectory to finishing?" Is there something you can do to make up time? Understand what that ramp down is and how these new bugs affect that and if so, what can you do to get back to a favorable trajectory. Can you apply more resources? Is there more effect that can be put in?

Assuming you have made it to the finaling phase by going through the proper gates, then scope is probably the last thing you're checking. You probably got here with a scope

that everyone wants to ship with. But as a last resort, can you cut something from the game if it really is an egregious problem?

Q: If you find a particularly buggy corner of the game or feature that is responsible for a disproportionate number of bugs, how do you go about evaluating which is riskier, cutting the feature or trying to fix it?

A: As an external partner in a distributed development relationship, it's important to understand how much is in your domain, your area of control. If it is entirely in your domain, then you get some in-depth analysis from your team on what it will take to fix and what your mitigation plans are. You assess the risks and start discussing your different options with your partner. And ultimately you come in recommending a solution and being clear on the risks. But don't make those decisions on your own or in a vacuum.

Communication and transparency are critical.

Q: Is there anything else about the finaling process that you think readers who are embarking on these kinds of journeys should keep in mind?

A: As a small, fledgling startup shop, one thing that surprised us during the finaling process was the IT needs required to final a game this big. It didn't catch us completely off guard, but picture working with a 150-plus person team, in this case with Treyarch QA, Activision QA, Certification QA, and a huge host of people working on the project. So the number of check-ins every day and just the sheer amount of data that needs to be passed around back and forth are incredible.

Q: Are there steps that you think small teams can take up front to prepare their IT departments, infrastructure, or support staff for this kind of strain?

A: Yes. Probably at the beginning of the process when we discussed who to involve in planning, I didn't mention IT. IT should definitely be involved in early planning and working with your partner's IT department to help make sure everyone understands what it's going to take at its peak and that you're prepared.

Q: Any final words for anyone who is trying to get their small studio into a distributed development role and wants to set their teams up for success in finaling projects?

A: Yes. When you're entering into a co-development project, which is likely, where you aren't solely responsible but are instead partnering with someone else who is ultimately responsible for the quality of the project, there is an adjustment you need to make. You'll be working for a client. And that's a change, because we're in game development, and most of us have strong ideas about what's right and what's wrong, and you need to make sure that your ideas are aligned with what your partners are looking for.

You have your independent development team, and you have your own internal quality controls, but at the end of the day you need to make sure that you know what quality looks like to them, because they may have different standards than you. Quality is very subjective. In the end you're catering to their standards. The sooner you get this alignment, the sooner you'll be successful. If you don't get this figured out your relationship with be filled with trouble.

6.9 The Postmortem

Postmortems are a well-understood project management tool. The venerable *Game Developer* magazine publishes a sanitized version of one almost every month. Many developers diligently keep notes on what went right and wrong, even during the darkest parts of project crunch. So why is it that distributed development teams so seldom follow through on having a postmortem once their game is released?

Most likely, no one wants to pay the cost of flying a collection of teams (or even team leads) to a central location once the game has launched. In addition, as we'll discuss later, once a game is done, it's often yesterday's news, and everyone begins busying themselves by thinking about the next great thing. Maybe teams are just sick enough of one another that they don't want to get together to rehash the last battle. Also, there is the possibility that airing "dirty laundry" during a postmortem might damage a relationship critical to one or all of the teams involved.

Despite everyone's best intentions during a project, this useful tool is less frequently used than one would like. But I'm here to tell you what you veterans already know: If you don't sit down and have an open dialog about what went right and what went wrong during a project, it's unlikely that the next go around will be much better. Open communication and sunlight are the best disinfectants for any nasty little sickness that can poison distributed development relationships over time. Get together with your partners and collaborators, and work hard to give everyone a voice.

Take enough time. Give yourself and your team enough time to get away from the project for a few days or weeks before jumping into the postmortem. Immediately after ship, people get frayed, sometimes badly. Their priorities become strange, and they are often exhausted. Their personal relationships outside of work are often crumbling from lack of proper attention. Take a few weeks to get some perspective and let your teams remember who they are outside of the context of the project. Then, for the postmortem, take more time. Don't rush through it all in one day. Send out surveys to gather information and give people a few days to ruminate upon them. Then schedule your in-person postmortems in two parts; don't try to keep everyone in a room for 6 hours in a single day. It's exhausting, and it doesn't give folks the proper time to mull over the important issues and to look for solutions.

The following are tips for how to hold a productive postmortem:

- Encourage everyone on all projects to keep a running notebook of suggestions and points of friction during the development process.

- Use SurveyMonkey-style surveys to gather information on quantitative feedback. However, be aware that this type of data tends to be much less valuable than longer form, qualitative information.

- Try to involve every member of development on every team, if possible. If you asked someone to work on this project, take the time to listen to their feedback about how it went.

- Allow for both anonymous feedback mechanisms and open discussion. Each solicits opinions from a different type of personality, and each generates a different type of information.

- Use leads to help identify common issues and comments from among their staff in cases in which it's impractical to host postmortems for an entire team.

- Encourage leads to solicit positive as well as negative feedback from their reports. Postmortems can easily become weighted down with vitriol. Seek to elicit feedback on what went well too.

- Always follow up a postmortem with a memo describing lessons learned and action items that describe how things will be different as a result of the feedback you've gathered. Little demoralizes a team faster than feeling like their well-reasoned suggestions have fallen on deaf ears.

- Use impartial moderators who were not involved with the development of a project to facilitate less polarized discussions. This person should be wise, judicious, impartial, and dispassionate.

- Try hard to avoid letting distributed development postmortems become extended sessions of "us versus them" axe grinding.

Figure 6.2 provides a checklist of topics you should cover in your postmortem. Add topics you know to be hot buttons for your team, and ignore those that don't apply. Clearly, the "answers" to each of these categories can't be put nicely into a spreadsheet without stripping them of the nuances that makes them matter, so use this as a guide for a more qualitative discussion.

6.10 Planning for Your Next Date

The game is out. People love it. Metacritic had to invent a new ratings system because the game scored so high. The fans are naming their children after your main character, and your paycheck has never been fatter. Congratulations!

But wait! There's franchise planning to be done if you're on the publisher side. Also, you've got to work with marketing to generate more assets if you're going

FIGURE
6.2

	What Went Well	What Went Badly	Take Home
Project Management			
Scheduling			
Task Allocation			
Resources			
Setting Goals			
Inner-team			
Communication			
Processes			
Sub-group Leadership			
Hardware & Software			
Tools & Pipelines			
Roles & Responsibilities			
Workload			
Intra-team			
Communication			
Site Visits			
Leadership			
Process			
Tools & Pipelines			
Workload			
Trust			
Product Design			
High Level			
Detailed Specs			
Documentation			
Feature Design			
Content Design			
Artwork & Art Direction			
Audio			
Design Change Process			
Final Quality			
Business			
Profitability			
Cost Overruns			
Contracts			
Subcontractors			

Topics for Postmortem Discussion

to keep the buzz high. There might be a patch required because your community manager is telling you that some people on a forum somewhere are complaining that the campaign isn't long enough and that there's one part of a level that's a little too easy. There's also a whisper of that lingering bug that QA was never able to fully find a repro case for and you got waived through cert. Then, of course, your fans are hungry for some downloadable content, and they want it yesterday. Of course, some PDLC would sure go a long way toward helping amortize some of those fat development costs you were forced to pay out. And on and on.

On the other side, if you're a developer, you've probably got a collection of hungry mouths to feed next month too, and all the milestone payment for final archiving just hit your bank account. A bigger chunk of it than you'd have liked was taken up by past due payments to the subcontractors who helped you get the game across the finish line, so there's not quite enough left to dole out the profit sharing that you'd promised. In addition, you're fully staffed now and have all of these high-end workstations and dev kits, and if you don't have something to do on them soon, the publisher is going to want them back.

Almost before the ink on the manual is dry, it's time to start planning your next engagement.

As the past few paragraphs illustrate, the exact steps you need to take (and the reasons) diverge greatly based on what type of group you're in charge of.

6.10.1 *For Publishers*

Keep communication with your developers open and constant. Because a potential follow-up title is lifeblood for small development houses, they're likely to be much less sanguine than you about the time in between projects. Although you've (probably) got no obligation to use the same developer again for anything, if things went well, you'll want to do so. The best way to make sure they don't end up rushing into the arms of another project or publisher is to be open and clear about your interest in working together again. This seems like common sense, but often after a game ships, the external production team at a publishing house goes dark. Now, as anyone on the inside knows, this is usually for very good and nonnefarious reasons. Everyone wants a little time off after a difficult birthing process. You may need to wait for sales data to determine if a sequel makes sense. There's usually a little shuffling of resources between projects, where those who succeeded ascend to bigger and better roles, and so on. All of this takes time, and it's quite reasonable to need 2–6 months after a project launch to determine your next move. But don't expect developers (especially small one- or two-team houses) to wait around indefinitely, particularly if you're not communicative. Touch base weekly.

As a way of giving your developer enough bread to survive (and generate some additional revenue for your shareholders) while you are working out the next big thing, consider building downloadable content. The costs tend to be low, and your

developers are already staffed with the right people and the right tools to crank out a little more to keep your customers engaged.

It's also likely that at some point, you're going to need to consider how to formalize a longer term relationship with the developer. There have been times when our industry was expansionist enough that once a developer made a few hit titles for a publisher, acquisition was the next step. Publishers would reach for a checkbook and snap up the development house and then spend the next year trying to get the studio integrated such that it could make another game. Some of these stories worked out well for everyone involved. Other acquisitions ended up with dead golden geese. Luckily, these days, everyone seems to have paid enough attention to the failures such that integration of acquired studios tends to be handled much more delicately than it once was. Beyond this, the pendulum that seemed to have swung away from the expansionist/acquisitive mind-set from 2004 to 2008 seems to be swinging back.

However, there are other ways to formalize a relationship with developers short of buying them. For starters, it's common for many contracts to include a right of first refusal for a developer's next game. A clause such as this essentially requests that if the developer wants to build a new game, it must approach its current publisher with the project proposal first. Beyond that, almost any kind of "master work" agreement can be put in place. This helps developers because they have a greater guarantee of work (usually, the master work agreement includes some kind of a cancellation clause that is stronger than that found in a one-off contract). This helps the publisher because individual teams don't have to constantly renegotiate for man-month rates and other common details of the project.

If you've found a developer who has executed well on a project and you believe there will be value in continuing the relationship on future games, consider putting at least some formal statement of the relationship together. It will make all future engagements easier.

6.10.2 *For Developers*

Your project is done, the milestone payments are about to stop, and you're looking at potentially hundreds of thousands of dollars a month in staff costs that are about to start burning through all the profits from your last job. It's easy, when in this position, to get panicked and get yourself into a disadvantageous bargaining position. Here are a few tips to help:

- Start negotiating follow-up terms early under the assumption that the first project will be a success. It takes a long time to get a new deal in place and people usually shuffle around after project completion. Try to get at least the framework of a deal ready before the folks who ran the game you just finished have moved on.

- Remember that your publisher very likely doesn't have the same urgency that you have to get a new deal done. It has cash reserves and lots of other projects

bringing in revenue typically, so it just is not in the same rush to get something signed as you are. Don't misinterpret a lack of haste on a publisher's side as a lack of interest in you. The publisher just isn't going to move as quickly as you'd like typically.

- Don't be afraid to keep after a publisher to get the next deal lined up, but don't come across as desperate. Desperation reduces your bargaining power. Besides, you don't want to have just one potential deal lined up. If for some reason the publisher can't sign you to do another game just yet, you need other potential suitors who can fill that void. Don't be afraid to court other suitors. There's no shame in talking to everyone you might be able to do business with.

- Consider having someone in your studio who is dedicated to business development. It's difficult when you are running a small studio to be able to afford the overhead associated with an employee who isn't billable to the publisher. However, having the right kind of person in this role can ensure that you never carry a staff without paying projects, and that can mean the difference between success and bankruptcy.

Now go get in touch with senior people at your publishing house and visit with them about other potential projects your teams could help with!

6.11 Summary

We've covered a lot here, from how to run milestones to how to final a product, how to conduct a postmortem, and getting ready for the next project. In the next chapter, we discuss common problem situations and how to deal with them, how and when to conduct site visits, and some issues associated with intercultural communications.

Seven

Site Visits and Common Situations

At this point, we've talked our way through an entire project life cycle. In this penultimate chapter, we look more closely at some of the whys and wherefores of site visits. We also study a variety of common situations you're likely to run into during your distributed development engagements and how to mitigate their ill effects.

7.1 Site Visits

Have you ever been a part of a project in which every decision made by upper management ended up becoming viewed as out of touch, incompetent, or part of a malicious plot to deprive the people in the trenches of their dignity and their weekends? If you've ever been in the middle of one of these projects that starts sinking into an abyssal trench of morale, it can feel like there is no way out – that every decision top brass makes to try to improve things for the project is met with even more suspicion and hostility. On single team projects, this sort of situation is complex and typically only resolved when the game ships or when a few key figures are removed from the project.

For distributed development games, these kinds of problems typically lack the personal rancor that the single team hate-fest can quickly devolve into. The bad news is that this kind of problem is nearly endemic on co-development or distributed development projects. The good news is that because the distrust usually is based less on personal vitriol and more on a generic distrust of an unseen other, the problem tends to be easier to fix. So how do you fix it?

The short answer ties back to the theme of this chapter: Get over there and stop being a faceless villain! If it's impractical for you to personally get your boots on the ground, get trusted advisors there, and fast.

Although this lead-in scenario describes an extreme (if woefully common) situation with a clear starting point for a solution, the same salve can help identify and

doi: 10.1016/B978-0-240-81271-7.00007-2

cure a host of communications problems between distributed development teams. Fundamentally, these types of problems are a reflection of a lack of trust between people who don't understand one another's motivations.

To start to solve a problem such as this one, you need to get boots on the ground. Once there, your immediate steps are as follows:

- Demystify the team on the other end.

- Establish other teams as competent experts.

- Identify malcontents on-site.

- Identify support on-site.

- Establish a plan to fix communication and trust.

So what's the best way to stop a problem such as this before any of your teams ever get themselves into as twisted a knot as the one described previously? Repeat after me: "Get some boots on the ground!"

There is no way around it. You're going to need to spend a fair amount of time over "there," wherever there happens to be. (Often, "there" will be several different studios in different areas of the world.)

First, there's the obvious reason: Some types of communication are simply better handled face-to-face. You need to establish a certain level of rapport, and there's just no great way to do this without spending time in the physical presence of the people with whom you're going to communicate. The power of a smile, a handshake, a few late nights together sharing drinks or a meal – the long-term value of this kind of soft bonding cannot be overstated. Second, you've got to be there in order to avoid the types of problems described at the beginning of the chapter. Third, there's lots of work that is best done collaboratively on-site.

7.2 Who to Send and Why

Who exactly is the right person or people to send to work on-site? Most of the time, this is very project or situation specific. However, a good rule of thumb is that you want people on-site who you have invested with enough power to make good decisions or who have some knowledge so specific that they can help spread it to the local team. Send your best and brightest because communication or relationship problems caused by the abrasive or unimpressive can be very costly to repair.

In our discussion of key leads for the core team, we covered some of the department- and domain-specific characteristics that best serve distributed development leaders. When it's time to visit remote sites of your development team, those characteristics will come in handy. It's usually best to send leads you've selected for just that purpose.

A good practice is to have one person from your team who is the primary line of communication to a studio. This person should be a part of your travel envoy during nearly every visit. This establishes a bond and some consistency in communication.

But don't just send the same single person every time. Ensure that other members of your team, and representatives of other disciplines, get a chance to spend time on-site as well. Each individual will be able to form relationships with different people on-site and will notice new and different things about the project. Try to rotate the ancillary visitors out. It'll help your team grow, and it will foster deeper, multilevel relationships.

Now let's take a look at some of the reasons why you'll want to send people from one part of your development organism to another, at different times.

7.2.1 Critical Meetings

Hold important meetings in person. "Greenlight" meetings during which the game or key sections of the game are evaluated and given the go-ahead are often more useful if key representatives from each of the teams are present. Likewise, major gate meetings during which a leadership group plans how to handle the next phase of development are good times to bring key stakeholders from each team. Bringing leads from different teams together for critical pit stops along the road to completion will help the distributed organism gel and is much easier than trying to relay the minutes of a critical meeting through e-mail or similar.

7.2.2 Collaborative Creation

Some types of work are better done alongside a partner. If you have a lighting artist who is responsible for lighting a level, have him or her sit beside the designer who is scripting all of the encounters for the level, at least for a few days, so that the lighter can learn about the dramatic moments the designer intends. Before your audio crew spends time recording and polishing a bunch of sounds for the game, have them work alongside the engineer who implemented or integrated the system of audio hooks for the game; they'll end up with a much better understanding of how sound events are called and the parameters they should keep in mind when authoring the audio content. User experience or interface designers should sit alongside the engineers who will be implementing the front-end flow, at least for awhile. There are numerous tasks of these sorts. On an entirely local team, these types of tasks tend to naturally get collaborated on, informally. With distributed development, you'll need to be much more premeditative and rack up some air miles in order to encourage the same sort of thing, but it will be worth it.

7.2.3 Getting to Know Individual Strengths and Weaknesses

Ask anyone who has spent too much time flirting with someone on the Internet before meeting them: There's just no substitute for meeting someone in person.

Spend time on-site well in advance of the difficult finaling phases so that you can learn (or learn based on the reports of those who go) which members of the distributed team are really getting things done. Who runs the show on a daily basis? Who does the team turn to when they are confused? Often, these kinds of influential "soft leads" aren't the ones at the top of the organization chart. If you learn early on who you can place faith and trust in locally, you'll be in a much better position when things get challenging.

7.2.4 *Soaking up Their Attitude*

I recommend that on at least a few of your visits, you stay for more than 1 week. It's easy for a small team to put on a great face, have all hands on deck working hard on your project, have the office clean, etc. when you're only there for a few days. But go for an extended stay, over a weekend at least, and you'll learn much more about what the company and team are really like. As your presence there becomes familiar, and your role as an outsider fades, however slightly, into the background noise of the day-to-day job, you'll find that people's real personalities start to come out and you'll get to see how the place really runs. There is huge value in understanding how a team and its key influential members think about the world. Knowing their personalities more intimately will make it much easier for you to understand how they'll react to changes or challenges in the future.

7.2.5 *Troubleshooting*

Sometimes there are troubles with a partner that require on-site attention. These could involve pipelines or some other technical hurdle that requires an expert on the ground. In these cases, it might make sense for you to fly an expert from one of your other distributed teams to the site to help unravel the knot. Often, this can be a much faster solution to a complex technical problem than trying to remotely troubleshoot or relying on a team on the ground to become familiar enough with the technology to muddle through to a solution.

Other times, personnel, attitude, or process issues require leadership attention to get them resolved in a timely manner. In some cases, these problems may not even be apparent to local leadership or the local team. Thus, occasionally when on-site, you'll have to do some sleuthing to determine exactly what the problem is and what solution can be put in place. It's always better, however, to clearly communicate your concerns about potential problems and then enlist the help of the experts on-site who will still be there when you are gone (and your attention is focused on problems elsewhere).

7.2.6 *Celebrating*

"Leaders celebrate!" Jack Welch tells us. And he's right. One of the best ways to establish an esprit de corps is to celebrate your wins with the team. Plan to be on-site for the conclusion of major milestone pushes, if possible. After a grueling demo process has borne fruit for a team, be there with them to help celebrate. Help your teams and your partners get a sense for what you value and what success looks like. Before long, they'll start bringing in more of it.

Keep it reasonable, of course, and don't be the person who just shows up when it's time for the launch party and does keg stands. However, do go out of your way to use positive rewards to encourage good behavior. After all, everyone involved is making a game, and no matter how serious the deadline or the pressures involved, if you're not all having at least a little fun together, there's something wrong.

7.2.7 *Surprise Inspections*

No doubt about it, showing up or sending managing members of your leadership group to show up on-site without warning isn't very nice. You really shouldn't pull stunts like this unless you have some serious reason to believe that the leaders of one of your teams aren't being entirely upfront with you. I've heard some horror stories about development studios that filled up their offices for a day or two with warm bodies when "management" was in town but actually employed far fewer people than they were being paid for. In a case such as this, preannounced visits will never penetrate this veil of falsehood.

Be very careful about employing this technique. Just showing up on-site will send local team leaders into a flurry of worry, distract them from their regular jobs, and potentially unduly concern the team. On the other hand, if you think there's a chance that the developer you've hired filled an empty office with rented computers and day laborers for your due diligence trip, it might behoove you to show up unannounced sometime, if only to lay your fears to rest.

7.3 Representing Your Company and the Project While On-Site

One would like to think that there would be no need for a section informing employees on how to present themselves well during on-site visits. It seems that professionals of a senior-enough level to do on-site visits would know how to carry themselves. Sadly, experience shows that this is not always the case. Folks act like petty tyrants, let their personal appearance go to the dogs, forget their manners, get involved in inappropriate romances with local employees, stay up too late partying with the team, act lazy, slothful, and indolent, or generally act in ways that don't

cast their company or team in the best light. So here are some pointed reminders to share with your teams:

Be professional. Moderate your language. Even if you normally curse like a sailor, try to restrain yourself.

- Dress well every day. Your cleanest Megadeth T-shirt doesn't qualify. Pants or jeans and button-up shirts are a reasonable minimum for representing your company on-site.

- Keep your communications crisp, formal, and on topic. Keep focused on the task at hand and don't get engaged in small talk unless you're specifically taking time off to bond with the team, ideally off-site.

- Set an example with the hours that you keep. Be punctual, and if you really want to lead by example, be the first one in each morning and the last one out each night.

- Establish yourself as a conduit to other experts on other teams. Use your connections for good. Help connect local experts on-site with similar experts on other teams whom they may not have had exposure to.

- Don't become a bottlenecker. We've previously talked about how much harm can be done by well-meaning people who take on too much of the responsibility for decision making. Avoid the temptation to become one of these people.

- Build up local leadership. Once you have determined who can be trusted to get things done, work to support them, and let it be known that they have your trust. This can really help make a local leader more effective.

- Empower subgroup leads. In general, try to push decision making down the chain as far as possible as a way of getting the most out of people and avoiding the bottleneck problems we've discussed.

- Understand local flow of information and workflow. Perhaps the most important thing you can do when on-site is to work to understand how information flows through a local studio, understand efficiencies and inefficiencies in the local workflow, and then think about how to work with these processes or how to improve them.

7.4 Language Barriers

It seems likely that the curse put upon humanity after the fall of the Tower of Babel has been the largest impediment to man's collective achievement since we developed opposable thumbs. Any time you are collaborating with people in different areas of the world, whatever your role, lack of a common lingua franca is likely to prove a cause of friction your project will need to overcome. In plainer English, not being able to talk to your partners is difficult.

Although English has been the dominant common language of the entertainment software field for the past few decades, this is changing rapidly. Thus, although most of the major studios in places such as Pune and Shanghai still require that their employees speak English as a second language, the ascent of the profitable Chinese markets means that more development can be done in and for native speakers of Mandarin. Also, although most of the executives from the major French and German publishers speak fluent English, the relative decline of U.S. strength in global markets is making this less of a mandate than it has been in years past. In short, there are trends that suggest that we are moving away from a common language rather than continuing to converge. What should you do about this?

Let's assume that you and your various team leads are unlikely to have the time to master assorted foreign languages during the course of your project. I certainly encourage this kind of effort to bridge cultural chasms and highly recommend programs such as *Rosetta Stone* as a way to quickly pick up some basic working knowledge of another language. But I realize that it's unrealistic to expect that very much of your team will have the time for such an undertaking, and in any case, it takes even the very bright student years to achieve even a basic proficiency sufficient to discuss something as complex as software development.

So make sure that there are people on all sides of every team who do speak common languages. Typically, this will still be English, at least for the foreseeable future. When possible, determine who on the project has the strongest grasp of the nuances of that common language. Even if they aren't otherwise part of the discussions and planning, seek to bring them in whenever appropriate. It may also help to have them translate meeting notes or important documents for other team members. Failing this, you might consider hiring local translators. This is typically an inexpensive skill (compared to, for example, a knowledge of *Maya*), and a few translators on-site at the right times can come in handy.

Beyond this, focus on ensuring that communiqués, instructions, and documentation are all written in a style easily understood by folks for whom English is a second language. This book is a clear counterexample of how to approach this. Notice the dense blocks of text? Notice the complex, multiclause sentences that declare clearly that this is written by an English native for native English speakers? Avoid these traps. When writing communiqués for teams who are non-native speakers, do the following:

- Use bullet points.
- Use diagrams and pictures.
- Avoid figures of speech.
- Break up complex sentences.
- Capture instructional video to share.
- Show; don't tell.
- Get translators to translate key documents.

Interview with Frank Klier, Development Manager

"Coordinating Technical Solutions across Cultural Boundaries"

FIGURE
7.1

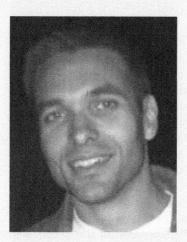

Frank Klier is a veteran software engineer with more than 14 years of experience creating tools, pipelines, and 3D graphics engine. Frank's titles include *Esoteria, Brute Force, Project Gotham Racing 3, Jade Empire, Gears of War,* and *Forza Motorsport.* Frank is currently a senior development manager for Microsoft Games Studios in Redmond, Washington. He can be reached at *Frank_klier@hotmail.com*

Q: Can you tell us a little about your background and your current role?

A: I have been a professional game programmer for 14 years. When I started out I wrote mostly tools and then moved into designing graphics engines. Now I'm a development manager for Microsoft Game Studios where I oversee the technical development of externally developed first-party games for the PC and Xbox 360.

Q: What are some of the biggest challenges you face working with development teams that reach across cultural boundaries?

A: Language differences and different workflow patterns are the biggest problems I've encountered.

Language is fairly obvious, but it extends to more than just the surface-level difference in spoken and written language. Good language interpreters do much more than translate words from language A to language B; they have to adjust for the tone and style of the statement to convey a similar meaning. Understanding something about your partners' language can help you to adjust your own language use to create a more direct mapping of statements and have fewer misunderstandings.

As for workflow patterns, other cultures may have ingrained styles of development that differ from what we're used to in the West. To get the maximum production from a team, it is important to understand how they work and not try to force a different style on them. A specific style may have been proven to be more productive on your old team, but it still might not be the best for a team of another culture. You can end up doing much more harm than good by trying to push another team too far from their comfort zone.

Q: What techniques have you found to work effectively to reach across the language barrier when collaborating on technical solutions?

A: Learning the basic constructs of the developer's native language helps because it can give you insight into how to better explain yourself and better understand your counterpart.

Work with your interpreters to document the base set of terminology early. Having a standard dictionary for interpreters to reference can save a lot of time and headache, and avoid situations where you may have a disagreement over the top priority problems, only to realize you were talking about the same thing but using different terms.

On the technical side, using pseudo-code examples makes things much clearer than trying to explain complex interactions in almost any spoken language.

Q: Are there any particular software tools you recommend to make collaboration across time zones and teams more effective?

A: For code sharing, *Perforce* servers with *Perforce* proxies are very useful. We have a script that syncs the local proxy in the early morning where the proxy is located so that the team there spends less time waiting for data.

For documents and binary build sharing we use auto-replicating fileshare locations.

For bug tracking we use a Microsoft internal tool called *Product Studio* that uses an SQL server to store and edit bugs. It allows us to track bugs in multiple languages and mark when a bug needs to be translated.

Q: Are certain types of software engineering challenges better suited to cross-cultural collaboration than others? Which ones?

A: UI design is an interesting challenge with cross-cultural teams. I believe that having feedback on the UI design from multiple developer locations does have a positive impact on accessibility. It forces you to be more careful with tool UI design as well.

Q: What are parts of a game that you would not want to ever distribute between teams in different places?

A: I think the core game object design/messaging system and graphics subsystem would be very difficult to work on in multiple locations.

Q: What's the most successful project you've ever collaborated on with developers in a different country? Why did it work out so well?

A: Hard to pick one out. Each title comes with its own set of problems to be worked through.

Q: What are potential pitfalls that teams about to embark on a project that spans time zones should be most on guard against?

A: You need to have robust documentation about how the game engine works. You also need more project managers to facilitate communication, since a lot of the hallway discussions that normally help you to avoid some issues don't take place.

Also, if you do need to deal with a language barrier it's important to have some multilingual team members at each location in addition to a dedicated translation team.

Q: Is there any other advice or personal anecdote that you'd like to share with our readers? Any situation in which working on a distributed development project has worked out particularly well for you?

A: As with anything else, always keep learning and try to make the best of the situation you find yourself in. In one project I was required to spend a significant amount of time in Japan. I was able to use the time there to begin to learn the Japanese language, since I could practice with almost everyone.

7.5 Cross-Pollination

Of late, larger R&D organizations and production houses have begun to talk more about "cross-pollinating" between departments and product groups. This is considered a best practice, as a way of helping seed the skills and thought processes that are commonplace in one part of an organization into another. As an example of this working well, it can frequently be helpful to take a person from marketing and embed him or her within a product development group for 6 months or 1 year. It helps marketing to better understand some of the realities of product creation and design constraints.

In a distributed development model, this may make sense for an initial kickoff period as a way of helping different groups absorb more of one another's culture, lexicon, habits, and worldview. For extended strategic relationships that you intend to cultivate across several product cycles, or in which there is some grand design for merger or acquisition in the future, seeding several people from each organism inside the other is highly recommended. In much the way that aquarists slowly acclimate new fish to the water by exposing them to the new environment in small doses over a few hours, so can cross-pollination between development groups help ease transitions and strengthen bonds of culture and trust.

It is highly recommended that for every 100 people collaborating on a project, at least 1 person from each team should visit the other team at any given time. In other words, try to keep a cross-pollination of approximately 2% between any two functional groups if you can afford it. It'll pay dividends in communication and cooperation, and it will strengthen both teams.

7.6 Dealing with Distractions

7.6.1 *Understanding Local Politics*

Leadership is not always obvious, and the way a team looks from an organizational chart or spreadsheet from 5000 miles away frequently isn't representative of the ways things look on the ground. There are many kinds of "soft" leadership, from domain experts who are constantly mentoring team members to the office clown who keeps everyone's spirits high and always knows which local bar is having an after-work drink special. You'll not be able to spot these folks without spending significant time around them. Also, you want to understand their roles – not because you necessarily need to meddle with the organic community that has evolved on-site but, rather, because without understanding these kinds of relationships, you're unlikely to know who really gets things done and what motivates the doers.

The second type of local politics you'll need to spend time on the ground to spot are the distractions or high-level forces working in opposition to your goals. An example of this might be a company vice president, project manager, or technical visionary who has a different agenda than getting your project completed on time. This will manifest itself as a constant drain on your resources, where people have an hour or two or a day or two of their time and attention refocused on a pet project or a different company initiative. Without spending time on-site, with each of the company leads, leaders, and key influencers, you'll not be able to spot this easily. Indeed, it is designed to be stealthy, hidden especially from you. How to deal with its presence is a matter of diplomatic finesse and very much depends on the particulars of your situation. Ideally, you'll be able to co-opt the leaders who are responsible into understanding that a successful completion of your project will help them more successfully achieve their own agendas.

Perhaps the most common case one typically runs into in the games industry is the "building our own IP" distraction. Most creative people really want to build their own products, games, or movies that appeal to them more than whatever it is they do to "pay the bills." I'm not sure I've ever met a developer who didn't have some of his or her own technology or IP in the works. Usually, since this doesn't pay, it is worked on by the dedicated after hours or simply by "skimming" people from principal, paying projects. I suggest that this practice is endemic. It's usually quite easy to spot; see that room in which there are frenetic whiteboard scribblings, diagrams, and pictures of muscle-bound barbarians all over the walls? If it really has very little to do with the kids' spelling game you're building, and it's clearly a

focal point for the creative energies of the team, odds are good that it's the "next game" they are all hoping to make. Obviously, there are usually plenty of other signs as well.

An important point here is that you do not necessarily want to set yourself up in opposition to this competing agenda. First, because you are usually not present and are a de facto outsider, you'll likely not win the hearts and minds of the people you need to convince, which is your ultimate goal. Second, the kinds of creative energies and passions that teams pour into their own IP are often exactly the reason you hired them in the first place. Finally, by aligning yourself with this competing interest, you can likely get first crack at considering how it might fit into the larger agenda of your team, publisher, or company. Might you be able to partner up with your external partners to help them distribute their IP later?

Clearly, if you've identified a competing agenda that is damaging your project, usually because too many people you're paying are working on it, you'll need to take some action. Here are a few ways you should approach this kind of problem:

- Identify the resources being drained.

- Consider their impact on getting your project done.

- Determine who the key thought leaders for this distraction are and why they are invested in it.

- Assess the possible benefits and costs to your company or team by allowing it to continue.

- Work with local leads to ensure that your project is getting the staffing and attention you are paying for. Don't quibble to the last percentage point. If the deal is good at 90%, it's likely still good.

- Discuss candidly with key influencers your concerns about the situation. Stress your understanding of why the competing agenda is important to them, and work together to determine a way for both agendas to coexist peacefully.

7.6.2 Ferreting out Destructive Non-Work Distractions

There's another kind of distraction that is worth mentioning. These are the leisure or non-work pursuits that can start out harmless but end up putting a real strain on some teams. Anything from a *Counterstrike* addiction to a culturally ingrained drug or alcohol problem could start to seriously affect productivity, bandwidth, or other resources. Common ones I've seen include a gaming culture that starts too early ("It's 4 pm! Time for a *Halo* match!"), peer-to-peer file sharing that kills bandwidth needed for critical file transfers, and one team that had a burgeoning crack cocaine addiction that was making it a tad difficult for them to focus.

Your natural inclination will be not to meddle with the "culture" of a team by intruding on these non-work pastimes. Indeed, there may be occasions when it is appropriate or advantageous to build rapport by participating. (Obviously, lay off

the crack-rock, but there's nothing wrong with taking the team out for a pint or two on a Friday night.)

I encourage great restraint, however, in getting too involved. First, you need to maintain a fine balance between being friendly, approachable, and "one of the troops" and being a leader. In the end, the former is just one pathway to your goal, which should always be the latter. It may become necessary at some point for you to curtail some of these activities, which is much more difficult if you're an accomplice. Thus, I encourage expressing interest and not contravening the activity (e.g., "Yeah, *World of Warcraft* is a lot of fun; I had to quit playing a few years ago – just not enough time – but I really think it's a great game"). Then, if the activity is really becoming damaging, speak privately to local leaders about it. From getting IT to restrict bandwidth-intensive applications such as P2P file sharing to getting some ground rules laid down for how hungover a team member is really allowed to be when strolling in late, your best bet is to identify and then quietly work with local leads to curtail any activity that is threatening your project. Direct opposition makes you an enemy, and that's not where you want to be.

7.7 Cultural Differences

Here, I present a few words on China. In approximately 2001, China exploded as a destination for low-cost outsourcing. A strong artistic tradition and a rapidly expanding high-quality university system combined with low wages to make Shanghai and Beijing very attractive to Western developers looking for help with high-volume artwork. Things have changed, however, in the years since.

As Chinese companies have built up the knowledge required to make quality game art, they've moved from being ancillary outsourcers to a development powerhouse in their own right. These burgeoning skills have combined with economic policies that are becoming ever more pragmatic with regard to international business. China is now home to hundreds of development studios and a dozen or so publishers.

Finally, improving prosperity for the citizenry and the ever helpful results of Moore's law have made Internet access near ubiquitous in the population centers and even in many "smaller" cities. (Of course, a small city for China is still enormous by most European or North American standards.) Most "Internet bars" in Hong Kong, Shanghai, and Beijing are equipped with gaming machines that are capable of running high-end 3D games. China now has a burgeoning class of gamers numbering in the hundreds of millions. Although very few of them are console gamers, tens of thousands of new players are daily becoming indoctrinated into the mysteries of games such as *World of Warcraft*, *ZT Online*, *Counterstrike*, and a host of other Chinese-targeted products.

The point here is that China has gone from an art outsourcing destination to a full-blown gaming market that is rapidly becoming larger than the rest combined. With different tastes and platform expectations, Western developers will be

challenged to meet the demands of this new market. Also, with homegrown competition that is rapidly catching up to Europe and North America in development acumen, there is now a new breed of competitors – and partners – to consider.

Although it's beyond the scope of this book to provide detailed information on how to do business with Chinese companies, I offer a few tips:

- To visit, you'll need a visa issued by the Chinese government. These can either be very easy to come by or very difficult, depending entirely on who requests it. Make sure that the Chinese entity you're considering collaborating with handles this side of things.

- Although English is spoken by many in the major cities, you'll still need a translator for getting anything meaningful done. The amount of specific jargon involved in game design discussions means that your translator likely will need to be someone in the industry.

- The Chinese government has a number of guidelines for allowable content for games released in the Chinese market. Don't expect to be able to build a game and sell it in China without having a "fixer" who can communicate with government officials to ensure that your product meets their (often mercurial) standards.

- Local operator companies are typically required for MMO products in the region. They handle running servers with localized content; deal with microtransaction payment processing; and maintain relationships with the government, the Internet bars, and other vendors.

- Although much is made of the differences in cultural etiquette between Chinese and Western business negotiations, these differences seem to be largely superficial. Attention to hierarchy, respect, courtesy, and honesty are important, perhaps even slightly more so than in some Western organizations, but these are differences in dialect, not in the fundamental language of interaction.

7.8 Regional Conditions

Another fascinating topic is the more direct way that actual regional social conditions or politics can affect your goals in working with an external partner. An obvious example is some of the difficulties you might face when trying to make a product rated mature, which shows lots of skin, in a religiously conservative climate such as Pakistan. (This, by the way, is probably not a great idea.) Less obvious examples include local graft or protection money your team needs to pay in order to keep the lights on or keep equipment from being stolen. Some of the former Soviet states, such as the Ukraine, tend toward a certain level of endemic corruption, and doing business of any sort in China without the proper buy-in from local party officials is likely to be disastrous. You'll want to understand these regional specifics in advance because learning some of these lessons the hard way can be very costly or even life threatening.

The following are suggestions on how to avoid trouble from outside the office while working with remote teams.

- Ideally, the leaders of the company or team need to be from the region. They will be attuned to the nuances of the local situation in a way that an outsider can almost never be. A couple of Caucasian Canadians trying to open a new business in Mexico are likely to find it difficult to get things done; a couple of Caucasian Canadians trying to start a business in Kiev are likely to end up as hostages if they aren't lucky and careful.

- Keep a close eye on U.S. State Department warnings (http://travel.state.gov/travel/cis_pa_tw/cis_pa_tw_1168.html). If the political situation in a place is deteriorating rapidly, you'll want to know. Likewise, everything from major terrorist initiatives to petty crime warnings will be covered. Don't be scared, just be informed.

- In many places, you'll want a local handler. Just a day or so of exploration with a person who is paid to keep you out of harm's way and is intimately knowledgeable about how things get done can make all the difference. If the company you're working with locally doesn't have someone, your hotel certainly can recommend a guide. This is particularly critical if you don't speak the local language.

- If there are governmental groups you need to deal with (i.e., China), then you're best off getting local teams to do the dealing; they'll understand the process, and it'll likely cost them far less than it would you. If this isn't possible, or the deal is large enough that local teams can't be trusted to ensure that it runs without interference from regional governments, then you'll need to work with your parent company to acquire the special resources you'll need.

- Invest in American Express cards for your people who are likely to be on-site. Membership, as their commercials claim, really does have some privileges, especially when abroad. For example, American Express has offices in almost every major city, which will help your people out of a jam if they get into one.

- Consider getting a traveler's medical and security assistance program under contract if you have many employees traveling to potentially unsafe areas regularly. Groups such as International SOS (http://www.internationalsos.com) or Medex (www.medexassist.com) and similar agencies will provide a bit of peace of mind by offering 24/7 emergency extractions, security, and other aid to travelers who find themselves in trouble anywhere in the world. Ninety-nine point nine percent of the time, no one on any of your teams will ever need this. But the one time they do, you'll be eternally glad you bought it. Because many of the major *Fortune* 500 companies already have contracts for this sort of thing, it may be worth asking your partners, if you're a smaller studio, if you can get people who need to travel regularly covered under their plan.

7.9 Helpful Tools for Staying in Touch with Home Base

Rapid advances in communications technology mean that (it is hoped) new and even better ways of facilitating communication will burst upon the scene in years to come. For today, however, let's look at five tools that are essential.

7.9.1 A Cell Phone with an International Rate Plan

Don't try to do business abroad without one. You want people in all offices with a stake in the project to have a "one-stop" phone number that they can call and get in touch with you or your surrogate decision makers immediately. Without an international rate plan, this can cost up to several dollars a minute.

7.9.2 Instant Messenger

It has become ubiquitous, and for good reason. Once you've settled on a company to work with, before the ink is even dry on the contract, I encourage you to send a mail requesting the IM address of all the leads with whom you're likely to work.

7.9.3 Skype

When you can plan a call, want to call home, or know you're going to sit in on an hour-long meeting, Skype is by far the cheapest way to call internationally. Also, you can set it up to project your cell phone number so that it's transparent to whomever you call; this is key for establishing the "brand" of your phone number in the minds of stakeholders.

7.9.4 Blackberry or Other Mobile E-mail Device

Yes, you need one. You can't get along without it and still be a project manager. With hundreds of e-mails per day, you need to be able to read and respond to queries from wherever you may happen to be. Also, since you'll likely be in transit (on buses, in airports, rickshaws, etc.) a fair amount, you'll not want to have to deal with the hassle of finding a wireless hotspot, booting up a laptop, etc. Even if you are not responsible for coordination between large numbers of people, I still strongly recommend that you have 24-hour access to e-mail; whatever your role, these days it's difficult to be effective without it. Luckily, with the ubiquity of the iPhone and other "smartphones" among the software development community, your teams are likely handling this task on their own.

7.9.5 *Remote Desktop*

It's built into Windows, and it lets you easily solve many of the slow-bandwidth problems you'll encounter. Since the machine you're remote-desktopping into either at home or at your head office is on a much faster connection to the resources you'll need, this will save you vast amounts of time. From defect tracking databases to internal *SharePoint* sites, you can have all the resources of a physical presence at your fingertips. Even if you don't keep an actual physical office, I'd recommend having IT set up a cheap machine at all sites you're likely to visit. You'll need a VPN setup for the various company networks you'll want to be inside in order to make this really work. However, the initial investment of a half-hour per site will pay off.

7.10 Failure Study: When the Schedule Is Wrong

Oops. The integration took 3 weeks, not 3 days, and now none of the levels will load because of a well-meaning but misguided change to the level loader code, which was implemented 2 weeks ago. Since then, it has had a large amount of technology built on top of it. Oh, and the postprocessing house just called, and it's going to take an extra 30 days and an extra $12,000 to process the FMV sequences. Now what?

Sometimes, despite the best efforts of everyone involved, project schedules slip. Tasks take longer than expected to complete, or whole new oceans of work appear that had never been part of the original plan but are seen as mission critical. Sometimes, the correct answer is simply that the game launch window will be delayed. If you're Blizzard or 3D Realms, "it's finished when it's finished" seems to be an acceptable answer. (At least for awhile, but even *Duke Nukem Forever* now seems to have fallen prey to the need to actually ship or sink.) For almost everyone else, "when it's finished" isn't an acceptable deadline. When your deadlines slip, and at some point they will, your choices are to

- Change what you're planning to ship by cutting features or content
- Recruit more help from subcontractors or elsewhere in your organization
- Change your schedule to adjust your ship dates

That's it. Unfortunately, there isn't any better advice I can give you in this case. When your early planning doesn't account for something major that arises, you just have to roll with it by changing the plan. There's no magic bullet, but there are often ways to minimize the painful impact of any of these possible solutions. In fact, if your team is highly distributed, you can potentially augment any of these solutions by leveraging your team's organization. Let's look at each choice individually.

Changing what you're planning to ship usually means cutting features. At least, cutting features is the obvious choice. It's painful, but it's often the right thing to do. As I've said elsewhere, the only thing more painful than having to cut something you've already

poured energy into is to have something that should have been cut end up appearing in your game and hurting the player experience. Try to keep this in mind when it comes time to murder your little darlings, and it might make the process a bit easier.

Also, keep in mind exactly why you're cutting the things you're going to cut, and make sure that your surgery is carefully crafted to have the maximum impact. It doesn't do much good to take the proverbial axe to a collection of small items when one or two more significant cuts might accomplish far more. In addition, since your team is distributed, it's likely that cuts in some areas simply won't help. So you need to focus your cuts in areas of the game that directly impact those teams in danger of falling behind.

Finally, determine if there are clever ways you can use these cuts to free up specialists in one area who might be able to take on some work that is causing problems elsewhere. You've got different teams with different characteristics. Can a few strategic cuts help you switch the work around in a way that will take advantage of your team organization? Can the multiplayer team cut one game mode that might free them up to take over the front-end tasks from struggling members of the main team? Can you give up on the idea of a third unique character skeleton and switch those animation resources over to helping script and animate world items to take pressure off your level designers?

Recruiting more help can frequently get you out of a scheduling jam, but it's never free and the costs are often higher than expected. First, there are the obvious dollar costs associated with having to hire additional specialized programmers, artists, designers, managers, etc. But worse than these purely financial costs, Fred Brooks taught us the lesson of the "mythical man-month" 30 years ago, and his observations prove as true today as they did then. Simply stated, while he was a program manager at IBM, Brooks observed that whenever a software project got into scheduling trouble, the tendency would be to "throw bodies at the problem." But many tasks, particularly complex engineering tasks, simply don't respond well just to having more people trying to resolve them. Brooks claimed that the communication and management overhead required to coordinate additional programmers and the time required for them to get up to speed on the project actually conspire to make tasks take longer, the greater the number of people thrown at them.

There's a lot of truth to this viewpoint, unfortunately. But you may still be able to cleverly bring on additional, experienced help to take on tasks that are not overly gated by dependencies. In fact, this is probably one of the more common uses of distributed development – as a way of pressing an emergency button to call in reinforcements when a team is overwhelmed. It's a poor substitute for proper planning up front, but sometimes it's the best of a collection of poor choices.

So how do you make adding people more effective by leveraging the power of distribution? Your best bet is to think about the problem the same way you did (or should have) during the beginning of the project. Look for discreet pieces that can be easily handed off to rescue teams. Are there large chunks of stand-alone work that can be sliced off and handed to a particular studio or team? Which major risks can you immediately negate by handing certain projects off to a team of dedicated specialists?

Needing to call in an emergency team to get you out of a jam is unfortunate, but it can save your game's bacon in some cases. This is a difficult job, however, and only experienced, professional teams that are very good at what they do should be called upon to parachute into a project on fire to help out. You should look for the following in an emergency team:

- Small numbers of experienced developers
- A track record of hitting tight schedules
- Proven experience on your target platform
- Experience with certification guidelines and processes
- Equipment and robust infrastructure in place
- Familiarity with your genre or style

When your schedule is off by a considerable amount, you may believe there is a real shortage of good options to get you out of a bind without tremendous expense or loss of face. But using some of the techniques discussed throughout this book, and leveraging the power of distributed development to bring in emergency teams or load balance cleverly, you can solve these sorts of problems and (sometimes) still ship something that will accomplish its goals.

7.10.1 *What to Do When Your People Are Spending Too Much Time On-Site*

There is a lot of value in on-site visits. As we'll discuss, cross-pollination between teams can break down communication barriers, help spread valuable knowledge, instill a sense of trust, and improve efficiency. But what do you do when this kind of travel becomes too one sided and you're in a situation in which people have spent weeks on-site and there's no end in sight? This is a common problem during a finaling phase. Teams can get hooked on the extra manpower or the expertise of on-site experts, and the needs of the project can quickly overwhelm any thoughts of or care for the individuals involved or their families.

My answer to teams stuck in this quandary is simple, if a tad British: Bring the boys back home.

Prolonged time on-site can have seriously detrimental effects on the productivity and personal lives of your team members. Ask any producer or team lead who has been around for more than a few ship cycles how many divorces on their team they feel some responsibility for. Most will get an embarrassed look and admit that they'd rather not think about it. Crunch time is difficult enough for people, but when they are far from home, perhaps even in a foreign land where they feel like an outsider, it can become downright unbearable. Yet few team members will simply quit under the pressure; usually they will instead stick it out beyond the point that it becomes unhealthy. It's up to the project leads to recognize this situation and put an end to it.

Set withdrawal dates in advance, and then stick to them. If the situation on the ground changes, as it invariably does, then make a firm rule never to extend someone's tour of duty by more than a week. Then get them out of there, even if it's just for a week of work back home. Invariably, the project will be able to recover, and even if it costs a few days of delay (which can be horribly expensive), it's almost always even more expensive to burn out a team and lose folks who were previously dedicated to the cause.

The following are other things you can do to make life easier for those who have to be on the road for extended periods:

- Offer to fly spouses or significant others to them.
- Offer a "combat pay" bonus for extended stays.
- Consider renting an apartment, flat, or house nearby for comfort and cost savings.
- Bring people home on weekends if the distance is not too great.
- Offer extended "comp time" for time served on-site; deliver on your offer.
- Swap out employees for fresh team members.
- Work to hand off critical knowledge to the local team.
- Try to have a producer or manager from the host team on-site along with other employees to provide air cover.

7.11 Failure Study: When Your Vision Is Clouded

It's challenging to admit that you were wrong. It's even more difficult to admit to something so grand as a failure of vision. But it happens, and sweeping something unpleasant under the proverbial rug never fixes a problem for long. So what to do? How can the vision of what the product is supposed to be become muddled or wind up far off target? What should you do about it?

There are likely two major ways a distributed development project can go astray from a vision standpoint. Either what everyone thought the game was supposed to be ended up being a bad target or there was a misunderstanding between the teams and different groups built games that diverged widely.

Either of these cases poses challenging problems. The later in the development cycle that this problem becomes clear to project leadership, the more difficult it is to course correct. So you'll want to be constantly vigilant for signs that either of these is the case. But how will you know?

7.11.1 *When You're Shooting for the Wrong Target*

It can occasionally come to pass in the course of a project that the market niche you expected the game to fill isn't possible for your team. (For example, maybe your group just doesn't have the artistry required to create truly frightening sequences

for a survival–horror game.) It might become painfully clear that the needs of your publisher or parent company have changed, meaning that your game no longer has the support it enjoyed at the beginning of the project. (Perhaps they have decided to pull out of the North American shooter market to focus investment on Chinese MMOs, etc.) Maybe you and the team hung your hat on a particular feature as being new and innovative, but it simply doesn't work; players in play tests hate it or they just don't get it.

The best way to prevent any of these disparate but categorically similar scenarios from becoming a nightmare for your team is to ensure that you are getting builds of the game in front of people as often as possible. Playtest early and often, even when the game isn't as polished as you (or the team) would like. Often, this can alert you to problems that everyone close to the frontline development might be unable to see. Seek out other people and teams in your organization and get their eyes on the game and hands on the controller; often they can alert you to winds of change that you might not have felt before they turn into the gale force storm that can capsize your project. In other words, early detection makes it much easier to apply a preventative change of course that can save your ship from crashing against the rocks if you'll permit the nautical metaphor to stretch so far.

Once you've found yourself in one of these messes, you're going to have to come up with a custom-fit solution. But here's the key: You need to find a new target for the game that will accomplish important goals. I recognize that this might sound insultingly vague, but if you realize that you're shooting for the wrong target – a game no one wants or no one wants to pay for – then you've got a fairly short amount of time to course correct. Also, there's no value (and a lot of harm to your career and your stakeholders' pocketbooks) in continuing on a worthless course, shooting for a target that's no longer worth hitting. Building and finaling a game is very difficult, even in the best circumstances. Save your teams from grinding themselves to dust on something that isn't going to accomplish any worthwhile goals.

This situation can offer a good chance to make use of the varied perspectives that your distributed team leads in all of your various sites and companies bring to the table. If you can't make the game you originally set out to build, are there creative ways to turn your game into something else? Maybe you can't pull off horror, but the multiplayer team is reporting lots of fun with a new "zombie killer" mode they've been toying with. Can you turn this into an online shooter? *Left4Dead* is a fine example of this notion pulled off well. If a strategic backer behind your development funding has collapsed, are there any interesting connections you can mine? (Maybe the team making the PSP version have been flirting with another publisher recently, one that just happens to be interested in moving into the North American shooter market.) Perhaps one of your other platform teams was unable to rely on what you'd hoped would be a killer feature because its hardware couldn't support it; what's the team's alternative solution? Might those mechanics translate over? Basically, having a team that is distributed, from different cultural backgrounds, and composed of nonhomogeneous parts, is a strength. Make use of these varied resources to look for a creative way to turn your at-risk game into a success for everyone involved.

7.12 Failure Case: When the Bugs Eat You

Uh oh. The numbers seldom lie, and these don't look good. Your bug count for a couple of versions of the product is way higher than that for the last version of the game at this time in the cycle – way higher. A little quick math tells you that everyone on this game is going to have to fix approximately 30 bugs a day for the next 3 weeks to get things back on track. Your top brass is pointing out politely that if you don't get this game to ZBR on time, then you'll miss your certification window, which will cost your publisher more money each day than you're likely to make in the next 30 years. The bugs are eating your project alive already, and your QA team in Montreal is due to report for work in 2 hours, which means you've got another 100 or so fresh ones coming in over the next 10 hours. What do you do?

When your distributed development game project starts to feel like a scene from *Starship Troopers*, you need to get it under control quickly. Out-of-control bug numbers are demoralizing, highly visible, and, worst of all, can indicate that your game may not be a very good one. On the other hand, they may mean nothing of the sort, and they definitely are a very measurable, quantifiable foe (Fig. 7.2).

The lower levels of QA staff in large quality assurance organizations are judged based on metrics. How many bugs do they find each shift? How many bugs are bounced back to them as being nonreproducible? If you employed 100 testers on a project for a year, they would find at least 100 things that could be considered defects each day for a year. That's their job! In a way, this problem is reminiscent of the situation in the early 1990s in which fear of a coming crime wave sparked police stations throughout the country to staff up hugely, which not surprisingly increased crime rates throughout the country because more cops caught more criminals. Pay someone to look for something, and they'll find it (if they want to keep their job). This observation is not to denigrate the fine work QA testers do (or law enforcement) but,

FIGURE
7.2

Advanced Bug Tracking System Circa 2008

rather, to explain an underlying truth about how and why the tide of bugs can so quickly swamp a project. In these cases, you should do the following:

- Work with QA leads to get bug finders focused on the areas of the game that need the most improvement, or that you can still fix, based on where you are in the development cycle.

- Assign people to cull bug databases and ensure that everything is properly assigned and has appropriate severity, priority, and good reproduction cases.

- Look for defects with common characteristics, and form hit teams to deal with high-incident areas of the game where they can kill lots of high-priority bugs with fewer changes.

- Consider cutting seriously buggy features.

- Work to rein in the tide by helping guide QA toward only those bugs with high enough severity that you'll consider fixing them.

- Establish dates by which noncritical bugs will start being "auto-shipped" so they don't get assigned out to the development team.

- Bring in heavy hitters from your distributed teams who can lend a hand without creating new bugs.

- Lock down high churn areas of the game that are creating many new bugs.

- Consider handing off an easily distributed section of the product to a different team.

- Motivate your teams by offering rewards for high bug-fix members, and make the bug counts and targets publicly visible.

- Work to get the serious, difficult to fix bugs identified; these will take disproportionate amounts of time to fix and are the real culprits that will make you miss certification.

7.13 Failure Case: The Decision-Making Bottleneck

It's a distressingly common scenario. Smart, alpha-type leaders succeed in life by following the mantra that "if you want something done right, you need to do it yourself." They earn success and accolades for being hard workers who get results. In many cases, their incredibly overdeveloped sense of work ethic and their complete lack of work/life balance is rewarded such that these "work all the time" muscles become overly dominant. They train everyone around them that nothing can or should proceed without their buy-in. They regularly override any decision made when they aren't around, and they become, for better or worse, the brain stem for their little corner of the world. Eventually, they end up in charge of a portion of the project that is too big for them, in which there are more critical decisions to make each day than even a superman could make in a 24-hour period. They take ownership of so many tasks that no amount of work ethic and brains could possibly allow them to succeed at all of them without some delegation. Then things grind to a halt because these people are completely unable to delegate effectively or empower others.

Sound familiar? One of the issues that exacerbate this type of problem is that the people who tend to be most guilty of bottlenecking are also often some of your most valuable contributors – your leaders. So how do you fix it?

These kinds of situations are almost never fixed from the bottom up. Unfortunately, there's a lot of the "I'm smarter than everyone else" mentality that tends to go along with the bottleneck personality type. This means that folks in this position usually have to feel pressure (which can come in the form of support) from above to bring in additional help and let go of some of the responsibility.

It's up to you as a leader, if you're above the bottleneck on the food chain, to work with the bottlenecker to identify a logical and productive way to subdivide the work. It's also up to you to work with the bottlenecker or other local leads to find the right type of person to help share the workload. Ability, personality, and work ethic are crucial characteristics for this person since it's easy for him or her to be seen initially as "taking" tasks that "belong to" the bottlenecker. The bottlenecker, if he has the characteristics described previously (which are present in almost every instance of this problem I've ever seen), will be resistant to accepting help and will be merciless about initial failures on behalf of anyone sent to assist him.

If you're below the bottlenecker on the food chain, you have the difficult problem of trying to gently persuade him to relinquish some decision-making control and get some help.

But what if the bottlenecks aren't the kind of pathological alphas I describe? What if they are just hard-working regular folks who happen to be a bottleneck for a particular task? In this case, your problem should be easier to fix because these people will often broadcast their distress, and they won't fight getting additional help to address the situation.

7.14 Hot Potato Projects

The case history reads like the dating history of a serial divorcee. This is a game that has been handed down from one team to another. Bodies and mangled teams can be seen from the rearview mirror of this wreck. The schedule has slipped and been pushed back a dozen times, and already a few Christmases have gone by without this one appearing under anyone's tree. Everyone in the marketing division has gotten as far from this project as they can at this point; they hand it off to the new guy who no one wants to succeed. But somehow, either because of a contractual obligation somewhere along the chain or because of someone with a burning passion to see this game through, the project doesn't die. It just keeps getting passed from one development team to the next.

And somehow it ended up in your lap. Now what?

These sorts of hot potato projects do exist, moving around the industry like a well-meaning disease that infects one team after another. In some cases, they've even become an industry in-joke, such as *Duke Nukem Forever* or *Starcraft Ghost*.

When you find yourself in a position to take on a project like this, there is usually something inherent in the project that is too compelling to walk away from. Often, these titles have had so much public exposure that the publisher or license holder is too embarrassed to just let them die. Perhaps (better still) there is someone high up in a publisher's organization somewhere who just really believes that this game can be great, if only it sees the light of day.

Your best bet is to first dig deep to determine why this project is still alive. Who needs it to ship? Whose egos are wrapped up in the matter? Is there a genuine product champion somewhere at a high level who is a true believer? Make it your first mission to find out why this geriatric beast refuses to lie down and die, and it'll help your chances to succeed where other teams have failed.

Second, dig into the case history to understand why it hasn't shipped yet. What went wrong for the other teams that worked on the project? Is there something inherently difficult about the material? Is there an unreasonable license holder who keeps scuttling the deal? Has the history of this game really just been the proverbial sequence of unfortunate events or is there more to the story? (There usually is.) It's tempting for people to just declare that the previous team was a bunch of idiots and dive right in. Look twice; a project that has been around awhile has likely had plenty of smart people involved in it. Avoid arrogance and really strive to understand why they failed to succeed.

Next, take a good look at the technology, code, and content that is being handed down. One common cause of serious overages and miserable development cycles is the problem of the "cursed inheritance." It may well be that working with an inherited code base, design, or set of content is making this project far more difficult to complete than it should be. It can often be the case that trying to understand, retrofit, and patch up poorly written code, or code that is unsuitable for a particular problem, can be much more time-consuming than starting fresh with more suitable technology. Is this a possibility here?

Finally, take a serious look at the schedule and the list of product specifications. Ideally, you'll do this before committing one or more teams to building the project. Try to apply a sharp and ruthless razor here to carve out the truly critical from those features that are just interesting or whose value is in doubt. Any game that has been around awhile usually carries a lot of old baggage with it, from the days when it was young and everyone involved still dreamed big, perhaps even so big that the promise of what the game might be ended up choking it to death.

For a project like this, until you've understood the four aspects described previously and redesigned your approach accordingly, there's little value in bringing on distributed teams to help. Shrink the number of key decision makers until you've turned this beast from a nightmare project that keeps getting passed around into a sober and manageable set of specifications and technologies. Once you've gotten buy-in from everyone who matters that the new, streamlined version of the software you propose building is something that the organization can live with, then you can start thinking about bringing in additional outside help to do the production work.

For games of this type, there will be a great deal of pressure to dive right in and finish the work someone else (or three or four someone elses) started. Resist. It's far better to understand the problem clearly and potentially abandon albatross legacy code than it is to jump right into production and be plagued by all the same problems that caused previous teams to fail.

7.15 Summary

We've talked about how and why to conduct site visits and about several of the types of common problems that occur in distributed development projects. We've talked about some of the intercultural issues that you'll want to consider. Finally, we discussed a few of the technologies you can use to keep in touch and tighten communication between your teams. Next, we'll wrap up by reviewing some of what we've discussed and muse about what the future might have in store.

Interview with Mark Greenshields, CEO of Firebrand Games

"How to Effectively Run a Distributed Game Development Studio"

FIGURE
7.3

Mark Greenshields has been making games professionally for more than 20 years. He is the founder and CEO of Firebrand Games, a game studio located in Glasgow, Scotland, and Merritt Island, Florida. Firebrand is best known for its work on racing titles, including the IGN DS Racing game of the year 2007 and 2008, *Race Driver: Create and Race* and *Race Driver: Grid*. Previously, Mark worked as the CEO of DC Studios and as a development director at Canal Media TV in France. Mark is credited on more than 50 shipped titles. He can be reached at *mark@firebrandgames.com*

Q: Can you tell us a little bit about your history and how you came to be the president of Firebrand Games?

A: I have been in the games industry since 1981. I started by writing teach-yourself programming books. I had three published books in the UK. I then progressed to a games programmer and coded about 35 games during my career, on platforms from the Vic 20, CBM 64 through to the Amiga and PC. Most were in *Assembler*. After founding other studios and working for 3 years in France as head of development for a French TV group, I founded Firebrand to bring together a top-notch team with my love of cars. Firebrand delivers quality because of the team and the passion we all have for what we do.

Q: Firebrand has two studios in different countries. How did this come to be? What strengths does your team derive from being co-located in Scotland and the United States?

A: I founded Firebrand in Glasgow because that is where an exceptional team was that I already employed through another venture. However, I did not want to live there (having spent 7 years in Canada). I needed a U.S. base and so Florida was my choice. This has been very good for us since although we have 41 staff, we have two studios in the 20-employees range, which gives a smaller "family" feel to each studio. I believe it increases productivity and the "give a toss" attitude needed, and removes the politics that invariably happens when you exceed 30 staff. Middle managers are the hardest to train right, and we have avoided that need by having two studios. We have the scale to do larger projects but not the politics!

Q: How do you decide the best way to divide up work between the two halves of the team?

A: Generally the expertise of the people concerned, location of our client, and team availability. No real rocket science, as both studios are top notch.

Q: What sorts of communications tools do your project leads use to keep the two studios in sync?

A: Weekly studio calls, IM, calls, frequent producer calls, and I visit the UK studio each month. Because everybody wants it to work, the effort is made and over 3 years it has proven a successful formula. But you have to work at it, as this is not an easy option.

Q: As a veteran studio, you likely get the luxury of picking projects that are strategically important for future growth. How do you go about evaluating potential projects to see if they are a good fit for Firebrand?

A: Firstly, is the brand good and is the publisher going to be around? We are a business first and foremost, so client stability is key. We also don't do substandard, chuck-it-at-the-wall-and-see-type games, and our success has fortunately given us the luxury of being able to choose the better games. We do turn projects down that don't fit. Most likely a

game will get turned down if we need a lot of crunch to do it, as we are a family friendly studio that limits crunch as much as possible. The weekends are meant to be family time, not additional dev time.

Q: What techniques has your team developed to ensure that you're always able to deliver quality games on time and on budget?

A: Very detailed production planning, a strict adherence to schedules, milestones, and timelines – and a bar to feature creep and continual change requests from our clients. Also, our team knows if they don't work well at the start they will have to work later, so we start working hard from day one. We also enforce the "if you are lazy we will fire you" mantra, and therefore we only employ people who want to work and work as part of our team. Dead wood gets removed by the team. So unlike a lot of studios, we don't have a "them and us" scenario. Our staff understands that a lazy bum is *not* their friend and is screwing them as well as the company. This is something unique as far as my experience goes, as too many places see a games developer as a place to browse the net, get free dinners, and IM all day, but not actually work. We ensure that the people who come to work here know they are here to *work*. To enjoy themselves and be proud of what they do, but to work between 9 and 6!

Q: What are some of the most challenging problems you've run into when collaborating on a project with a publisher? How did your team successfully resolve them?

A: The hard things are feature creep and when some publishers do not understand the difference between in-house employees and an external, third-party team. We work to schedules and content so we deliver high quality on time and get paid for it. Our pre-production phase is extensive, which is part of the reason we deliver on time and budget. Feature creep kills cash flow, profits, team morale, and often quality. A lot of publishers have now learned this, but there are still some who live in the dark ages. The other is when a publisher signs a specific game at a specific budget, but then when under way changes the spec and wants a lot more, but for the same cash in the same time. We behave professionally and show them the impact of their decisions, and usually this helps allay this. Noncombative discussions with accurate detail from our side are the most successful way. There are occasions you just have to do it but you learn the next time. Also, the biggest problem is with publishers with poor QA departments or a lack of understanding of the value that good and timely QA brings to a game. I could list examples but would not breach confidences, but poor QA on one title made for four submissions while a much more complex game with great QA passed the first time – and both were online games.

Q: What kind of subcontractors do you use? How do they help your teams run more efficiently?

A: We use artists and outsourcing art studios, mainly. We do have some freelance coders, but these are people who we employed before who moved away but wanted to continue working with us. The outsourcers stop us from having big teams that swallow cash

when there is no work for them to do. They allow us to do more projects at a time than we could do without them and keep our profitability up.

Q: When you think about the ways game development companies operate 10 years from now, what do you think will be the most likely changes?

A: I think there will be more distributed development. Games are getting more and more expensive to make, and expectations are getting higher. But revenues don't grow at the same rate. So a way of keeping quality high and costs controllable is essential. I think the model we use of the core people in house and out-of-house add-on workers is the way to go. It also removes the dead wood from the equation as why use 100 people to do a game that really needs 40? Highly detailed preplanning pays dividends and in the future people will question these huge teams and ensure that everyone is actually working.

Q: How can publishers' teams set up their externally developed projects for success more effectively?

A: Start them in good time (far too often contracts take months but the delivery date never changes). Know what they want from the start. Ensure they listen (but challenging is fine) to the developer when they say there are problems or these changes will have a negative impact. And the four most important – *pay* invoices in *less* than 30 days, stop feature creep and using inexperienced producers to manage an external team (unless there is good support), and get good QA early in the process. If the publisher's teams start thinking it is their money and not some faceless organization's, they might work differently.

Q: Any final advice you'd like to share with project leads who are planning how to work with development houses like Firebrand on their next game?

A: Yes, talk to us early in the process; do not wait until you *must* start, as then there is no time to plan properly. Ensure you *know* what is involved in the game and what you require, and tell us your budget. Secrecy does nobody favors. And when we say we cannot do it for that price, please believe we are a professional company that uses financial costing and planning like their CFO does, so our figures are *actual* and not just guesswork. And finally, remember to work *with* us and not against us. Unless we work as a team, the final result will never be as good as we both want. This is a collaborative process and that means collaborating.

Eight

Review, Conclusions, and the Future

There is never an end to a book like this, or at least it seems like we could easily go on for another thousand pages. With such a fascinating array of topics to talk about, and such nuance in the ways you can structure and manage groups of people, a person could study this matter for a lifetime and still have new things to learn. Also, as the hardware, software, and tastes of the game-buying public evolve, there is always some new challenge appearing. But (relative) brevity is said to be the soul of wit, and besides, we've all got games to make!

So let's quickly review the topics we've discussed and summarize the key lessons from each chapter. Then we'll close by taking a look at what the future of distributed development might hold.

8.1 A Review of What We've Discussed

8.1.1 *Chapter 1: Preface and Overview*

We started by talking about why you might need to know about distributed development and how the practices we discuss differ from traditional outsourcing (which is really just a subcomponent of distributed development). Whereas outsourcing traditionally is best used on well-understood tasks not requiring much in the way of exploration or complex engineering, distributed development seeks to bring together the collaborative power of widespread teams to accomplish more than would be practical with a single team whose members are located in the same geographical place.

doi: 10.1016/B978-0-240-81271-7.00008-4

8.1.2 *Chapter 2: Overview of the Development Process*

To give ourselves a common framework for discussing how to build games, we looked at the development process as a whole and established some standard terminology for each of the major phases most games go through on the road to ship.

We talked about the concept phase and why it's so important to get this part correct and avoid expensive time creating something no one wants. We talked about greenlight meetings and some of the things that can help make them go your way. (Show a great build!)

For getting a vertical slice of your game together using distributed development, we discussed exercising each part of your distributed team. We also looked at some of the things that most commonly go wrong the first time you try to spin up a newly distributed organism (most of which are technical and communications problems). We also talked about why it is so difficult to give pre-production the time and attention it deserves, and I cautioned against jumping into production as quickly as everyone on your team would like.

We talked about the milestone process in broad strokes and gave an overview of how to plan upcoming milestones. Then we discussed some of the challenges you'll face with integrations of different branches and previewed some of the problems we would delve into more deeply later. We looked at ways to leverage the advantages of our distributed team structure to bring a little peace and sanity to the demo process and discussed how important it is for project leads to manage the demo process by pushing back when necessary, lest it derail the production of the actual game. We foreshadowed our later discussions of the finaling process and studied some diagrams of sample time lines for alpha through ship. Next, we previewed the phase in which the certification process gives way to manufacturing and distribution. Finally, we talked about planning and organizing for titles you expect to patch or extend with post-ship content.

The key takeaway from this chapter is to understand the common phases of development. After reading it, I hope you have a broad sense for how they work together to create a product that has been proven to have mass appeal and how the phases fit together to help minimize the risk of a catastrophic failure or slip along the way.

8.1.3 *Chapter 3: Your World and Your Internal Team*

We began Chapter 3 by taking a look at how the basic revenue model for games works, in which consumers pay retailers for boxed products, some portion of the proceeds of which go to publishers, which then fund developers to create new products to put in boxes. We talked about the advantage of this model but also about some of the reasons why a new model would be more ideal. Groups such as Microsoft's Xbox Live! Arcade team and Valve's Steam group are working hard to create new digital distribution models that work, which are likely to have a significant impact on how we approach making games in the future.

Next, we discussed the most valuable types of characteristics of staff for your core teams, and from there we moved on to hiring criteria for a number of specific and critical leadership roles. Beyond strength in their individual disciplines, you should look to staff distributed development teams with expert communicators who can work flexible hours and are able to travel regularly, if needed.

Finally, we took a hard look (and a dim view) of insourcing, a situation in which you rely on centralized teams that have no allegiance to a particular project. We discussed some of the perils and some of the advantages of relying on this kind of support during production.

The most important point to keep in mind here is that the characteristics you'll use to select ideal members of the core team on a distributed development project are not the same criteria you might use when pulling together a team to build a game all by themselves. Diplomacy and a certain flexibility are critical.

8.1.4 *Chapter 4: External Partnerships*

After we talked about how to staff your internal crew, we moved on to discuss where to find partners and how to evaluate them. We discussed many ways to find a developer you'd like to hire, from popular websites to trade shows.

For developers, we took a good look at some ways to promote your studio. I issued a warning about how to limit your exposure to agents should you consider using one. We continued with warnings about how to evaluate development deals that you're offered. Definitions of the assignment, roles and responsibilities, and various types of pay you might try to receive from basic contracts were also discussed.

Next, we discussed some of the basics of a contract, starting with milestone definitions. We talked about how developers are compensated for their work, from milestone payments to back-end royalties and performance-based bonuses. I stressed the importance of making sure you establish a fixed man-month rate for future work that might arise and that is agreed upon to be outside the scope of the original agreement. We talked about termination clauses and how developers should be careful to get some protection here. Then we discussed the use of sub-contractors and why people care about getting this specified in a contract in order to avoid pass-through abuses. We talked about milestone acceptance rules and about why it might be helpful to structure parts of the deal in appendices. Next, we discussed the importance of thinking about the strategic value of deals you consider taking on as a small developer in the world of distributed development.

Finally, we explored an overview of all of the key stakeholder groups that are part of shipping this type of product. From marketing to first-party certification and localization, we covered the basics of all the groups that are part of the distributed development process.

It's critical that you do your due diligence in this early phase to ensure that you're choosing the right partners to collaborate with. You should be looking carefully at

the suitability of potential teams for the exact roles you need each distributed group to play in the project. As developers, you need to ensure that the contract you enter into for a distributed development project resolves as much ambiguity as possible up front, and that the deal is good enough to keep you alive and motivated for the length of the project.

8.1.5 *Chapter 5: Getting off on the Right Foot*

Your project is best started by establishing a shared vision. We talked about why this is so important, and we discussed various techniques for working out the vision for the game and communicating it to everyone in your distributed development organization. We talked about how just having some cool materials such as ripomatics or a mock box won't get you a shared vision. To do that, you'll have to get out there (or get key vision holders out there) to pound the pavement, visiting all of the teams in your organism.

Next, we discussed different ways to schedule a project, from Scrum to agile, lean to waterfall. Ultimately, you should use the appropriate combination of these tools for your project and push the specifics down to a lead or sublead level. Beware the temptation to let process get a stranglehold on progress; I warned of the overly zealous who become slavish adherents to a particular process dogma.

We then moved on to discuss how to schedule milestones and determine what kind of work should be performed for each milestone. We also looked at how to break up and coordinate work across different teams. We discussed how you progressively add detail to milestone definitions in order to build your game in a process-agnostic manner.

Then we considered how to divide work between distributed teams. First, we looked at logical similarities based on what we know about the platforms and the games. Next, we made some rough estimates for team sizes and their assignments at the highest level. From there, we briefly discussed some techniques for ensuring that the team-driven detailed schedules for production created around the time of your vertical slice are as accurate as possible. This kind of collaborative scheduling is the best (and likely only) way to get buy-in from all the teams in your distributed development universe.

We briefly talked about how important it is to determine in this early part of the project your exact criteria for success. Typically, this is some sales figure or set percentage return on investment.

Next, we covered those times when you need to have key meetings in person, as a prelude to the longer chapter on how to conduct site visits. We talked about the value of hammering out the project details in person with key leads and about getting all of your art directors or important artistic leads together at the beginning of the project to get things off on the right foot.

We discussed some of the problems that occur when teams get factionalized and how to set the right tone initially in order to avoid these sorts of problems.

From there, we moved on to discuss some of the types of software you'll need to get set up. First, we discussed source control software and some of the challenges involved in getting it running across multiple development sites. We also discussed a few of the high-level solutions you can consider for dealing with the common issues surrounding bandwidth. Then we looked at other useful common tools, from e-mail to instant messenger, and how to use them effectively on large distributed projects. (Etiquette is key.) We discussed the value of video conferencing and then dove into defect tracking software and how to think about its utility early so that it can save your bacon in the end game.

Above all, it's critical that you ensure that everyone on all the teams engaged in building the game has a shared vision for the ultimate goal. Then you need to make sure that the job is divided into coherent chunks that are as discreet as possible.

8.1.6 *Chapter 6: Maintaining the Organism*

First, we discussed ways to keep the milestone process clean. Try to focus on goals, not tasks. Don't rely on a disconnected QA team to gauge progress.

We then discussed how important it is that people have the right tools to do their job. As a developer, ask for what you need but no more. As a publisher, remember that hardware is cheaper than man-months.

We discussed how easy it can be for a leader to lose touch with the day-to-day pulse of development, especially with teams spread far and wide. We talked about how to know when things are going wrong. I emphasized that you should play every build every day, if possible. We moved on to talk about how you can use tracked metrics to help provide additional insight, but I warned against becoming too hooked on metrics, at the expense of following your senses. Finally, I advised that you break down communication silos in order to get better intelligence regarding how things are really going from the perspective of those in the trenches.

We discussed what to do when your time estimates are wrong. First, find out where your estimates were off. Second, determine if additional resources are the right answer. If they are, then procure and apply additional resources to fix the problem. We also talked about how important it is to keep your integrity, even in difficult situations.

Next, we discussed the thorny problem of how to handle the dissolution of a project or relationship. First, try to be graceful and avoid dismantling teams. Second, tread carefully and avoid lawsuits by following the contract.

We spent a lot of time in this chapter talking about how to make the finaling process better. Our topics here included the following:

- Be realistic about what can be accomplished.

- Don't rely on crunch.

217

- Encourage rest days.
- Use defect tracking databases to guide work.
- Broadcast the game's status regularly and widely.
- Make cuts early and often.
- Set aside enough time for certification and compliance.
- Keep your QA team close, but keep your QA managers closer.
- Lock down content intended for localization early.
- Run performance tests early and often.
- Test on target media early and often.
- Don't commit to launch dates until after beta, if possible.
- Remove dependencies between shared platforms early.
- Decouple platforms from one another at the right time.
- Empower the right people on each distributed team.
- Search for and eliminate bottleneckers.
- Communicate urgency to support staff; engage extras.
- Remove distractions.
- Set mini-goals; use short sprints.
- Become change adverse to reduce churn and increase stability.
- Lock the right people out at the right times.
- Establish good build practices and cadence early.
- Rigorously sanity test each CL that you intend to submit to QA before you submit it.
- Rely on your well-honed diplomatic skills.

Finally, we talked about how to plan for your next engagement with the same group. I advised developers to line up several suitors in order to ensure that if one deal falls through, they won't be left in the lurch. I also reminded the hopeful about how long it can take to get a deal done, how important it is to start early, and the importance of building up cash reserves so you can afford to be patient.

8.1.7 *Chapter 7: Site Visits and Common Situations*

In this chapter, we studied the whys and wherefores of site visits. Site visits can serve to strengthen bonds, be the most effective way of getting certain types of work done, and be the best way to cut through the fog of war to solve critical problems. We talked about the value of having one person serve as the primary point of communication to establish consistency and having a rotating coterie of people work to establish additional relationships across different levels.

We discussed the value of having some visits last more than 1 week to soak up important cultural nuances easily missed in a shorter visit. We also talked about the value of celebrating on-site with teams. We discussed surprise visits and why these might be valuable if things seem shady. But remember, these aren't a "nice" thing to do to a developer, so use this tool only if you are suspicious, and use it sparingly.

Later, we talked about some common sense rules for how to behave when you or your team is on-site. Most of these rules should be clear and obvious, but it seems that often, at least once during a project, someone violates some or all of them. A good summary of these rules is be a professional and lead by example.

We reviewed a few rules for clear communication when working with a staff that doesn't share a common language. Rely on translators, establish written documentation in the target language, and understand your audience for every communiqué. We also talked about the value of cross-pollenization and how teams that expect to work together for long periods of time can benefit from embedding staff on-site for extended periods of time.

The problem of local distractions, from having too much fun playing *World of Warcraft* to competing projects siphoning off energy, was discussed, and advice was given for how to quell this type of problem indirectly so as to not become an enemy.

We talked about emerging markets in China. We discussed the great potential of China as a consumer market and some of the challenges that developers or publishers that seek to enter this market face.

We continued on to discuss the need to monitor regional conditions when on-site. Be sure to monitor the U.S. State Department's travel warning website and have locals serve as the titular heads of any team you have in areas where cultural differences may be murky and the cost of doing business for outsiders may be far higher than it initially appears. Finally, we discussed the value of contracting a traveler's medical and security assistance program if you're going to have large numbers of employees traveling to potentially unstable regions of the world.

Next, we discussed the tools and software that your teams can use to keep in touch when traveling. Many of these are quite common already, such as smart phones with e-mail access and instant messaging services. Others, such as Skype or other VOIP services, can cut costs tremendously and aren't yet as commonly used as they should be.

From there, we discussed failure cases such as when the schedule is wrong. I emphasized the importance of understanding why your initial estimates were wrong. I offered a variety of practical solutions, including ways to find emergency teams to take over large chunks of a troubled project.

We next discussed the other side of the coin: What to do when your people are spending too much time on-site. This is an easy trap to fall into as a small developer, and it can be quite destructive to those who must spend weeks at a time away from their families. We discussed a laundry list of ways to make life easier when there is no good solution but to send team members to live on-site for extended periods. In short, the answer is to ease the burden on your people whenever you can.

We talked next about how to deal with a lack of shared vision on a project or how to salvage the situation when the product vision changes. Look hard to find a new goal that still has strategic or commercial value, and then realign your sights. Fortunately, the world is full of high-quality games that ended up being something quite different from what they started as.

Then we studied failure scenarios involving an overwhelming tide of bugs threatening to eat the team, like something out of a scene from *Starship Troopers*. We talked about how to work with QA, how to prioritize, how to group like issues, how to consider strategic amputations of parts of the game that are causing too many problems, and so on. We discussed the often related problem of the "bottlenecker," a team member or lead who ends up constricting the team's ability to make decisions effectively and who slows progress. There are ways to unclog the bottle, but it takes delicate social engineering.

Our next study in catastrophe focused on hot potato projects – games that keep getting passed around from one development team to another. We talked about how important it is to understand why someone still wants this project after it has started to look like damaged goods. Somewhere in the answer to this query lies the secret of how to make this project great. Second, I advised that anyone who inherits a project such as this should carefully examine the parts of the existing work that are really worth salvaging; it's typically less than would seem at first glance.

8.1.8 *Overall Conclusions*

Understand the development process and the different scheduling and project leadership tools at your disposal. Select and form the nucleus of your distributed development leadership team with great caution. Think carefully about how to break up the project into meaningful pieces that can be worked on with some autonomy and then brought together into a coherent package without great risk. Cast wide nets when searching for external partners, and apply rigor in evaluating their suitability. Ensure that the business side of things is clear, mutually agreeable, and tightly defined. Integrate QA leads into the process early. Play all the builds every day, and work hard to find ways to listen to what everyone on all your teams are telling you and what they aren't. Ensure that the right people are spending enough face time with one another.

If you can do all of these things, and also apply the rest of the lessons discussed in this book and the wisdom of the experts interviewed, then you'll be able to create games using distributed development.

I look forward to playing your creations.

8.2 What the Future Holds

Imagine new interfaces such as Wii 2 or Natal allow for much more sophisticated interface models. Users can now mime sophisticated *Assassin's Creed*-style climbing,

jumping, and execution motions, and their avatar onscreen will faithfully replicate the attacks. In fact, four at a time, per console, can do this in a pervasive, networked environment using heavily personalized avatars. But the Americans with Disabilities Act lobby gets involved and mandates that all games supporting these interface models also support the same quality of interaction with a standard controller. Now not only has the level of fidelity evolved a generation beyond the brilliant work done on *Assassin's Creed* but also you need to support this kind of motion set on heavily customized character models in game. Moreover, you need to support it on several controller types. What's your solution? You need a full studio assigned just to character animation work and controller inputs. Also, add a distributed team to your list.

Imagine Microsoft finally gets off the couch and into someone's pocket with an Xbox-family mobile device. At the same time, Apple, Sony, Nintendo, and Nokia all have similar models garnering major support. In fact, the handheld device market is now vastly larger than the console market (hardly a stretch of futurism), and you've got a combined total user base of approximately 300 million for your game. The great news is that each of these handheld devices can push almost the same level of visual output as a PS3 can today. But of course, attempts to one-up the competitor's hardware have led to significant variations among the hardware and the environment used to develop for it. So now, instead of "just" supporting 8 platforms for a AAA release, there are now 11 to support, and all of them require a level of attention to artistic detail that only the big 3 do today. What's your solution? Distributed development, with specialists on each platform working together to share assets when they can and branch when they must, all dealing with their own particular hardware certification and compliance guidelines.

Imagine China, India, and Brazil have exploded. Their combined 800 million gamers demand localized quality content based on their regional dialects, and they have the marketing clout to get it. At the same time, rampant piracy in these places (and everywhere else) hasn't subsided as bandwidth has become more affordable worldwide. Microtransactions are considered the standard solution, and that works great (but you need regularly refreshed content tailored to each culture and language, all cert'd, loc'd, and released on a monthly cadence). What's your solution for building all of this content? Distributed development content teams with a unique cultural awareness of the different markets, all coordinated by a central development and planning team that understands the feature needs of each and can support the macro-trend contortions the parent franchise needs to undergo annually.

Imagine 120 frames per second is standard. Fully articulated characters with 2 to 3 million polygons each and highly advanced skin, cloth, and hair shaders are able to explore vast, detailed, and ever-changing cityscapes filled with other highly detailed AI and player-controlled agents, all of whom are going about their daily business, all driven by a sophisticated AI back-end that allows for natural language conversation trees that are constantly being updated to reflect the state of the world and the deeds of the players within it. What's your solution (after you've

solved some serious hardware and software engineering challenges)? Distributed teams of brilliant engineers who can tackle the slew of high-rent technologies required to drive a game like this.

You can keep imagining future requirements for high-end entertainment software, and if you're like me, you can quite enjoy the exercise. However, the point here is obvious: As games become ever more complex, the number of highly specialized people required to bring them to life, to prepare them for various markets, and to support them as they go live continues to increase. You aren't going to be able to hire all of the top-notch artists, engineers, designers, and managers required to support these efforts in the same city. (There's just too much competition, and it's too difficult to manage teams so large.) So you're going to have to use distributed development to solve problems such as this.

Fortunately, at the same time, new generations of hyper-communications-literate developers are busy entering secondary and postsecondary education programs throughout the world, right now. The armies of game developers you need to make these visions reality (or to deal with them when they are foisted upon you) are out there training right now. The talented teams exist now, and their numbers are continuing to grow at an almost alarming rate.

Better still for our utopian futurist game development fantasies, the tools for collaborating are getting tighter every few months, and widespread use of highly advanced personal communication devices (e.g., iPhones) is making it much easier to collaborate with people who are geographically distant.

Of course, there are even larger challenges in this brave new world. We'll all be forced to accept a level of intercultural tolerance and cultural relativism that may make some people uncomfortable. Also, for those of us who are in the business of making games for a living now, the idea of having to compete with 10,000 or so new developers each year who are younger, maybe smarter, and willing to work longer hours for less money can be pretty daunting. Finally, there is a lot lost when working on giant teams spread throughout the world. Some of the intangible benefits of camaraderie that come from working on a tight-knit, small crew already seem a nostalgic memory of times gone by to those who have worked on the kinds of distributed development projects we've been discussing throughout this book.

But nostalgia for the good old days of the horse-drawn carriage didn't slow Henry Ford. All the cultural evils of the automobile era, from teen sex to traffic fatalities and greenhouse gas buildup, haven't stopped the adoption of the motor vehicle. For us old-timers, our fond memories of hacking games together with a friend or two on a Commodore 64 haven't slowed the adoption of the Xbox 360 one iota.

The future of entertainment software development is in distributed development, using multiple teams in much the manner I've described. Fortunately, this sort of project needs great managers who are willing to travel to interesting places, form strong relationships with smart people, and collaborate with them to make great games. That doesn't sound like such a bad life, now does it?

Index

Printed and bound by CPI Group (UK) Ltd, Croydon, CR0 4YY

21/10/2024

01777093-0002